THE SISTERHOOD

THE SISTERHOOD

The 99ers and the Rise of U.S. Women's Soccer

ROB GOLDMAN

University of Nebraska Press
Lincoln

Library of Congress
Cataloging-in-Publication Data
Names: Goldman, Rob, author.
Title: The sisterhood: the 99ers and the rise of
U.S. women's soccer / Rob Goldman.
Description: Lincoln: University of Nebraska
Press, [2021] | Includes bibliographical
references.
Identifiers: LCCN 2021009804
ISBN 9781496228833 (hardback)
ISBN 9781496230157 (epub)
ISBN 9781496230164 (pdf)
Subjects: LCSH: 99ers (Soccer team)—History. |
Women soccer players—United States. | Soccer
for women—Social aspects—United States. |
Soccer—United States—History.
Classification: LCC GV943.6.N56 G65 2021 |
DDC 796.3340973—dc23
LC record available at
https://lccn.loc.gov/2021009804

Set in Minion Pro by Mikala R. Kolander.

Dedicated to the memory of Tony DiCicco

In terms of history and sports,
I don't think people will forget.
—KRISTINE LILLY

Contents

THE SISTERHOOD

PART 1

ROUGH AND TUMBLERS

1

The Mavericks

It's game day, the national team is hosting Belgium, and the site of the old LA Sports Arena is rocking. The venue rocker Bruce Springsteen tagged "The Dump That Jumps" has gone the way of the wrecking ball and was replaced by state-of-the-art Banc of California Stadium.

The building was made possible by a group of investors including Magic Johnson and Mia Hamm. To christen the place, an alumni group chaired by Becky Sauerbrunn and Alex Morgan invited a number of former national team members to the event.

The gathering is unprecedented; several generations of national team players altogether for the first time. The old Sports Arena site, like the national team, had transcended into the twenty-first century. The old guard kicking the ball to the new kids, the ghost of the Sports Arena clinging to its last vestiges of memory before the wrecking ball vanquishes it into oblivion.

Invitees include the charter 1985 national team. A meet and greet is held a day before the match in a plush stadium lounge. Midway through the festivities, two former teammates, Emily Pickering Harner and Michelle Akers, reunite. A conversation ensues, and Pickering is shocked to hear Akers tell her husband, Steven, that it was Emily who first set the bar for the national team. Pickering is flattered. In her mind, Akers set the bar.

The truth is both players were instrumental. In the early 1980s, Pickering helped lead the University of North Carolina Tar Heels

(UNC) to three national championships. Those early Carolina clubs, in turn, set the tone for the first national team. Pickering's aggressive no-holds-barred, kick-ass approach was what her coach Anson Dorrance was looking for in his players. Pickering and other rough-and-tumblers like Akers, April Heinrichs, and Lori Henry became the prototypes for Carolina and the early national teams.

But it was Pickering, in particular, who possessed the killer instinct that set her apart. Emily took on everybody: opponents, teammates, referees, fans, even coaches. Inspired by her grit, Akers integrated the mentality of the Massapequa-born New Yorker into her own game.

Akers's compliment was especially gratifying to Pickering. Historical videos and books generally offer snippets of the first teams, then fast-forward to the 99ers; the 85ers barely get a mention.

But the national team didn't emerge from pixie dust. To become the 99ers, they had to first go through the 85ers, and it took strong-willed, hard-hitting warrior-beasts, like Pickering and Akers, to get the proverbial soccer ball rolling.

Pickering wondered why those early teams were rarely acknowledged. Without them this week's USA vs. Belgium match at the swank Banc of California Stadium could never have happened.

The reunion is a two-day event, and before the match the following day, the 99ers were invited to the field for introductions and photos. Pickering's 1985 squad, with the exception of Akers, remained upstairs. Despite the slight, Emily's heart swelled. The thousands of fans and the kids in Alex Morgan jerseys and multicolored face paint inspired her. Knowing she'd been partly responsible for all this filled her with pride.

As the 99ers were announced, Pickering became nostalgic. Her mind drifted back to a hot, sultry summer day in Baton Rouge in 1985. She was twenty-two, and her Southern Regional club was at the Olympic Sports Festival ready to take on the West for the tournament championship.

They were getting set to play when seconds before the opening whistle, Pickering's coach, Anson Dorrance, pulled Emily and teammate Michelle Akers aside with some exciting news.

"Listen," Dorrance barked, "a national team is in the works. Mike

Ryan's coaching. He's a stickler for detail, so if you want to make the team, wear your socks up and your shirtsleeves out."

"This is how we always wear 'em," Pickering replied.

"Do it, Emily! Look professional. You need to prove to Ryan you belong."

The news of a new national team didn't impress Pickering as much as her socks. It wasn't until 1985 that the U.S. Soccer Federation started requiring shin guards, and it happened because everyone was concerned about contracting AIDS.

"We thought it was weird given we generally didn't bleed from our shins, but we get strawberries on our hip and thighs if we slide tackle," says Pickering. "There was such a fear of AIDS that this is what they came up with, and it forced us to use our socks as shin guards. So for the start of the match, we wore our socks up and shirtsleeves not tucked in our bras, lest Ryan think we're mavericks."

The West Regional won the match and the tournament. Afterward, participants from all the regions settled on the grass for the awards ceremony. Included in the group was North Regional sweeper and tournament MVP Linda Gancitano. After the medals were disbursed and Gancitano received her award, the presenter informed the entire group he had some special news.

"We have a surprise," he boasted over the loudspeakers. "We are pleased to announce the first U.S. Women's Soccer team. In two weeks they'll be going to Italy for Mundialito Cup. Will the following new national team players please come up to the podium."

"We were all sitting on the grass," recalls Gancitano. "I'm on my knees in my grass-stained socks, and one by one Mike Ryan called us up. He said we've been invited to Italy for a tournament and had two weeks to get ready. He said he would push through our passports, and we were to meet at C. W. Post in Long Island to train a couple of days before flying to Milan."

Ryan introduced the players to his assistant coach, Roger Rogers, from England, currently living in Alabama. Rogers had chosen the East Coast and Southern players, and Ryan picked players from the West, including four from his Seattle club team.

From the sidelines Carolina's Anson Dorrance looked on with mixed

emotions. If there was resentment, he didn't show it. Granted, he coveted the national team coaching job, but Ryan was chosen on merit. His Seattle club team had won three consecutive championships. The highest level of the women's game took place in the Seattle-Tacoma area. Dorrance knew in the mid-1980s, the women's game went through Seattle.

He also knew the decision to form a national team didn't happen overnight. Ever since President Nixon signed Senator Birch Bayh's Title IX into law in 1972, a small but determined group of volunteers had been trying to raise U.S. women's soccer into the forefront. Title IX was the equivalent of the Emancipation Proclamation for female athletes. All publicly funded schools and universities were mandated by law to have female teams and receive scholarships on par with male athletes. The bill liberated females from the obscurity of club and recreation teams into the spotlight of universities and colleges.

The volunteers gained traction when a group of advocates headed by Marty Mankamyer, a chairwoman for the United States Youth Soccer Association, took on the USSF (United States Soccer Federation, or U.S. Soccer) with their demands. She had pushed in vain to get women's soccer into the 1984 Olympics, but the effort did not go unnoticed. In the summer of 1985, the USSF received an invitation from organizers of the prestigious Mundialito Cup to field a women's team in their annual summer tournament in Italy. The same year the United States Olympic Committee finally accepted women's soccer at their Amateur Summer Sports Festival in Baton Rouge.

"It was an incredible coincidence given women's soccer was not even an Olympic event yet," recalls Pickering. "Volunteers spent countless hours pushing for the Women's National Team, and they were a big driving force for getting things started. Names I remember were Chuck Blazer, Mavis Derflinger, Frank Baroni, and Betty D'Angelo, but many others helped get it through."

The summer events finally thrust U.S. women's soccer onto the national limelight. For Emily Pickering it would be the start of a short but memorable national team career. For Linda Gancitano, a blaze of glory before a devastating knee injury ended her career. For Michelle Akers, it marked the beginning of a fifteen-year odyssey that concluded at the 1999 World Cup and the Soccer Hall of Fame.

For Akers, her journey started with a letter. A few days before the start of the Olympic Sports Festival, she received a note from the U.S Soccer Federation on their official stationery: *Congratulations you have been chosen by U.S. Soccer to participate in the player's pool and come to Baton Rouge . . .*

"I had no idea what at all I was getting into, recalls Akers. "I never got a letter like that, and I had no idea what the U.S. National Team or U.S. Soccer Federation was, but it all looked super important and fun. I was excited just to go play soccer."

Growing up in the Seattle suburbs, Akers was obsessed with sports and soccer. Tall for her age, she dominated every team she played on. Stronger and more skilled then her peers, Akers got the attention of several colleges including Anson Dorrance at UNC and Jim Rudy at Central Florida University (CFU). During her recruitment trip to Chapel Hill, players tried to in vain to convince Akers to come to Carolina, but she thought Dorrance was arrogant and chose Central Florida.

Stacey Enos, a Carolina defensive back at the time, recalls Akers's decision. "Michelle said Carolina was the best team and she wanted to be able to beat the best," says Enos. "She thought she could prove herself more by pitting herself against UNC. I was sad when she chose Central Florida but respected her choice."

Akers admits she was no match with Pickering's activities off the pitch, but on the field she was every bit the competitor. By the time Dorrance ordered Michelle to lift up her socks and pull her shirt-sleeves out at the Olympic Sports Festival, she had been selected to numerous paper national teams and collegiate All-American teams. Linda Gancitano, a teammate of Akers at Central Florida, says Michelle possessed a presence and talent that couldn't be quantified.

"My boyfriend Bruce was a pro soccer player, and he'd visit me at Central Florida, and we would practice together," says Gancitano. "Bruce was drilling Michelle on heading one day, and she leapt up in the air and just exploded like a rocket. As a sweeper, I could serve the ball to her anywhere on the field, and Michelle was going to win that ball. Any ball that I ever served her she got. She's the best player I ever played with. Even at a young age, Michelle had it all."

Unlike Akers, Emily Pickering never received official notice about a national team. A star athlete at Massapequa's McDonald High in Long Island, she was eighteen when Dorrance snagged her for Carolina in 1981.

Pickering played with distinction at Chapel Hill. She helped lead the Tar Heels to four National Championships and shared the captaincy with April Heinrichs. Typical of the early players, Pickering earned her chops by rejecting traditional social mores.

"I was the self-professed weird girl who played sports," recalls Pickering. "I wasn't like the rest of the girls who wanted to play with dolls and wear pink. I was a tomboy who wanted to wrestle and play in the dirt."

Growing up in Massapequa wasn't easy for Emily, the seventh of eight siblings; she was only six when a drunk driver killed her brother. In high school her best friend was killed in a car crash returning from a soccer tournament. Then in July 1985, a month before the Olympic Sports Festival, a car accident killed her two best friends. Her father later died from AIDS from a tainted blood transfusion.

"All that made me rough at the edges," Pickering admits. "Sports allowed me to pool my energies into something without fear of retribution. It gave me an edge, and I took it to the pitch."

Like many of her peers, Pickering played soccer with a vengeance and partied just as hard off the pitch. Pickering could hold her own in the bars along Chapel Hill's Franklin Street, then scare the bejeezus out of her teammates at practice the next day with a full-on performance. It didn't matter what she partook in the night before—Pickering always rose to the occasion. Whether it was with her punishing play or finishing near the top of the physically demanding Carolina endurance runs, Pickering never backed down.

"It's not like we were out drinking before games," says Pickering. "The legal age was eighteen then, and I was no different than any other college student. I just happened to be one of many.

On or off the pitch, Pickering was not easily intimidated, as evidenced by a run-in she had during her sophomore season with one of Carolina's rising sport's stars. One evening Emily and a teammate

were cruising Chapel Hill's Franklin Street, near the Rathskeller, a popular student hangout, when they bumped into a familiar face.

"It was spring, 1983, and Carolina men's basketball just won the NCAA title," recalls Pickering. "We were trying to earn money to go to Europe, and having a contest to raffle off a TV. Walking down Franklin with my roommate, Ann Beattie, we ran into Michael Jordan. I said, 'Hey, Michael, would you like to buy a raffle ticket?'

"Michael's like, 'No.'

"I looked at him and said, 'We support you and your team. You should support us.'

"So he opened his wallet, and there is only one dollar, and he gave it to us, and he got a raffle ticket. We were like, 'Yeah!'"

Enos claims buried beneath Pickering's rough exterior was a kind soul. "Emily had some hardships throughout her family, but she has a heart of gold and was a great teammate," says Enos. "She was also our team's roughest player. She took control of the midfield at Carolina, and if you weren't where you were supposed to be, she'd let you know it. In one breath she would be screaming, 'Don't lose your friggin' mark,' the next minute, she'd be slapping you on the back saying, 'That play was friggin' brilliant.' Anson appreciated her, and I loved her."

According to Pickering, in the early days, Dorrance was awkward around women players. "I was eighteen and Anson's thirty when we met," says Pickering. "He was just a puppy then, trying to establish himself and was very robotic. We didn't have competitive cauldrons back then or leadership meetings, and we didn't talk about our feelings much. It was an interesting time, and Anson treated us just like the men, so we trained just like the men."

Enos says Dorrance was still trying to find his identity and at times could be standoffish. "In the early days Anson only wore a white shirt and white shorts," recalls Enos. "That was his training gear, and he had multiple sets of the same shirts and shorts. His coaching gear was blue pants and a white shirt. It was like he was in the military. He had his hair combed forward and was very structured. Over the years I think he realized he could have some personality and enjoy himself a little bit more. I remember the first time he showed up in a

pair of jeans, we couldn't believe it, we're like, 'Anson has jeans, and he's combed his hair back!' It was a huge deal."

Following the Olympic Sports Festival, Akers, Enos, Gancitano, and Pickering joined the rest of the national Team at C. W. Post University on Long Island. For two days they lived in the dorms and scrimmaged with local club teams. A cheerleading camp was happening at the same time, and cheerleaders led cheers each morning under their windows.

The night before they departed for Italy, sixteen blue, diagonally striped, discarded U.S. men's jerseys were doled out to the team. Volunteers and some of the player's parents spent the night sewing patches on the sleeves and hemmed the shorts and jerseys. Legend says the players sewed the patches on themselves, but Pickering says it wasn't the case. "It was a cute little story that has taken off as fact, and historians repeat it," says Pickering. "We had men's uniforms, and maybe they were a tad big, but we were missing some required patches. I never sewed anything, and neither did my teammates. It was a nice story Mike Ryan made up, and like anything else it took flight."

Stacey Enos still has her original shirt. "It had this kind of bulky patch, and everyone was trying to figure out where to put it. I don't remember any of the players sewing them, but if there was one who liked to sew, I could see that happening."

There were no dramatic send-offs at New York's JFK Airport when the team departed for Italy. The passenger list included sixteen players, Mike Ryan, Dr. Roger Rogers, who doubled as trainer, an equipment manager, general manager, Chuck Blazer, a woman doctor, and a volunteer who helped with laundry.

As the team stepped onto the skyway and boarded the plane for Italy, they had no premonition they were pioneering a movement that would someday change the culture for female athletes and thrust women's soccer onto the worldwide stage. At the time, they had no way of knowing the national team would someday become role models, advocates, and beacons for social justice.

All that was the future. In August 1985 the national team players were mavericks who wanted to follow their hearts and play soc-

cer. There was no money in it, and except for their families, the first national team was as relevant to outsiders as a punctured soccer ball on a muddy high school pitch.

"At that stage, I didn't conceptually get the sense other countries had been playing soccer and were competing against each other," recalls Enos. "I had a few days at home before driving up to New York. I remember spinning a globe around with my dad, and putting my finger down, and him saying, 'I think you're heading to this area of the world.' I had no idea what I was getting into, and neither did my teammates."

In 1985 a team of American female soccer players traveling to Italy to play in a tournament was unheard of. As the group made their way onto the plane in their matching white-collar shirts, Adidas jackets and shoes, and their short blue tennis shorts with big pockets, people mistook them for a tennis team.

"We were all jacked up singing and just being silly," recalls Pickering. "People kept asking, 'What are you, and why are you here? A women's national team, what's that?' We had a great time telling them who we were."

Akers compares the first step of their soccer journey to climbing Mt. Everest.

"You got your backpack on, and you're looking up at the mountain except you can't see the mountain," says Akers. "You only know you are going someplace you'd never been before, and doing the thing that you love, and that's all we cared about."

Of the sixteen national team players, Michele Akers was the most physically gifted. As a freshman at CFU, she led the Lady Knights to the NCAA quarterfinals before losing to Carolina. Her aggressive style captured the soccer world's attention, but Akers wasn't in it for accolades. She gauged her success on personal goals, and not judgments from others. Her mindset allowed her to focus on her play and personal improvement.

In time, her work ethic, drive, and skill would set her above the pack, but for now, she typified thousands of young female soccer players across the country. High school and college teams were sprout-

ing up everywhere, breaking sexist barriers and changing America's athletic and societal landscape.

Unbeknownst to Akers, she and her group were riding point on a cultural shift. Their plane to Italy was, in essence, filled with quiet revolutionaries. But for now, as the jumbo jet lumbered over the dark Atlantic, the soccer mavericks rested. Akers, Gancitano, and goalie Kim Wyant clustered together by the emergency exit and fell asleep on the floor. As they neared the European continent the plane hit turbulence, and emerging from her slumber, Akers looked around. She could see Mike Ryan in the ambient glow of his cabin light going over game notes, and drinking whisky. She and Ryan weren't getting along, so she looked for someone else close by to talk with, but Linda and Kim were asleep. Only Ryan was awake, feverishly writing notes, sipping Jack Daniels as if he was at the corner bar in Dublin.

With nothing else to do, Michelle gazed out at the dark Atlantic. That she was part of the first U.S. Women's National Team still hadn't registered. All of this was new, a grand adventure, and an excuse to play soccer at the highest level.

"It was how I feel when I first get on a horse," Akers recalls. "I love exactly where I am and what I'm doing, and yet I have no idea what's going to happen."

Most of the other players would agree. They were on the cusp of something big; they just didn't know what it was. For now, they were just in it for the adventure and love for the game.

2

OOSSAAA, OOSSAAA, AH

The Mundialito Cup, also known as the Little World Cup, was a prestigious four-team tournament featuring the best women soccer teams in Europe. The U.S. team was scheduled for four matches: Italy, Denmark twice, and England. The first two matches were held at Stadio Comunale Armando Picchi in Jesolo. The third match, against England, was scheduled at Stadio Comunale Giovanni Chiggiato, in Caorle. No one expected the U.S. team to win anything.

"We flew into Milan and then got on a bus," recalls Linda Gancitano. "It was a long ride, and there was no speed limit, so everyone was just flying. The hotel had windows opening to the sea, and we had an ocean breeze. We tried to get something to eat at certain times of the day, and we'd go into stores, and there's nobody taking money. It was my first experience with the siesta."

Located on the Mediterranean, Jesolo is a tourist destination, known for its azure waters and sandy beaches. In Roman times a lagoon covered the area now dominated by the town. There were several islands in the lagoon, the biggest of which was known as Equillum, the place of horses. Jesolo represents an altered form of this name.

In ancient times fishing boats and harbors lined the beaches, but now sunbathers inhabited the sandy coastline. It was hard for the coaches to stay away.

"The women were all topless," recalls Michelle Akers. "All I remember is Mike Ryan and Roger Rodgers sure liked hanging out on the beach."

"Women don't wear tops in Italy, and we all had them on," adds

Stacey Enos. "People were shouting 'Americanos,' laughing at us. They figured us for prudes."

While the staff checked out the scenery, Akers and her teammates rented a board and tried windsurfing. They sailed a couple of miles before realizing they couldn't turn it around. They left the board on the beach and had to walk back two miles to the hotel.

Back in town, they discovered another treat. "Someone had a cappuccino," Akers recalls. "I tried theirs and liked it. I had three cups a day every day I was there: one in the morning, one at lunch, and one right before bed. I'd bring it up to my room put the sugar in, and I'm thinking, this is the most amazing thing I've ever had in my life. Meanwhile, I'm drinking espresso trying to go to sleep at night."

Accompanying the group to Italy was their general manager, future international soccer guru Chuck Blazer. It was Blazer's initial entrée into women's soccer, and according to Gancitano, he was eyeing more than the team's logistics.

"I don't know if he had crushes on some of the girls, but whenever we were downstairs, getting stuff to eat or drink or whatever, Chuck told me to charge it to his room, and so that's what we would do. I don't know if he had a crush on me—I have no idea. I just thought that was kind of funny."

It's ironic that Blazer, a future player in the growth of women's soccer and who would be someday charged for corruption, already had a roguish element to him.

The Americans found the locals accommodating and friendly. The plan was to play matches every two days, then hit the discotheques and party. "We were getting invites for dinners and stuff like that," recalls Gancitano. "If there was a curfew, I don't remember it."

Game #1, USA vs. Italy, August 18

When the national team bus arrived at Stadio Comunale Armando Picchi for their first match, players were sent to the locker room underneath the stands to change into their uniforms. They then entered the pitch through a tunnel. Tiers of seats sat in three rows on the locker room side, a bank of tall trees towered over the pitch opposite them.

Armed guards secured the perimeter protecting players from potential hooligans and rowdy fans. As they stepped onto the brown, roughshod, water-depleted pitch, players were nervous but found it exciting being away from home and around people who didn't speak English.

Before the match national anthems of both teams played. It was the first time the "Star-Spangled Banner" played for the national team in competition. For Stacey Enos, the anthem combined with her naivete supplied some unintended drama.

"We hadn't done any trial runs," says Enos. "It's not like we practiced the anthem in Long Island, like, here's the anthem, we want you to put your hand over your heart. There was no precedent, and we just didn't know what to do. I've watched the men's U.S. team, but in Italy we lined up, wearing a patch that has the stars and stripes on, and the national anthem comes on. I just remember smiling, thinking, *I'm singing the national anthem*, and I felt this deep sense of wonderment. I couldn't believe I was playing for my country in the first game ever for the U.S. Women's National Team."

Linda Gancitano's sentiments are comparable but with an Italian twist. "I remember singing, crying and getting goose bumps when they played the anthem," she said. "But being the only Italian on the team, I heard a lot of fans calling for my last name."

For Michelle Akers, her anthem experience differed somewhat from her teammates. She admits she didn't yet grasp the significance of the national team, and during one practice she says Ryan reprimanded the players for their perceived lack of patriotic zeal.

"I wasn't the only player who didn't get this was the U.S. team, and what an honor it is to play for your country," says Akers. "At one practice, he was just pissed at us. He was yelling at us, spit flying, and frothing at the mouth. 'You guys aren't getting this,' he screamed. 'You're playing for your country, and this is an honor. You're representing every person in your nation. Now everyone, stand up and sing your national anthem.'

"Right there on the field, he made us stand in a row and shout out the national anthem. Ryan was a yeller but was Irish, so he knew what playing for your country meant.

"I was like, oh my god. . . . We yelled out the national anthem, but it still didn't sink in. The only thing that struck me was how much spit flew out of his mouth when he was talking."

Enos, Pickering, and Gancitano don't recall the shouting of the national anthem. That is not to say it never happened—every player has their take on events. But for Pickering, a veteran of several state and regional teams, shouting it at practice doesn't ring a bell.

"To be honest, I don't remember," says Pickering. "It's a hard song to sing, but I always kind of sang it anyway so it probably didn't bother me. I heard Michelle say something to the effect she didn't know what the national team was, but I did. And I was full of pride whenever the anthem played."

"Star-Spangled Banner" aside, once the whistle blew, the national team was a bundle of nerves. "We were frantic," says Enos. "It took several minutes to find our legs and feet."

The immediate challenge the U.S. women faced was the physicality of the Italians. They were pulling shirts, kicking shins, and spitting in the U.S. faces; and for Akers and Pickering, normally enforcers, the abuse was doubly frustrating. Sidelined by injuries and a coach's grudge, neither player was in the game and could only watch hopelessly as their teammates got pummeled the entire first half.

The rough play stirred the Americans, and when they returned for the second half, Akers started to comprehend what Ryan was getting at when he chewed them out for their perceived lack of patriotic zeal.

"We were losing, 1–0, and I'm watching my team getting the crap knocked out of us," recalls Akers. "We came back after the half, battered and bruised, and that was the first time I realized we were the USA playing against Italy, and I wanted us to win because it's our country.

"It was a deepening of the understanding Mike Ryan was trying to inspire in us. Throughout the tournament, even though we didn't play well and weren't a threat, we did start to understand what it meant to play for the U.S. team."

For now the abuse persisted, and Ryan looked to his bench. Despite her being injured, he ordered Pickering to sub center-back Sharon Remer (McMurtry) but quickly changed his mind.

"I had a stress fracture and couldn't play," recalls Pickering. "It's

1–0, Italy, we're still in the game, and they had taken down Sharon. I thought she was going to take the penalty kick when suddenly Ryan yanks me off the bench, 'Get ready,' he says.

"I'm like, okay, what do I do? I've never been in this position. I'm hurt, and I can't play. Then Sharon misses the kick, and he throws me down on the bench again. It was bizarre, weird behavior. I never thought he had control of the situation."

To help turn the momentum, Ryan turned to sweeper Linda Gancitano. "Get warm," he said. "You're going in at right back."

Gancitano was about to become the national team's first substitute.

"We were physically getting beat up," recalls Gancitano, "and I decided I was the player who wasn't going to take any more from anybody. I brought in a lot of energy and helped stop those unnecessary hits. I don't think the Italians liked getting put in their place, but I came back with it hard, and was why I started the next game."

The Italian fans meanwhile were falling in love with the Americanos' vim, and hustle, and as the national team's lone Italian American, Gancitano got her share of affection. "The fans had been calling me 'Gancitanooooo,' then they started shouting something else like 'OOSSAAA.'"

"We didn't know what the Italians were yelling," adds Pickering. "Turns out the USA to them was OOSSAAA, so they would start saying, 'OOSSAAA, OOSSAAA, AH!' They would run around with American flags, shouting, 'USSA, USSA, USSA.' Finally, we figured out what it meant, and I was like, are you kidding me?"

"Initially we thought they were booing us," adds Enos. "We could hear, 'OOSSAAA,' and I was like, 'Oh man, we must suck.' But later, when we were walking out of the stadium, they were smiling, and all saying the same thing, 'OOSSAAA,' and wanted us to sign stuff. So that's when we put it together. They were saying, 'The USA,' but it came out, 'OOSSAAA.' We're like, 'Oh my god, we have fans, and they're cheering for us.' Later people would come to our hotel wanting autographs. It was freaking remarkable."

Though the U.S. lost 1–0, they made a positive impression and had won the hearts of the Italian faithful.

"We were loved by the Italians, and it felt good," recalls Akers. "It

was like they wanted us to do well. I'm thinking, 'Oh my gosh, they like us.' To be away from home and them to root us on was pretty cool."

When they weren't playing soccer, the U.S. women stayed busy. During downtimes they partied at local discos, made side trips to Venice, went to the beach, and rented mopeds. By the time they took to the pitch for their second match against Denmark, a few players were a bit peaked and sunburned. The U.S. managed to tie the Danes, 2–2, but what's up for debate is who scored the first U.S. goal. In an article written at the time by Antonella Antonelle for the Italian sports daily, *Gazzetta Dello Sport*, the first goal gets credited to Akers.

The translation: "The Americans managed to draw first after a foul, with the goal scored by Akers and then went ahead with a goal scored by Pickering. Only a header by Schmidt-Hansen off a corner kick preventing the Americans from obtaining a victory that would have been sensational."

The *Gazzetta Dello Sport* reflects U.S. assistant coach Roger Rogers's game reports: "Denmark went up early 1–0, in the first half, and Akers tied the game," wrote Rogers. "Pickering put us ahead and then Denmark scored with 8 minutes left to tie the game off a corner kick. It was a girl named Schmidt-Hansen, and the cross was a player named Munk Nielson."

But the story doesn't end there. In 1991 Mike Ryan told Grahame L. Jones of the *LA Times* a different story: "Akers didn't score the first goal, it was a girl named Emily Pickering. She got the first goal on a free kick and put it right in the corner. The Danes were flabbergasted."

When it comes down to who scored first, no one can say for sure who did. "I thought I scored the first goal," maintains Akers. "If somebody else says they did, then they did. I have no idea."

Enos's memory is also fuzzy. "I can't remember who scored first; I just know Michelle was fierce that game. She scored on a vicious header."

For Pickering, what stood out more than her goal was validation. Ryan had started her at left-back, not center-back. She felt slighted, and after she scored felt a bit of redemption.

"My goal was a left-footed shot in the upper nineties," says Picker-

ing. "What makes me think it was the second goal is we tied or went up 2–1. Denmark scored again, but I felt good about scoring. Like, 'Take that, Mike Ryan! Ha.'"

By the time the national team arrived in Caorle to play England two days later, players were beat and showing signs of fatigue. The previous matches and Italian nightlife had taken a toll.

"We were bleary-eyed," says Pickering. "They had just thrown us into a parade in Jesolo, and the discos were fun, but by the third match with England we were completely exhausted, which made it difficult to perform."

To top it off, the team bus got lost going to the stadium, and the driver spent an hour roaming the streets before finding the field. The England coach asked Ryan if he wanted extra time to warm up, but Ryan declined. When England snapped off three quick goals, Ryan realized his mistake and searched for a scapegoat.

"Bam, they scored. Bam, they scored. Bam, they score again, and Ryan blames me for it," says Pickering. "I was like, 'That wasn't my girl! That was Stacey's [Enos] mark.' It was a frustrating trip for me in a lot of respects. Getting injured, and not feeling I got the credit that I felt I deserved, put a damper on things."

The England match was Akers's last one for the tournament. She scored early but dislocated her shoulder after a vicious hit. The U.S. lost, 3–1, their worst defeat in the tournament. The U.S. played Denmark again two days later and kept the Danes close, but lost 1–0.

Despite failing to win any games, several positives came out of the tournament. For one, the U.S. didn't get blown out in any game, thus winning respect of the opposition and adoration from the Italian fans. Several precedents were established. U.S. flags were unfurled on foreign pitches, and the OOSSAAA chants, originated by the Italians, reverberate to this day.

"We made it our rallying cry, and they have not stopped doing it thirty-five years later," says Pickering. "There's a connection between every one of us who have been on the national team, and it is OOSSAAA OOSSAAA OOSSAAA AH!"

The national team also proved they had marketing potential. Fol-

lowing the second match with Denmark, Pickering, Akers and Ganci-tano became fashion models.

"They brought girls in from every team, and did a photo shoot," recalls Gancitano. "They put us in dresses and did our makeup and hair. Emily had a beautiful Italian gown. I have no idea what happened to the photos, but it was fun."

Italy was a proving ground for the national team, and when they returned home they were forced to reassess. "We fought hard and did our best, but the Europeans were just better," recalls Akers. "They understood soccer nuances and cultural-social aspects of the game we just didn't get. Whenever a foul occurred back home, it usually meant a yellow or red flag. They bashed us in the face, grabbed my crotch, and yanked at everything, including my shorts, and even my underwear. They pulled as hard as they could, stomping our ankles, and spitting at us when we're on the ground.

"In the U.S., the referees were like, 'Oh, you're a horrible person—here's a red card.' We were looking for the same treatment in Italy, but the ref didn't call for cards. We were in Italy playing Italy, and the ref was Italian, and no one had taught us those things."

For Pickering, the rough play proved to be an asset.

"We found the Italian jersey pulling effective. Anson introduced it at Carolina the following year. We called it push-pull. We were grabbing jerseys, trying to balance ourselves and figure out how we could stay on our feet without punching the girl who's ripping your clothes off. 'When in doubt I'm going to take you out,' became our mantra. Thank the Europeans for that."

Italy had been baptism under fire, a crash course on finding their international legs. If there were any misgivings, Pickering puts it all on the coach.

"During the England match, Ryan just started yanking people," recalls Pickering. "He should have shown us more respect. You put your starters in, there should be a sense of, 'Hey, we're going to pull this off. Don't worry about it. Let it go.' But you don't start yanking your starters out. You should give them the benefit of the doubt and let them work their way through it. I think pulling players early was a mistake on Ryan's part."

In retrospect, communication with the team in 1985 was limited. "It was hard to understand what U.S. Soccer was thinking because the coaches didn't share a lot," adds Pickering. "That's why the history for that period is so poor. But I loved every minute of it. I thought the way we played, we did the USA proud. We kept our heads up, we didn't win, but we got a tie, and I never thought we embarrassed ourselves. The U.S. Soccer Federation could have communicated better. Still, given the situation we were put in, I feel like my teammates and myself and the coaching staff did a great job."

If anyone in the United States noticed a group of professional American soccer women had just played their first major international tournament, it was a minor miracle. News of the event, if there was any, was buried in the back of sports sections and had zero impact.

In the summer of 1985, women's soccer was unknown, as foreign to Americans as the packages of Italian cappuccino some of the players smuggled home in their travel bags. With no immediate plans, the national team dispersed. Players returned to their club teams and colleges or got jobs. Akers went back to Central Florida, where she tore her meniscus and was forced to red-shirt her sophomore year.

Pickering and Enos returned to UNC, where they shared tactics learned from the Europeans with Dorrance and their fellow Carolinians. Mike Ryan went back to his welding job in Washington and coaching his club team. His duties with the national team were finished, and he was released. Never again would the Irishman order a group of national team players to shout the national anthem.

But Ryan's patriotic plea resonated. At the University of North Carolina, an equally zealous, patriotic coach was waiting eagerly in the wings. In due time the national team would be able to compete with anyone in the world, and it would be Anson Dorrance and his group of talented, spirited Carolinians leading the charge.

3

Fury and Finesse

By 1985 Anson Dorrance had already won three national collegiate titles and was considered one of the best soccer minds in the nation. With his influence and track record, why wasn't he chosen over Mike Ryan as the first national team's first coach?

The United States Soccer Federation said Dorrance was unqualified because he'd never coached at a USSF-sanctioned event, but was that the real reason? Both Ryan and Dorrance were present at the Olympic Sports Festival in 1985 and readily available, but where Ryan was manageable, Dorrance, in the eyes of the USSF, wasn't.

The core problem was that the USSF officials were bureaucrats, with little or no soccer experience, and Dorrance was an experienced player and coach who didn't suffer fools. Chuck Blazer, USSF executive vice president at the time, explains, "Anson was an abrasive combination of politically incorrect and noisy and the administration at the time generally wasn't sophisticated enough to see the potential in that."

It became obvious from the player reports following the Mundialito Cup that Mike Ryan lacked the capability to get the national team to the next level. When the federation traveled to Dallas for their annual coaching tryouts in early 1986, several regional and junior national coaching positions were still available, including the Women's National Team.

Dorrance arrived at the meetings intent on becoming the new national team coach. The job was appealing because it presented the ultimate challenge. To take something from nothing and mold

it into something relevant appealed to his competitive nature. There was also his patriotism: Anson Dorrance's ancestors fought in every U.S. military engagement since the American Revolution; his lineage included soldiers and fighters. Anson had relatives who fought the British in 1776 and the War of 1812; they were in the Civil War, both world wars, and Korea. Anson's uncle on his father's side was buried at Normandy Beach. Patriotism raged hot in Anson's blood, and the national team was an extension of those ideals.

Dorrance's heroes were imperialists like Rudyard Kipling and warlords like Winston Churchill. Like the prime minister, Dorrance yearned to be a force for positive change, and he wasn't afraid to use his intellect, fierce desire, and talent to realize his goals.

Dorrance's father, known affectionately as "Big Pete," could be considered Churchillian, in a sense. An enterprising international oil executive, Big Pete traveled the world with corporations eager to take advantage of the energy boom occurring in third world countries. Perhaps Anson picked up on his father's ideals and most certainly his patriotism and confidence.

Born in Bombay in 1951, Anson, by the time he arrived at college, had lived in Singapore, Ethiopia, Kenya, and Switzerland. He survived his nomadic lifestyle by combining brashness, smarts, and athleticism. Smallish in stature, Anson held his own as an athlete and gained acceptance by excelling in the local sports where he resided. He used athletics as a means to gain stature and make friends. Since soccer was played virtually everywhere, he naturally gravitated to the pitch.

If his fraternal side was accountable for his audacity, Anson's respect for female athletes came from his mother. A star-studded athlete in college, Peggy Peoples was living proof women had athletic capabilities and the will to compete. Though he had much to learn about women, Dorrance understood at an early age they were capable of becoming great athletes.

After graduating from high school in Switzerland, Anson did a semester at a Jesuit school in San Antonio, but the rigid doctrine clashed with his independent streak. In search of his calling, in 1970 he visited his grandmother's farm in North Carolina. Anson fell in love with the South and the nearby college town of Chapel Hill. Anson

transferred to the University of North Carolina in 1971, where he majored in philosophy and English. At his fraternity he was known as a prankster, hell-raiser, athlete, and competent sports coordinator. He also played varsity soccer and was good enough to be named All-ACC (Atlantic Coast Conference) three times.

On the pitch Dorrance relied on toughness and guile more so than athleticism. He also knew his playing days after college were limited. Big Pete urged Anson to follow in his corporate footsteps. He thought law fit Anson's combative and competitive nature and had big plans for him to become chief lawyer for his refinery after graduation.

But a career in law wasn't in the cards for Anson. In the fall of 1974, while waiting to be accepted into law school, a part-time coaching gig opened up near Chapel Hill. The Rainbow Soccer Club Recreation League was looking for people, and at a friend's suggestion, Dorrance took a part-time position. His responsibilities included coaching several age groups. The league was recreational, and no one took the playing serious except Anson. Frustrated by their competitive indifference, he started bringing in local ringers, claiming team morale was higher when they won. His tactics alienated fellow coaches, which pleased him immensely. Anson's wife, M'Liss, a former professional ballet dancer, thought with his competitive drive, he might consider a career in coaching, but Anson brushed it off, insisting coaching lacked intellectualism and wasn't a bankable profession.

In the fall of 1976 Anson was accepted into law school at North Carolina University in Durham. He was destined for a law career when fate intervened. Dr. Marvin Allen, Anson's soccer coach at Carolina, was retiring. When Athletic Director Bill Cobey asked Allen about a successor to coach the men's team, he recommended Dorrance.

When Cobey offered Dorrance the job, he was stunned. He couldn't believe an athletic director of a major university would offer a varsity coaching position to someone as young and inexperienced as himself, but Allen saw something in the twenty-five-year-old that defied his age. "Anson understood soccer better than anybody I'd ever coached, and possessed competitive drive, and ability to teach," Allen later said.

As with everything he did, Dorrance took on coaching soccer with zeal. He experimented with conditioning methods and playing strate-

gies and instilled in players a winning mindset. Most importantly, he focused on recruiting and started a homegrown scholarship program, proving U.S. colleges didn't need foreign players to be competitive.

The successes of the Carolina men's team led to stature and opportunity. In 1979, when a female Carolina club soccer player, Laura Brockington, asked Cobey about the possibility of forming a varsity women's soccer team, Cobey didn't hesitate. He understood soccer was the future, and whoever was first with a women's program in the ACC would be well ahead of the curve.

Without the chancellor's approval, in 1979 Cobey christened the first women's soccer program at Carolina. Of course, he would need a coach, one skillful and smart enough for the program to excel. Turns out, he didn't have to look far.

Dorrance initially balked at Cobey's offer. He had no desire for coaching women, but after observing Laura Brockington's college club team, the Pioneers, he reevaluated. The skill set of the girls and their will to win impressed him. When Cobey sweetened the deal by offering Dorrance a full-time faculty position to coach both the women's and men's teams, he accepted.

The same day Dorrance was scheduled to coach his first UNC women's club match in Wilmington, M'Liss called informing him she was going into labor. For Dorrance, the soccer season would have to wait until his first daughter, Michelle, arrived. After rejoining the team a few days later, Dorrance went to work. Using similar methods he applied to the men's team, he turned the women's program into instant contenders. His biggest challenge was setting a combative mind set. "I had to eradicate this dislike for direct confrontation if we wanted to lead women's soccer playing culture," says Dorrance. "Our girls needed to embrace 1v1 and not be afraid of it."

Dorrance discovered coaching soccer full-time was gratifying. It brought him prestige, acceptance, and purpose, and satisfied his need for strong and purposeful leadership. But to succeed Dorrance needed committed, like-minded players to put his vision into action.

Dorrance was aware that scores of the first-generation Title IX girls were determined to break free from their societal binds and follow their competitive desires. In some cases players came to him, but

early on that was the exception. A tip from a friend could send Dorrance, a relentless recruiter, scurrying across the country in search of soccer gold. Such was the case in 1983, when a tip led him to Littleton, Colorado, and a local high school standout. Her name was April Heinrichs, and with this tough, determined youngster from Arapahoe County, Dorrance practically met his match.

4

The Perfect Intersection

After we leave the field, it's kind of like napalm in the
morning; it's like this destruction.
—APRIL HEINRICHS

"I was almost a troubled kid," says April Heinrichs. "I say almost because in a sense, I never got in a lot of trouble, but there was a lot of craziness around me. My mother divorced several times and had several children, five that we know of, all of whom were girls, and probably all had different fathers.

"That's what I mean by an almost troubled kid; if I hadn't found sports, I would have gotten in big trouble. I had lots of energy, I was wildly competitive, and nothing intimidated me. I could hang with any kid in the neighborhood in any sport, and I played everything, baseball, basketball, and soccer and usually won.

"For football, we'd have on helmets and shoulder pads and played tackle in the dirt. We also played full-contact street basketball. Not the kind you played with your dad with the rim connected to a garage, and there's some nice fluffy grass around the edges. We're talking asphalt where if you slipped you were in big trouble.

"Between my competitive drive and wildness, I was able to survive. I wasn't sure if my aim was a drive to succeed because I was still too young to think about success and failure, or if I was on a path taking me somewhere. I never thought about the future. I was too busy competing, having a blast."

It's safe to assume April Heinrichs wasn't a typical 1970s girl from the Denver suburbs. She didn't play Barbie or bake brownies, and similar to most national team players, she was a tomboy who grew up with male siblings who challenged her.

The reason April's chaotic upbringing didn't break her was due in part to her stepdad, a kindly man named Heinrichs, who cared about April and helped fulfill her athletic destiny. It was through their mutual love of sports that April was able to channel her anxieties into something productive.

"I hear a lot of stories about how people say girls weren't competitive, or girls couldn't play certain sports, but I never had any of that," says Heinrichs. "I never had anyone question whether I should be playing with boys, and nobody ever said I couldn't, so I never questioned it. There's a lot of angst in a lot of people from their social acceptance, I either didn't care about being socially accepted, or I never faced those feelings. I'm not sure which one it is."

As April entered college age, some of the baggage of her youth remained. To her teammates, she could come off polarizing and egotistical one minute, supportive and giving the next. Luckily, she had a coach, Anson Dorrance, who, despite their often rocky relationship, embraced April's toughness. This odd couple helped form the team's aggressive, fighting persona and guided the group through its most challenging period.

April was playing club soccer and varsity basketball at Littleton's Heritage High School when a visiting club coach tipped her off to Dorrance and Central Florida's Jim Rudy. She had just received rejection slips from four colleges, so the offers presented an intriguing dilemma.

"I realized Carolina had finished first in the NCAA, so I automatically wanted to go Central Florida," recalls Heinrichs. "I wasn't interested in UNC because I wanted to go to the number two ranked school and win it. But Anson is a good salesman. He came to Colorado and watched me train on a slippery high school gymnasium floor and offered me a half scholarship. I could not have gone to UNC on anything less.

"I was twenty when I came to Carolina, and Anson was thirty-five

and relatively new to coaching women, so we came along in each other's lives at this perfect intersection.

"He saw a competitive style in me comparable to players on his men's college team and probably thought: 'Will if one of them can have it, why can't all of them be like that?' He started to coach that competitiveness using me as an example."

Coaching women in the early 1980s was still a work in progress for Dorrance. While being recruited, Heinrichs once asked him how the team got along.

"Why are you asking me about that?" Dorrance replied.

"I'm asking because it matters to me," Heinrichs told him.

Dorrance hadn't yet grasped team chemistry is far more significant to women then it is to men. The prevailing thought among male coaches at the time was, "As long as my team wins, then feelings shouldn't matter," but Dorrance discovered the opposite was true for women.

"For us, it's let us invest in the game and ourselves and have fun along the way," says Heinrichs. "My generation taught Anson those ideals, and he took them to heart. Once he realized if you can tap into women bleeding, sweating, and crying for each other, you will be far more successful and accepted as a coach.

"We showed Anson cohesiveness and working for each other mattered, and to his credit, he tapped into the differences. Instead of addressing us like he would his male players, he found himself saying, 'Win your battle and then help the person next to you win their battle. And if your battle isn't going well today, then you make up for it tomorrow, and your teammate will make up for you.'"

Dorrance used the training environment at Carolina as a testing ground to see what worked and what didn't. He was honing skills he would someday bring to the national team. One big challenge was breaking down cultural inhibitions that kept female athletes from being their best competitive selves. A practice drill Dorrance used to accomplish overcoming this problem was small-sided soccer. He'd construct mini-teams, 2v2, 2v4, 4v4, 7v7, and have players choose sides to see who they valued most. According to Heinrichs, the ultra-competitive setting went to the core of Dorrance's new ideology.

"When you give women permission to compete it opens a magnificent door for us to thrive in," says Heinrichs. "The drills were either sink or swim, but everyone got the opportunity to show what they had." Heinrichs excelled in this space. The games allowed her to showcase her strengths, and Dorrance loved it. He coveted players with killer instincts like April, who were willing to go after blood and show no mercy.

Heinrichs was not only competitive but incredibly strong. Emily Pickering recalls a time at Carolina when she mistakenly challenged Heinrichs to a game of tackle football.

"We had a play, April got the ball, and I'm like, 'Okay, I'm gonna try to tackle her,'" recalls Pickering. "I latched onto her and was trying to drag her down, but she took another five steps before I finally got her to the ground. I had her in a bear hug, but she still kicked my ass. I was completely humiliated."

Heinrichs excelled at Carolina, leading the team in scoring and being named All American in three of her four years. She was named Intercollegiate Soccer Association Player of the Year in 1984 and, as their captain, helped guide Carolina to three NCAA championships.

Heinrichs had been selected for the national team paper squad as a freshman and junior, in 1983 and 1984, but it failed to materialize. When the U.S. team finally formalized in 1985, Heinrichs couldn't go to Jesolo due to a leg injury.

The national team didn't play again until July 1986. A tournament in Blaine, Minnesota, against Canada marked the first time the national team played since the 1985 Mundialito Cup. The matches were a tune-up for their second trip to Jesolo, Italy, scheduled for August.

Much had changed from the previous year when Mike Ryan only had a week to organize a team. That spring Anson Dorrance had been one of several coaches invited by the USSF to Dallas to an audition for several coaching positions, including the national team. Though he had no expectation of winning the job, he told Chuck Blazer, the federation's most influential member, there was no doubt he was up for the task. "Chuck, give me the job," Dorrance demanded, "because I am going to win."

Blazer agreed, and Dorrance departed Dallas as the new national team coach. Unlike Mike Ryan, he had several months to prepare

for Mundialito, and he had no intention of going to Italy and losing. Heinrichs was also eager to go. From an early age, she dreamed of being an Olympian, and for women's soccer at the time, this was the closest thing to it.

"I could virtually smell the national team program," recalls Heinrichs. "For me that was the Olympics. I remember thinking, 'I'm one of the best players at Carolina and the national team, and now I want to be the best player in the world.'"

Before taking her dream abroad, there was still some team business back home to attend to. Before their opening match against Canada at the Blaine tournament, Dorrance collected his team and placed several ballots on a conference table. "Choose a captain, one captain," he said. When the votes came in, Heinrichs came out on top. She calls the moment one of the honors of her life.

July 7, 1986, marked Heinrichs's first match as national team captain, and Dorrance's first as coach. The U.S. beat Canada, 2–0, with Marcia McDermott and Joan Dunlap doing the scoring. Two days later, the U.S. beat Canada again, 2–1. For the grudge match on July 10, Heinrichs scored a brace of goals, en route to a 3–1 U.S. win.

Assisting on one of Heinrichs's two goals that day was a UNC senior, Lauren Gregg. The future national team assistant coach recalls a conversation she and Dorrance had on their way to the team bus following the game.

"At the time there was nothing on the horizon for the national team," recalls Gregg." But as we were getting on the bus, Anson turned to me and said, "One day there's going to be a World Cup.'

"I said, 'Yeah, I'd carry somebody's suitcases to be part of that,' and we just kind of laughed and got on the bus."

Just before the team headed on their plane for Italy, an issue arose that almost put Heinrichs's dream on hold again. "I had sprained my ankle at Blaine and cried for three days because I thought Anson wouldn't take me," recalls Heinrichs. "I kept telling him, 'I can walk, we still have ten days before our first game, and I'll be fine.'"

After a few days of deliberation, Dorrance gave his captain the green light. When the national team boarded the plane for Milan on August 20, a limping Heinrichs was in tow.

The U.S. defeated Japan, China, and Brazil at Jesolo, and despite losing the final to Italy, 1–0, the national team won their group and departed Europe on a high note.

"We didn't win a match the year before, but Anson revamped the team, and this time we almost won it," recalls Emily Pickering. "We were no longer the new kids in town."

Upon their return home, the team dispersed, and another year would pass before they would play together as a group. During the break there was no pay or team-sponsored training. Players who had recently graduated had to choose between soccer and the workforce. For Heinrichs, who graduated in June, the choice was easy. Soccer for her wasn't about the money—it was competing at the highest level. Set on her career choice, Heinrichs trained and did some college coaching until the national team regrouped the following year.

April Heinrichs would go onto play another six seasons for the national team, and for the entire time, she never let up. As a player Heinrichs was someone her teammates respected on the pitch and never liked going up against. Emily Pickering, who played with April in college and on the national team, has nothing but praise for her former teammate.

"The world did not get to see the real April Heinrichs play in the 1991 World Cup," says Pickering. "Her knees were pretty bad by then, but she was the best. I don't want to blow up her head any more than it is, but she is.

"April was fast, made intelligent runs, and she would run at you at speed with the ball. There was no slowing down with her. She was definitely before her time. Unfortunately, the world did not get to see her play because she was phenomenal."

Heinrichs, in turn, credits Pickering for paving the way for players like her to follow. "Emily was a senior when I was a freshman," says Heinrichs. "If I epitomized the younger generation, she did the same with the older generation. Emily would party hard and then show up the next day and train as hard as anyone, and I respected that. The women of Emily's generation were hard and intense, but they didn't intimidate me, because I have no problem with that kind

of attitude. I was up for it. 'Let's go sister!' I'd say. 'I'm used to playing with boys. Let's go!' It was awesome."

Dorrance believes Heinrichs's contributions to Carolina soccer and the national team were significant and helped establish the template for future generations to follow.

"When April first came to UNC, she chewed through her teammates in practice. She ruthlessly pounded them," says Dorrance. "Concerned over her aggressive personality, some of the players came to me and asked, 'What are we going to do about April?' I answered without hesitation, 'Clone her.' I wanted everyone to compete like April. I thought it was terrific. Being dominant, aggressive and courageous that's the powerful part of you. That is the part that is worthy of self-respect, and ultimately the respect of others."

With the national team's strong showing in Italy in 1986, Dorrance proved to his detractors what he already knew: the national team had the potential to be a dominant force in international soccer. With proper conditioning, training, and mindset, they could be as good as any team in the world.

The 1986 Mundialito Cup closed the first chapter in the history of the national team. In two short years a group of relatively obscure mavericks blazed a trail others would follow. The next generation would never be as raw and gruff as the first wave, but would possess other winning attributes.

In the summer of 1987, Dorrance brought into camp a crop of youngsters who were the polar opposite of the rough and tumblers who'd preceded them. They arrived in camp in their teens, shy and insignificant to the point that Michelle Akers barely noticed them.

These youngsters, adequately nicknamed "The Babies," would be the players caught between the rough-hewn hell-raisers of the past and the more polished next generation. Who better than rough and tumblers like Akers, Lori Henry, and April Heinrichs, the one her teammates called "Ape," to teach them the ropes.

5

The Babies

I first met Mia at our first regional camp in 1987. I remember
being in our room listening to Michael Jackson and jumping
on the beds. On one of our early trips to Italy, for some odd
reason, they roomed, Julie and Mia and myself all together,
and somehow we all slept in and missed breakfast.
We were in complete disarray, thinking, "Oh my god, what's
gonna happen to us?" Back then, you couldn't miss a meal.
Whether you ate or not, you had to be in the dining area, and
so the three of us were in trouble. The staff was whispering,
"Don't ever put these kids together again."

—KRISTINE LILLY

Though the Women's National Team did not meet again until the
summer of 1987, Anson Dorrance had not been idle. In the winter
of 1986, Carolina avenged their loss to George Mason University in
the 1985 finals and took back the NCAA title from Colorado College,
for their third national championship in four years. The unprece-
dented string only reinforced Carolina as the go-to college for any
young prospect serious about building a career in soccer and joining
the national team. Dorrance wasn't shy about sharing UNC's exploits
when he recruited. The championships were tremendous selling points
used to entice players to come to Carolina.

Among those new recruits in 1987 were several teens who had lit-
tle in common with the rough and tumblers of the past. Still in high

school, they didn't have to kick and scream their way through the club ranks to be seen.

But their looks are deceiving. These teens might have had a gentler, kinder soccer upbringing, but it didn't mean they were any less competitive or determined than their salty predecessors.

Though few realized it at the time, these youngsters were the future of women's soccer. Today the names Mia Hamm, Julie Foudy, Joy Fawcett, and Kristine Lilly are synonymous with the sport, but when they first arrived, they were insignificant to everyone but themselves.

That they all came on the scene at precisely the same time probably had more to do with Dorrance's skill at deciphering talent than coincidence. Regardless, the times were ripe for new blood. It had been fifteen years since the inception of Title IX, and a new generation was needed to carry the torch.

Of the four babies, perhaps Hamm's story is most applicable because it shows the extremes Dorrance would pursue to get recruits to come to Carolina, and Mia's wiliness to do anything she could to get there.

Mia and her five siblings, the children of an air force fighter pilot and a former ballerina, led the unsettling life of military brats. Their father's career led to a succession of military bases in Monterey, California; Florence, Italy; Annandale, Virginia; Wichita Falls, Texas; and San Antonio, Texas.

Adversity and adaptability became second nature to Mia. Born with a clubfoot in Selma, Alabama, in 1972, she was forced to wear corrective shoes as a toddler. As she got older, a bad haircut and an aversion to dresses resulted in her often being mistaken for a boy. Though small in stature, Mia compensated with intensity, toughness, and an uncanny drive.

If Mia had a soft spot, she could be emotionally fragile. As a girl, her anger and frustrations could give way to tantrums and withdrawal. Her insistence on perfection might have led to this aspect of her personality, but for whatever reason, Mia was wired tight as a drum and used sports as a means to unleash her pent-up emotions.

Mia lived in eight different locales before she turned seventeen. Thus home was never really home, and her main refuge became the

pitch, the football field, or basketball court. Friends came and went, but sports remained. Her vagabond existence became more tolerable on the athletic field, where she was doing something she excelled at and enjoyed, and there was some semblance of order. An outstanding athlete, Mia preferred competing with boys because it eased fears of being stigmatized by girls intimidated by her ability.

Mia's hero growing up was her adopted brother Garrett. In neighborhood pickup games, in whatever town they lived in, and in whatever sport was in season, Garrett made sure his kid sister was always in the mix. He protected her, taught her the ropes, organized her thoughts, and practiced sports with her for hours on end.

But Garrett couldn't be there for her 24-7, and being great in sports made for a healthy dose of peer pressure. When Mia made her junior high school football team, she was perceived as showing up the boys. On her female soccer teams, she was accused of showing up the girls. Mia played through the adversity and burned off her anxiety by practicing alone long after everyone else had left the field.

Mia's military dad, fighter pilot Bill Hamm, taught her never to whine or complain. He ingrained in her a win-at-any-cost attitude. And Mia took to her dad's high standards. She refused to surrender to bland mediocrity—if that meant kicking ball after ball, running sprint after sprint, hour after hour, day after day, year after year, so be it. Her yearning for perfection, to not accept just anything, but to be her absolute best was a driving force, and in time that attribute became her biggest ally and worst adversary.

Mia's mother, Stephanie, a former ballerina, no doubt was a key ingredient to Mia's athleticism. Stephanie ingrained into Mia and her siblings humility and the family's ethic: *You're no better than anyone else. We're all equals in the community, all responsible for one another.* It was Stephanie's idea to nickname her daughter Mia, after prima ballerina Mia Slavenska, but the tomboy in Mia rejected her mother's attempts to make her a dancer. Mia preferred mainstream boy sports, and though she excelled at several, her favorite was soccer.

Mia was so good that in her sophomore year at Notre Dame Catholic High School in Wichita Falls, Texas, she was invited to try out for the North Texas Olympic Development girls' team in Dallas. The

summer camp included some of the top female soccer players in the state. Mia entered camp as a junior but within a week was promoted to the senior team.

Future teammates April Heinrichs, Carla Overbeck, and Tracy Bates, who were in the league as well, recall Mia as a stand-alone talent. "It was instant respect," says Heinrichs. "Mia always had the fire."

Mia was so good her coach, John Cossaboon, called his friend Anson Dorrance to see if he might want to come down and take a look. "Anson, you got to come to Dallas and look at this kid I got . . ." "Well . . . what's her name?" "Mia Hamm . . ." "How old is she?" "She's fourteen . . ." " John, do you mean you want me to fly to Dallas to look at a fourteen-year-old for the full national team?" "Yes."

A week later Dorrance was on the sidelines at a regional tournament in Metairie, Louisiana. He was there to scout Mia but didn't want Cossaboon to let on because he wanted the excitement of discovering Mia for himself. Minutes into the match, the smallest player on the pitch received a looping ball from midfield. Gathering it on a dead run, she attacked the nearest defender, slid the ball past her, and then zoomed toward the goal.

Dorrance turned to Cossaboon. "That's her, right? That's Mia?" Straight-faced, Cossaboon replied, "No, you got it wrong . . ." "Yeah right," Dorrance replied with a grin.

By the time the first half ended, Mia was on her way to becoming the youngest member of the national team. The following spring, on Dorrance's advice, Mia relocated to Lake Braddock, Virginia, where she lived with a cousin and attended soccer-centric Lake Braddock High. She registered as a sophomore but was permitted to cram her senior and junior years into two semesters. Mia lettered in basketball and led her soccer team to the state championship, graduating a year ahead of her peers.

Later that summer Mia was invited to the USSF interregional camp at Wisconsin's Marquette University. Also present were three fellow teenagers, two from California, Julie Foudy and Joy Biefeld, and a shy sixteen-year-old from Connecticut, Kristine Lilly.

"We were playing for our regions and got called into camp at different times," recalls Lilly. "I was representing the East, Mia the South,

Julie, and Joy were from the West. That's when we first met. We probably played against each other, but I can't remember for sure."

Foudy was impressed with her fellow teens right away. "Kristine was this little squat who could fly down the wings, and Mia was like a deer in the headlights," recalls Foudy. "Her hair was short in front, long in the back, and she had a little mullet and big brown eyes that always looked like, 'Oh god!' Both were quiet, yet Mia, when she got the ball, she just took it and just went. I was like, 'Oh my gosh! Who are these two gals?'"

The group made a favorable impression on Dorrance, who promptly promoted them to the Under-19 National Team. On July 5, 1987, they all reported to camp in Blaine, Minnesota, for the North America Cup. Of the four, Lilly was the greenest. Upon her arrival in Blaine, a young man with dark hair whom she didn't recognize said hello to her. Confused, she asked Mia who he was.

"That's Anson," Mia replied, "He's the coach."

Lilly has fond memories of her first camp. "Julie, Mia, and I were competitors," says Lilly. "But when we all made the U-19 team, we became teammates and friends. We were wide-eyed kids, and everything was new, but we all had a common denominator in we all loved playing soccer and winning, and we all loved each other."

The senior national team did not fare well in Blaine. After defeating Canada in the opener, they lost successive matches to Sweden and Norway. The U-19ers, on the other hand, swept their age bracket. The one-sided results convinced Dorrance the future of the senior team lay with the youngest players.

Of the four young prospects, Mia was probably the most excited. She returned to Texas bubbling over to her folks how she had at last met and played with girls with the same competitive desire she had. Even better, she had made new friends with shared goals and aspirations. After years of searching for athletic commonality, and keeping her ambitions to herself, Mia finally had people to share them with. Everyone in her group, she discovered, was a unique talent unto themselves, with similar goals, and it invigorated her to no end.

Meanwhile back in Blaine, Anson Dorrance had a decision to make. The national team was making their first trip to China in a

few weeks, and if he kept the youngsters, he'd have to cut four veterans to make room for them.

He had taken note of Foudy's sophistication, Hamm's speed and athleticism, Lilly's endurance, and Biefeld's quiet consistency. There were rumors afloat of a world championship for women, and Dorrance knew he needed to prepare for the future. Everything pointed to a sea change, and Dorrance was going to make sure the national team would be riding the crest of the wave when it came crashing to shore.

Michelle Akers, also at Blaine that summer, recalls the reaction from her four veteran friends when they got word they were expendable. "At the end of the camp Anson put the roster up who made the team, and several players from Mike Ryan's Seattle group were not on the list," recalls Akers. "They were all great players who could kick Mia's, Foudy's and Lil's ass, and mine too probably, but they were not the next generation. They were not as athletic as the kids or the future of the team. They'd probably be gone in a year or two anyway, so Anson cut them, invested in the youngsters, and mixed them in with us."

Michelle was nestled in her dorm suite with some of the vets when the word came down. Among them was her good friend from Washington, Sharon Remer (now McMurtry).

"I had played with Sharon on her coed team when I was fourteen, and she was good," recalls Akers. "They had a case of beer they were drinking, and Sharon picked up a can and threw it against the wall. I was like, 'Oh my god!' I was like a little Betty Crocker girl compared to them and wasn't used to this. I remember going back to my room going, 'Oh my god, they're so mad,' and these were tough, seasoned vets. I just couldn't believe it."

When Akers is asked if she saw the full potential in the youngsters during those early days, she readily admits she didn't, but that doesn't mean she didn't notice them.

"Mia and Lil were little girls," says Akers, "So little I could crush 'em, but Anson was optimistic about them, and we had our role as leaders, and our order was to take them in and teach them the ropes.

"I remember Anson telling us, 'This is the team I want to develop to win and be the best in the world,' and so I was all in. I looked at

the babies like everyone else. They didn't have their driver's license and they were little girls, but they could play."

Akers says the babies weren't the only new faces in the camp that had made an impression. Carin Jennings from Santa Barbara was impressive, and so were Tisha Venturini and Shannon Higgins, both from Carolina.

"There were always a lot of incredible athletes around, but the players themselves didn't differentiate," says Akers. "I've always imagined Anson looking at all of us to know how we operated and our potential. How he was going to encourage that package to become the best we could be was his challenge, but that's what he did. He figured out how to intermix all those pieces. But I didn't have to worry about all that. I focused on doing my own thing, so I didn't really concern myself with it."

On August 1, 1987, the Women's National Team boarded a jet for their first overseas trip to mainland China. The trip was a total culture shock. China had just recently opened its doors to travel, and the average Chinese had never seen an American in person. For twelve days the U.S. players stayed in hotels without traditional plumbing or showers. They traveled on dirty coal trains and ate exotic dishes like dog or snake. Some of the players even got their hair pulled.

"The Chinese for the most part have dark hair," recalls Carin Jennings. "That meant the blondes on the national team were a novelty and a potential target. Blonde hair was the rage, and they pulled on mine every chance they got."

In Tianjin on August 3, Jennings, hair still intact, scored a brace, and the national team defeated China, 2–0. The match marked the debuts of Hamm, Lilly, and Biefeld. The U.S. didn't play again until August 13. During the layover, the team experienced China firsthand. They strolled some of the more treacherous streets at night oblivious to the underworld mayhem present around them. Veteran Lori Henry was designated taste tester for the group. After sampling a dish, she'd bark if she thought it was dog or snort if it was pork. If fish heads were the entrée, she made a point to insert them on her fingers and perform fish finger puppet shows for her amused teammates.

Of the four babies, the one most traumatized was Lilly. A month

earlier, she didn't even know a national team existed, and now she was a member in good standing. At 5'4", and one of the team's smallest players, Lilly possessed a fearlessness and toughness that defied her years.

"Growing up, my older brother Scott was my role model," says Lilly. "Everything he did I wanted to do. After him, it was Willie Randolph of the Yankees and the Jets' Wesley Walker. Those are the people I modeled myself after. My dream was to play second base for the Yankees, I didn't watch soccer, and Pele was the only name I knew. It never occurred to me I would be able to play soccer until I got older.

"What made my path a little different was I made the national team before I went to college. I was still a junior in high school when I met Anson, Julie, and Mia. I'd go on a trip with the national team, and then I'd come back to class. It was a lot of travel, but it allowed me time to figure out what college I wanted to go to.

"And college was a difficult decision for me. I was kind of a homebody and afraid to go away, no matter where it was. I finally chose UNC because of the university, and the comfort level I felt when I went on a recruiting trip there. I knew I liked Anson as a coach and a person, and that made it easier for me."

Julie Foudy and Joy Biefeld's California upbringings were different. They didn't experience the oppression Mia had faced playing with boys, nor were they as green as Lilly. Nevertheless, they found solace in the group. To ease the pressure Foudy used humor, and more often than not, it was Lilly who was the brunt of her jokes.

"Lil was kind of a homebody," recalls Foudy. "She had a little stuffed animal, named Tigger, she clung to. She'd become super homesick when she was on the road, and so we would torture her by hanging Tigger on a rope outside the bus window while she was taking a nap. She'd get kind of teary about being gone. I was like, 'Aww, that's super cute, but c'mon Lil, let's go.'"

The babies were adaptable and didn't whine or complain, both prerequisites for surviving the rigors of the national team. To assure they didn't disrupt team chemistry and transitioned smoothly, Dorrance assigned them big sisters. Mia paired with Lori Henry, Carin

Jennings chaperoned Julie Foudy, and April Heinrichs roomed with Joy Biefeld.

"I've always been attentive to players who were equally attentive and quieter than me," recalls Heinrichs. "I was a right-wing forward, and Joy was a right midfielder who played directly behind me, and so I gravitated to her right away.

"I remember our first trip. We were on a bus ride in China, somewhere. We just had a match, but Joy didn't get to play. I looked over to her and said, 'Joy, how are you doing?' But she couldn't utter a sound. She was crying, and I felt for her in the way a big sister feels for her little sister who's crying. I said, 'It's only a matter of time, and you'll get the time.' Joy, of course, went on to play eighteen years for the national team."

In a 1–1 draw against China on August 13, Lilly scored her first national team goal. When the tournament ended, the U.S. team went home and didn't regroup until mid-December, after the college soccer season ended. Once again Carolina reigned supreme, defeating UMass in the frigid cold for their second consecutive NCAA championship.

On December 14 the U.S. traveled to Taipei, Taiwan, for the inaugural women's soccer event, the Chunghua Cup, hosted by FIFA (Fédération Internationale de Football Association). Of the sixteen players on the roster, six attended Carolina, and Hamm and Lilly were slated for Chapel Hill, so in essence, the total was eight. The number of Carolinians incensed several youth-level players and coaches around the country who felt they were just as qualified to be on the national team, but Dorrance found the criticism unfounded.

"When you pick a lot of your players for the team, the only way you can justify that is by winning," says Dorrance. "We were always under great pressure, and there were charges of nepotism, even though I felt it was unjustified. You're going to select a lot of players from the dominant college in the country."

For those who figured the U.S. team should win every match, the Taiwan tournament was a disappointment. The national team beat Japan in the opener but went on to lose to low-ranked New Zealand and Taiwan. The results irked the suits at USSF to the point that several members called for Dorrance's ouster.

When the Taiwan tournament ended, players returned to their respective colleges, high schools, and jobs. Dorrance retreated to Chapel Hill and readied himself for the barrage of criticism sure to come, but the caveat was his players had his back. By now, they had bought into the system and were determined to show the world his vision for the national team was the way to go.

"The common denominator is everyone wanted to win," recalls April Heinrichs, "and we never put anything over that end goal. I don't recall questioning any of Anson's choices in terms of who should or shouldn't make it. The longer Anson coached, the more players realized this was not high school soccer, and not everybody plays. This isn't club soccer where only the stars play for ninety minutes. We are a performance-oriented program, and it's not about popularity based around friendships. It's about proving it from your performance every day."

Michelle Akers recalls the team had to continually prove themselves to the pundits. "It wasn't an easy time because there were a lot of critics and second guessers," says Akers, "and the only way to prove the critics wrong was to win.

"What's unique about Kristine, Joy, Mia, and Julie is they just had this unbridled passion for the game," adds Heinrichs. "They almost didn't know any better than just to be a part of this glorious ascension. Along with their joy, energy, passion, and desire to learn, they had a completely different level of talent. Once they came in 1987, the national team was never the same."

6

Green and Growing

If there was a symbol representative of the spirit of Carolina and the national team, it would be the 1930s New Deal–era WPA (Works Progress Administration) stucco structure adjacent to Fetzer Field, affectionately known as the Hut. The army Quonset hut, darkroom, and dormitory turned locker room was ground zero for Carolina soccer and for its myriad of stars who went on to the U.S. Women's National Team.

That the Hut was on the small size worked to its advantage. The place offered no privacy and little room for hierarchies or cliques. There was one eternally clogged toilet, a boarded-up fireplace, no central heating, a few small windows, six rotted benches for pre-game talks, and a storage closet in the back, which became Anson Dorrance's office space.

The Hut might have been primitive by today's standards, but in terms of charm and character, it had no equal. It was not the place for cynics, nonbelievers, and doubters, but one of hopefulness and camaraderie. "The Hut is a perfect representation of the humility of all the players who have played here," says Anson Dorrance. "And it mirrored its inhabitant's innate optimism and toughness."

The Hut is gone now, torn down to make way for the multimillion-dollar McCaskill Soccer Center, but ask the veteran players which locker room they'd prefer, and most would say the cozy confines of the Hut, ground zero for champions who dared to dream.

From the Hut Anson Dorrance could see his entire universe, including the dorms he resided in as a student, rock-strewn Fetzer Field,

where he competed in soccer, and the green athletic fields where he once channeled his competitive fury.

It was in this place in 1988 that Dorrance hunkered down to battle U.S. Soccer and to set the course for Carolina soccer and the national team. April Heinrichs, who knew these surroundings well, says Dorrance's national team blueprint emerged from here, ground zero for young women athletes unsatisfied with the status quo.

"Anson told us we're going to model the national team after some of the lessons learned at Carolina," says Heinrichs. "That means we'll be a physically aggressive, high-pressing team that focuses on one-on-one battles, and he built the national team around that premise.

"Anson wasn't coaching at Carolina more than three years when he became national team coach," Heinrichs adds. "He was able to use the UNC incubator and move it to the national team program. He said, 'Okay, well, now I have even better athletes and better soccer players to build from.' And that's what he planned for and eventually did."

The national team went a disappointing 3-3-2 in 1988, with the majority of their matches played at the Women's Invitational Tournament in Panyu, China. It was FIFA's first sanctioned women's event and a test competition for a possible Women's World Cup.

The lone U.S. win in the twelve-team tournament came against Japan in the first round. They managed draws with Sweden and Czechoslovakia before losing to Norway, 1–0, in the knockout round.

The national team's weak showing in Panyu had big ramifications down the road and marked the start of a drawn-out ordeal for Dorrance, one that nearly resulted in his dismissal.

"In 1987 Anson brought the babies onto the team, and in 1988 we went to the test event for the World Cup and lost," says Heinrichs. "We didn't advance, and we took a dose of criticism from the USSF. It was a world event, we looked bad, and it all focused back on Anson."

A friendly in Sardina, Italy, a draw with Poland, was the lone national team match in 1989. The trip was notable in that it featured the debut of twenty-one-year-old Brandi Chastain.

Part of the reason the team was ineffective in 1988–89 was the absence of Michelle Akers. Her luck began to turn during a match

in China, on June 3, against Sweden, where she sustained a severe concussion. After a couple nights in a Chinese hospital, Akers went home to face a barrage of tests. Doctors concluded she'd suffered a bad injury and would be risking permanent brain damage if she continued playing.

Insisting the doctors were wrong, Akers had an MRI clearing her of spinal cord and nerve damage. Following a recovery period, Michelle planned to resume her career, but the U.S. Soccer Federation wouldn't allow her back in the program, insisting she stay off the team pending further examinations. Medically there was nothing to keep her from playing, but the federation claimed her injury was more severe than diagnosed.

Akers hired a lawyer who placed an injunction on U.S. Soccer, stipulating that her spot on the roster remain open, and the national team not play any matches until the case was resolved. In response, the USSF ordered Dorrance to cut Akers. When Dorrance refused, the federation prepared to fire him. It looked bad until a Dorrance ally, former USSF director of coaching Walt Chyzowych, stepped in.

"The national team is going to win the World Cup someday, but they'd need Michelle Akers and Anson Dorrance to do it," Chyzowych told the board, and thus Dorrance stayed on.

While Akers waited on her case, she returned to Central Florida to complete her last semester and then used her connections to search out players on the men's team she could train with. She also pondered her future and how she could turn soccer into a full-time occupation.

But opportunities back then were nil, salaries for national team players were nonexistent, and there was no professional U.S. women's league. The only option that seemed plausible was coaching. Akers headed to Washington State and met up with the director of a local camp called Northwest Soccer, run by Cliff McGrath, and inquired if she could observe his coaching methods, McGrath agreed, and after she explained her situation with the USSF, McGrath called USSF board member Art Wahls and discussed Akers's predicament. Wahls said he'd recommend Akers be allowed back on one condition: "That she'd better be telling me the whole scoop because if anything happens to her, it's my head as well."

While awaiting word of her reinstatement, Akers came across an ad in *Soccer Magazine* about a camp in South Carolina run by a former pro, Roby Stahl, called Post to Post Soccer. Akers called Stahl and asked if she could observe his coaching and would he possibly consider her as an instructor.

Stahl was receptive, and for the next several months, Akers traveled up and down the East Coast assisting him. In their downtime, Stahl introduced Akers to the art of blasting and shooting, which is slang for kicking shots near the net and long precision strikes. The two practiced shooting for hours on end, all based on Stahl's shooting technique. Along the way the two fell in love.

Akers believed that Stahl's maturity and their common interests were the basis for a lasting bond, but Michelle was a footballer first. After being married in the spring of 1990, she took off for Italy to play for the Tyreso club in Sweden and put her new scoring methods to excellent use. Along with her improving game, Akers discovered she had natural leadership skills. The young and struggling team required discipline and guidance. Akers stepped up, and the youngsters followed her example. She departed Italy a more complete player and leader.

On her return to the national team in July 1990, Akers was more resolved than ever to make a difference. Dorrance noted the improvements in her game and moved her to striker, where she could use her new shooting arsenal to maximum effect.

"I had developed myself as a forward and was faster," recalls Akers. "I had worked hard, and when Anson saw the changes, he called me in for a meeting.

"'What the hell are you doing, Akers?' he said, and when I told him my new routine and workouts, he almost fell off his chair. He later called it 'The Akers Speed Training Program' and gave a modified version to his Carolina kids.

"Anson made a point of teaching us how to train ourselves in the offseason and share whatever we did with the team," adds Akers. "Lil was in Connecticut one winter and had to find an indoor training place to train and did like a million push-ups. I remember thinking, 'Oh my god, I've got to do some push-ups.'

"Whatever I liked about somebody else's training I wanted it to be in mine and vice versa. Anson had me share my speed training with the others, which I didn't think was a big deal. I just knew it would make me better and closer to where I wanted to be as a player. Anson was excellent on creating a focus on how to continue to grow as a player away from the team and focus in the environment you have."

Akers's soccer odyssey brings up several pertinent points: First, it shows how indispensable she was to the success and growth of the national team. That the U.S. won just two matches in the entirety of her absence speaks volumes. Second, her journey shows the contempt some members of the USSF had for Dorrance, and how far he would extend himself for a player. Dorrance's loyalty and commitment may help explain why some envious USSF members were so anxious to bring him down, and why players on the national team would go to war for him.

The Women's National Team's first match in over a year came against Norway in Winnipeg, on July 25, 1990. Michelle Akers-Stahl, Mia Hamm, Carin Jennings, and April Heinrichs all scored in the 4–0 romping of their rivals. With Akers back in the fold, the team went on a seventeen-game winning streak. They wouldn't lose again until the Netherlands beat them 3–2 on May 28, 1991.

National team matches during this period seem infrequent by today's standards, but in the early 1990s women's soccer was a niche sport. The national team was still in flux and underfunded, but Dorrance understood youth movements take time, and despite the federation's incessant grumbling, he knew the team was gaining traction.

In 1989 Kristine Lilly and Mia Hamm joined ranks with Dorrance at Carolina. At seventeen, Mia was still underage, and Dorrance became her legal guardian. The Lilly-Hamm tandem resulted in four consecutive NCAA college championships. Dorrance kept them under his watchful wing, giving them the added confidence they in turn brought to the national team.

Another significant move during this period was slating Julie Foudy into the national team starting lineup as a charging midfielder and shifting Akers to forward. The legendary 4-3-4 offensive juggernaut

was beginning to take form. With veterans Shannon Higgins, Debbie Belkin, Tracey Bates, Carin Jennings, and goalie Amy Allman, the team was showing signs of a maturing dynasty. Meanwhile promising Carolinians Linda Hamilton and Wendy Gebauer were becoming stars in their own right. The national team was emerging into a force to be reckoned with, and chatter of an impending Women's World Cup helped keep the team motivated during the long periods of inaction.

The team was measuring up, but the question was would the USSF allow Dorrance to keep his job long enough for his vision to develop? Michele Akers recalls this period as being touch and go.

"Some at the U.S. youth and adult programs thought their players should be on the national team, and some of the clubs we played as part of our training figured they were better than us and wanted our jobs," says Akers.

According to Akers, "Anson said, 'There are people in positions of authority that want their players to be on this team and that means every time we play them, we have to crush them. There has to be no doubt in their minds that they do not belong on this team!'"

The opportunity to prove their mettle came in July 1990 at the U.S. Olympic Festival in Minneapolis. A four-team, round-robin tournament consisting of the Women's National Team, the U-19s, and two additional teams composed of the best remaining American players was set into motion.

The national team breezed through the competition with the exception of their match against the U-19s. The seniors won 2–0, but their underperformance brought out the catcalls from disgruntled players on the U-19s. Some of them boasted they were better than Dorrance's reserves and deserved to play on the national team. To prove their point, they demanded a rematch. Dorrance happily obliged and boosted the stakes by saying he would start seven of his reserves. The move was risky. If the national team lost, he would open himself to all sorts of criticism, and it would quite possibly cost him his job.

Michelle Akers, present for the entirety, details the subsequent events. "There was a group from some of the youth national teams putting a lot of pressure against U.S. Soccer," says Akers. "They insisted their players

be on the national team and wanted Anson out. So Anson had a meeting with us. He said depending on how we do, some of our jobs might be on the line and his as well. He said, 'There's a lot of politics going on, and we need to be clear about what our goal is and what the standard for the national team is. There has to be no doubt in their minds that the U-19s and the other complainers do not belong on this team.'

"The senior players had a team meeting without Anson the night before the match with the seven reserves who would be starting and explained how important it was to crush the U-19s, like, 15–0, and we all agreed to turn it up a notch."

The next day the reconfigured national team decimated the U-19s and its dissenters, 10–0. Dorrance called it one of his most satisfying moments ever as a coach. "It was an incredible display of soccer and teamwork," he told Tim Crothers in the definitive Dorrance biography, *The Man Watching.*

If Dorrance figured the lopsided showing would solidify support for him among his critics, he was sadly mistaken. After the match a perturbed USSF secretary-general, Keith Walker, confronted Dorrance in the locker room demanding why he had left some of the best American players off of his team.

Dorrance was stunned. The players Walker referred to were the same ones the national team just annihilated. Walker told Dorrance, "The Germans would be coming to play the U.S. soon, and he refused to be embarrassed when they play us."

The confrontation proved the USSF's ineptitude and solidified the team's resolve. "Anson took some heat for that," recalls Akers. "No doubt he stirred the pot, but he was like, 'Bring it.' He wasn't one to back down."

Akers's dealings with Dorrance until now had not been entirely harmonious. She found him arrogant and a masochist when it came to training. ""His fitness killed me," says Akers. "He did things as a coach I'd never experienced. I was usually the fittest player, but I was not up to snuff with his fitness. I had to learn it quickly, and it was a big challenge."

When it to running and cardio, it was even worse. Dorrance was a long-distance runner. He'd often run with the team, and his preferred route was usually a three-mile trek.

"He would take off and out of a hotel or school or wherever we were, and we would try and keep up," says Akers. "He'd lead the pack in his tight white shorts that we made fun of, and then he'd crush everyone except Tracy Bates and some of the Carolina girls who trained under him. I always hated the three-mile runs. My body wasn't into them at all."

When it came to conditioning, Dorrance was ahead of the curve. He brought the workout he used at Carolina to the national team and called it the Competitive Cauldron, where every element performed in practice would be charted, scored, and posted. It was a way of showing players every move they made in practice counted.

"He thought the cauldron would make players more competitive, but I didn't care about that, and so I never looked at the list," says Akers. "I wasn't about playing against other people—it was always an internal challenge for me. It wasn't about me being better than someone else as much as how can I be better? I was always applying new things to help me reach my potential. It had to do with personal growth. I always was wired that way, so it was nothing new."

Although Akers raised the bar, she never considered herself a team leader in the traditional sense. "Anson wanted me to be captain, but I said no," says Akers. "He was like, 'C'mon,' but I told him I wasn't the captain type. He claimed there are different ways to be a leader, so I tried the captains' band, but after a few weeks backed away. He was like, 'Okay, never mind,' and I was like, 'Well, I told you.'"

"I was a leader, but it was more as a supporter and encourager. My leadership came in how I passed the ball to a teammate. I was concerned about the weight of the ball and where it was delivered. My goal was to give them the ball the exact way they needed for them to do something great. I liked to support people to be their best, and that was my strength as a leader.

"For team meetings, I was always trying to hide," adds Akers. "Anson asked a lot of tactical questions, like, 'Okay, so if the ball's here, in this part of the field, how do you set the defense? How about in this part of the field? How do you set the midfield around it, and then if the ball goes here, how do you adjust?'

"But all of that was completely over my head. You might as well

throw a bunch of rocks around because I had no idea. In meetings I'd be praying, *Anson, please don't call on me. I have no idea what you're saying.* Then, of course, he'd choose me to talk, and it would be horrifying. I'd always do strategy sessions wrong. I was in front of everybody during those meetings, and it was a horrible experience every time."

The Akers-Dorrance relationship got off to a rough start but eventually evolved into a well-oiled machine. "I didn't like him at first because he was so arrogant," says Akers, "but over time, his arrogance became funny. I had so much respect for him as a coach that we eventually became good friends, and today I love him. I still think he was arrogant, but he's super smart and knows the game, and incredibly gifted at motivating people. He knows what each player needs and how to instill confidence in her.

"I also loved Anson's intensity and how he challenged me. In our one-on-one meetings he'd get intense and look you in the straight in the eye, but his goal was to inspire you to get better. He made it clear he was on your side, and once you realized that, you'd go to the wall for him."

April Heinrichs had been with Akers since the team's inception. She was Dorrance's ears and eyes when he was recruiting Akers for UNC and the first player to recommend her.

"Of all the players I played with or coached, Michelle played more like a male athlete than a female athlete," says Heinrichs. "She never cared about whether she was popular, but we all loved her. She was awkward socially, inappropriate at times, and she'd say some things, and we'd go, 'No, no, no, no, you didn't just say that, did you?'

"Michelle didn't have her radar up in regard to what people thought about her, or how she came off, but she commanded respect. She and I were never close, and that's unusual for female teams, but we were never adversaries, and that's also unusual for women. It's usually one or the other. You're close, or you don't like each other.

"For the most part, Michelle was lukewarm on me, but it wasn't mutual. I had tremendous respect for her. When she came on to the national team, Anson did a fantastic job of making her feel import-

ant right away, and Anson was excellent about making players feel important.

"You've got to make sure Michelle Akers feels good about herself because she was a giant, and then you've got to make sure Mia Hamm, who eventually comes along and is fighting for recognition, feels good about herself, and then Foudy and Lilly. . . . Anson could make everyone feel like they were first-round draft picks, and for the national team, that was invaluable."

All in all, 1988–90, insignificant in terms of wins and losses, was significant in terms of structure and team chemistry. With the emergence of Akers, the coming of age of the babies, and with U.S. Soccer's grudging acceptance of Dorrance, the team was moving ahead, and with rumors of a Women's World Cup, the timing couldn't have been better.

The national team was in Europe in 1990 when word was passed that a World Cup was in the works. "Anson said there might be something, but it wasn't going to be called a World Cup," recalls Akers. "He called it a World Tournament or something. I may have not even been listening to the meeting."

Heinrichs was listening: the prospect of a world championship was a big deal to her, and something she'd waited on her entire career.

"I don't recall exactly how we found out about it," says Heinrichs, "but we were always trying to be the best in the world, and to have an actual World Cup meant everything to us."

With the World Cup slated for 1991, the national team took on a rigorous schedule. At the Canada Cup in Winnipeg, they defeated Norway in the final, 4–2. At the North American Cup in Blaine, Minnesota, in August, the U.S. beat powerhouse England, West Germany, and the Soviet Union. The U.S. played six matches in 1990, and all of them were against high-caliber teams. That they were undefeated speaks to the quality of their game. On April 7, 1991, the U.S. swept a tournament in Bulgaria against some of the best European teams in the world. Eleven days later they headed to Haiti for the CONCACAF regional qualifiers. The winner would be going to the world championships in China. It was their most significant tournament to date, and potentially the most dangerous.

7

The Breadcrumb Generation—Haiti

In 1991 Haiti was a country in turmoil. A coup to oust pro-democracy president Jean-Bertrand Aristide was in the works, and the nation was riddled with dissension. Why FIFA chose Haiti to host the CON-CACAF world championship qualifiers that year remains a mystery.

Matches were set in the capital city of Port-au-Prince. Of the eight teams invited, only one would qualify for the world championships slated for Guangdong, China, in November.

FIFA, in their infinite wisdom, believing women had less stamina than men, trimmed the matches from the standard 90 minutes to 80. To distance the tournament from the Men's World Cup, and in case it flopped, FIFA called the event the 1st FIFA World Championship for Women's Football for the M&M's Cup. Mars, Inc. was the chief sponsor.

The U.S. team departed for Port-au-Prince on April 16 for the qualifying matches. Their confederation consisted of eight North American, Central American, and Caribbean nations, including Mexico, Haiti, Martinique, Trinidad and Tobago, and Canada. Haitian officials warned the U.S. not to beat their opponents too badly, or the locals might riot.

Haiti was unlike any country the team had ever seen. Departing the Port-au-Prince airport, the players saw streets littered with burned-out cars, pockmarked buildings, and thousands of locals just milling around. Their hotel was a fortress, its roof and walls encased in concrete and glass, and guarded by armed soldiers.

A curfew was in effect. When players weren't playing or practic-

ing, they were bunkered in their un-air-conditioned hotel rooms, like prisoners, clad in their underwear on account of the heat. Haiti was a country in total disarray, with a poverty level that was shocking. But in typical national team style, they accentuated the positives.

"It was sad, but we knew why we were there, and we learned to adapt and to make light of the journey," recalls April Heinrichs. "We played cards for hours; it's hilarious the number of jokes you can make about showering in a swimming pool or one toilet flush per room.

"But when we played and trained, it was delightful. We loved playing under the Haiti sun on the country's plush grass fields. Our region was not up to our standard, but we felt the best way to respect the opposition was to compete hard, and so we rarely took the foot off the gas."

Hotel life was not quite as tranquil as the pitch. The electricity was out half the time, and there often was no water; and if there was, nobody was drinking it. They traveled on an oversized tourist bus, their equipment bags tied to the top, with Haitian soldiers lying over bags so they wouldn't fall off.

As they headed to Stade Sylvio Cator for their first match, guards armed with machine guns rode on the sides of the bus. En route to the venue, players could see streets packed with people and an occasional dead body.

When they arrived at the stadium, fans surrounded the bus and started pushing it side to side. Their guards used rifle butts to keep people at bay. Once inside, another game was in progress so there was no place to warm up. They ran under the bleachers, but fans above them threw trash and urinated on them.

Before they left for the field, the players were told by Haitian officials the best way to win over the crowd is to toss flowers to them. The players tried, but the fans fired the roses right back at them.

"I'm going, 'Holy shit!'" recalls Michelle Akers. "Like is this happening? It was scary but exciting. It's a national event, the stadium's packed, and fans are climbing light poles to watch the game. It was awesome, but I remember thinking this is freaking scary. Haitian officials told us not to score too many points, or it would anger the country. But Mexico was horrible, and it was hard not to beat them. The

final was like 12–0. Brandi Chastain came off the bench and scored like five goals. It was crazy."

The first match with Mexico was just a prelude. The U.S. demolished Martinique, 12–0, with Heinrichs scoring a hat trick and Akers a brace. They crushed Trinidad and Tobago, 10–0, with Akers, Hamm, Jennings, and Wendy Gebauer scoring two goals apiece. For the semifinal match, the U.S. annihilated host country Haiti, 10–0, with Akers, Heinrichs, Tracy Bates, and Carin Jennings each scoring a brace. For the championship final against Canada, Akers scored a hat trick, and the U.S. won 5–0.

The Americans apparently made a lasting impression. The same fans who tossed flowers back at them in their opening match were screaming, "USA, USA, USA," during the final.

Afterward, players signed autographs, posed for pictures, and were treated like rock stars. The national team posted six shutouts and scored forty-nine goals in front of a skeptical foreign press that couldn't grasp how the national team became so dominant in such a short amount of time.

The press claimed European training and foreign coaches were the reason for the team's sudden rise. At his press conference Dorrance tried to convince reporters the national team was American born and bred, but they refused to believe him. They were so turned off they didn't even bother taking notes. Instead, they wondered how a country that lagged behind international soccer could become so good without an international influence.

Only when Dorrance mentioned his international upbringing did the scribes come to life. He said the national team was wholly American, made up by a group of American players, trained and conditioned by American coaches in U.S. clubs and universities, and on American soil, but his boast was met by blank stares.

Dorrance has said the 1991 CONCACAF qualifiers in Haiti were one of his most satisfying moments as a coach. It was the first time the world saw the true power of the national team, and it pleased him immeasurably.

Years later Dorrance explained his philosophy to Tim Crouthers for his book, *The Man Watching*. "I learned how to play soccer in

Chapel Hill, and I learned how to coach soccer at the United States Soccer Federation coaching schools from the National Soccer Coaches Association of American convention clinics. I learned everything I know about soccer in the United States of America. I was the ultimate patriot, and I turned that on my women for visceral reasons. They felt it every training session, every pre-game, every halftime. I wanted to win more; then breathe oxygen."

After the qualifiers Michelle Akers attended a Soccer Industry Councils of America Symposium in North Carolina. U.S. Soccer was there along with several apparel companies that advertised within the soccer industry. When Akers was invited up to the stage to speak, she somehow got up the nerve to let the council know the national team needed their help.

"I told them several players had moved back in with their parents because they couldn't afford life on their own and be successfully trained," recalls Akers. "You can't have a job while you're getting ready for a World Cup."

In attendance that day were two of U.S. Soccer's heaviest hitters, Hank Steinbrecher and Alan Rothenberg. Also present was the vice president of Umbro Soccer Development, Nick Hogan. All three men had been moved by Akers's presentation.

"I met with Hogan, and he gave me his card," recalls Akers. "A few weeks later we met again, and I became the first American female soccer player to sign an endorsement contract."

From May through October 1991, the U.S. played in twelve matches against the best European teams and China. They went 5-6-1, with Norway beating them twice. Dorrance was displeased with the results. If they were to win the championship in Guangdong. he knew the team would need extra training, and he finagled U.S. Soccer to sponsor a two-week residency at UNC. Players stayed at a nearby hotel and practiced twice a day at Fetzer Field. It was the team's first official residency, and some players didn't know how to handle it.

"We were against it at first because it sounded so long," recalls Carin Jennings-Gabarra. "We never trained together before, we just

played the games. We'd have one or two days' practice and then go travel abroad and play in major tournaments. We were well versed and knew each other's styles, strengths, and weaknesses, but it's a whole new level when you train together for two weeks and work on specific things."

In early November the team loaded their ball bags, peanut butter, and tubs of oatmeal into trunks, bid adieu to Chapel Hill, and headed to China.

"I always told people we were the breadcrumb generation," recalls April Heinrichs. "We were just happy with what we got, but at the same time trying to measure ourselves. The first time we played Norway, it was like this is the best team in the world so let's play Norway. Then Germany came and beat Norway, so then it was let's beat Germany. We always measured ourselves against the best in the world, and now we were ready to be the best in the world."

After years of politics, maneuvering, and in-fighting, the national team was about to embark on their first world championship. In truth, the long road to China had started five years earlier, by one determined Norwegian lady, who, despite the overwhelming odds, refused to quit.

8

The Queen of Women's Soccer

Mexico City, May 29, 1986

It's the eve of the men's World Cup in Mexico City, and FIFA's forty-fifth annual World Congress is in full swing. The Presidente Chapultepec hotel's main ballroom is packed with a 145 male delegates eagerly awaiting FIFA president Joao Havelange's annual report.

Among the sea of men, one female delegate, Norway's Ellen Wille, looks on with rapt attention. Wille was sixteen, in 1958, when she founded Norway's girls' soccer program and has continued to fight for female inclusion ever since. Her mission today is simple: get FIFA to commit to a Women's World Cup.

As Havelange approaches the dais, Wille wonders if anything he says will be relevant, and her skepticism is warranted. The longer Havelange speaks, the worse she feels. His entire report is devoted to the men's game. Only one paragraph toward the end mentions the women's side. Once Havelange is finished, and the ovation subsides, he is open for questions. From the male milieu, like a phoenix, Wille rises.

"Imagine this situation," Wille recalls, "I, standing at just 1.50m in height and the microphone too high, in front of a hundred men, well aware that I am the first woman to stand in this gallery, and it was terrifying. Because the annual report was 99 percent for men only I had to start my speech with a scream of anger.

"This is unacceptable, Mr. President," Wille opines. "There is nothing in your report about women's football, just the men."

Mildly amused, Havelange cracks a wry smile. *The men call the*

shots around here, but this one seems serious. The crowd quiets, the tinkling of glasses cease, cigar smoke hangs lucidly in the rafters like a dank, blue cloud, and all eyes fall on the diminutive Norwegian.

"Mr. President, I can tell that we are not happy with the report you have presented because women's football is only mentioned once, not even a full page. This is not correct."

"What is it you want, dear lady?" Havelange asks.

"I will tell you what I want," Wille replies. "I want a world championship for women. I want women's soccer program in the Olympics, and I want common rules for all the countries."

Silence engulfs the room. The Norwegian tiger has ambushed President Havelange. If the man is flustered he doesn't show it. After all, he didn't write the damn report; the general secretary Sepp Blatter did. Havelange takes a sip from his brandy and deflects Wille to his number two.

Blatter adjusts the microphone, "Madame," he says with an honest grin, "I will accept the challenge. And you will see we will go for the organization of a women's World Cup."

The room stirs, and the drama thickens. No one expected the most powerful man in soccer to appease the feisty Norwegian by agreeing.

Wille is weary. For decades Blatter stalled the women's game. How does the sport's greatest obstructionist suddenly now become its biggest enabler?

It takes six years, but the man whose corruption scandals will someday be his downfall is good on his word. He will produce a FIFA Women's World Championship, but why did he wait twenty years? Women's basketball and volleyball held championship matches in the early 1970s.

"Because FIFA was sleeping," Blatter later explained. "You can blame me because I was the technical director of FIFA at the beginning, but I had other problems."

9

Crazy Legs Carin

No one ever handed us anything. It wasn't an equal world
when we played. Women weren't getting what we wanted, and
female athletes were not entirely accepted. But we were tough,
and Anson played on it and made us tougher, and then he
made us collectively tougher.

—CARIN JENNINGS-GABARRA

On November 13, 1991, the U.S. National Team boarded a plane from
JFK for Guangdong, China. Rather than flying the direct route, they
made several stopovers in Europe to pick up the Swedish, Norwe-
gian, German, and Danish National Teams. The extra stops turned
the standard thirty-six-hour trip into fifty.

The final passenger list includes a group of elite athletes who in a
few days will tear each other's throats out. Among the athletes in the
crowded jet is Carin Jennings, a six-year U.S. National Team vet and
a prolific scorer. At Palos Verdes High School (1980–83) she scored a
state record of 226 goals. Several colleges courted her including Car-
olina, but Jennings forsook Chapel Hill in favor of the quaint sea-
side town of Goleta and the University of California, Santa Barbara.

Jennings tore up the collegiate ranks, setting NCAA records for goals
and points per game. Her success was primarily due to speed and
her uncanny dribbling. Being pigeon-toed has advantages in soccer.
Carin rarely stumbled because her ankles didn't roll, and the angle of
her feet allowed her to dribble at speed and rapidly change direction.
After making the national team in 1988, teammates began calling the

rubbery-legged speedster Gumby or Crazy Legs. Carin impressed the young Mia Hamm to the extent she modeled her game after Carin's.

Presently Jennings wasn't talking. Like everyone else in the plane, she was sizing up the opposition, conserving energy, pondering what lay in store. In a few days, she and her fellow countrywomen would be in a grueling competition for the world championship, and they were looking for any edge.

The flight was long and arduous, and when they finally touched down in China the national team got right to it. "Anson didn't waste any time," recalls Jennings. "It was fitness day, and we went straight from the airport to practice. We didn't complain. That's how Anson conducted business. We just stashed our bags at the hotel, found a field, and went to work."

Having visited China, the national team knew the routine. Taking photos in sensitive government areas was taboo, and short pants were frowned upon. If you happened to be blonde like Jennings, it was traveler beware.

"In rural areas where they'd never seen blonde hair, it became quite the sensation," recalls Jennings. "The first couple of times we went to China, locals would pull on it all the time. This time I made sure I wore a hat."

The U.S. team usually traveled coach to China, but FIFA was sponsoring the event with Mars, Inc., and a five-star hotel awaited them in Guangdong. The players' families were invited, and because the national team rarely played in the United States, families rarely saw the team compete. Having family along for the ride was a treat and made for a more memorable visit.

One big problem was the local cuisine. The Chinese food wasn't the same as it was in the States, and players got sick or lost weight. "We had diarrhea because of the water, and if we ate the local food, we would be starving to death. One trip we had broccoli, and Carin was screaming, 'Don't eat that broccoli, there are maggots in there,'" recalled Michelle Akers.

"So this trip we came prepared. We bought Anson's brother Pete, and Carla's boyfriend, Greg, who owned a restaurant in Chapel Hill.

They cooked and supplied us with staples like spaghetti and foods we could stomach."

As a rule players wanted rice because carbohydrates helped their recovery, but the Chinese considered rice a staple and not a dish to be served their better guests. "We always wanted rice, but it would always come out last," recalls April Heinrichs. "We're like, 'Pass, pass, pass, where the rice? Pass, pass, pass.' We never took an international trip without trunks of oatmeal for every morning and a snack in the evening. Snickers, rice, oatmeal, and peanut butter where the go-to in China. You can get bread in any country, just bring peanut butter and jelly. Our theme song was, 'Peanut butter and jelly, that's all I put in my belly.'"

Bizarre food tales have become legend among the national team players, and most of them involve Carla Overbeck, known to be a finicky eater.

"We would beg for rice and bread, and they'd bring out this platter with an entire fish with the eyes and head still on it," recalls Overbeck. "I'm picky, but you didn't want to be offensive and not eat it so you kind of spread it around your plate to make it look like you had tried some things. I used chopsticks, and for one meal, I'm thinking, *What the heck is this thing?* It was light, yellow, and soft, so I spread it out, and it was a duck's foot. We were like, 'Oh my god!'

"We brought big tubs of peanut butter and jelly, Pop-Tarts, stuff that we knew because we would go over there, and we might lose ten pounds. One of our food trunks got lost one time, and we cried and cried, but this trip, we brought big wheels of parmesan, dried pasta, and spices. They arrived late, but when they finally showed up it was like, 'Alright, we can eat now!'"

Twelve teams qualified for the first Women's World Cup tournament. Team USA's group B included Sweden, Brazil, and Japan. The top two teams and the two best third-place finishers from the three groups advanced to the knockout round of eight teams. FIFA, convinced women players didn't have the same stamina as men, shortened matches to eighty minutes from the standard ninety.

The U.S. game plan was to take their 4-3-4 high-pressure attack and aggressively hammer the opposition. In the opener against Sweden the strategy worked to a tee. In the 40th minute, Carin Jennings dribbled past several Swedish defenders for the first U.S. goal. Nine minutes later she scored again, a left-footer, to give the national team a two-point lead. Then in the 62nd minute, Mia Hamm, who'd replaced the injured starting midfielder Megan McCarthy, fired a twenty-five-yard rocket making it 3–0.

The U.S. was headed for victory, but Swedish goals in the 62nd and 65th minute closed the gap. The second goal, a forty-yard laser by Ingrid Johansson, is considered one of the greatest in World Cup history.

The U.S. managed to hold on for a 3–2 win, but to advance they'd need to bring their game up a notch. They hadn't played in enough big games to finish well. Several positives did emerge from the match. The three-pronged offensive attack made life miserable for the Swedes, who struggled with turnovers, and the U.S. frontline was quickly becoming the talk of the tournament.

"We were pressing like there is no tomorrow," recalls Heinrichs. "We brought our unique style into the world arena, and our opponents didn't prepare for our take-no-prisoners attack."

One of the ill-prepared teams was Brazil. The knee-high tackling, chitty-chatty group generally gave the U.S. fits, but the national team had their number. On November 18 the fourteen thousand at Ying Dong Stadium in Panyu looked on as Jennings, Akers, Hamm, and Heinrichs tallied goals for the impressive 5–0 win.

While the U.S. breezed through group play, China did everything they could to impress. Festivities, flags, and colorful soccer-style floats were displayed in the cities where they played. The Chinese government proclaimed the tournament a national holiday and ordered all local workers to attend matches. The government designated countries for them to support, and they were told to cheer if a goal occurred for their appointed country.

Carla Werden (later Overbeck) traveled to China as a teen when she played for the club team Dallas Sting. She'd made numerous trips

since then with the national team, but in terms of scope this trip was different.

"The Chinese fans would cheer all the good plays, so it wasn't like they were cheering against us," recalls Overbeck. "When we played China, we could tell they were cheering for the home team, but at every other game, we got huge ovations.

"The size of the packed stadiums excited us," adds Overbeck. "We were used to playing in front of crowds of five hundred, but never to tens of thousands. There were decorations with bright displays on light posts and hundreds of bikes parked by the venues, and they made the tournament a big deal. It was fantastic because we had never experienced that level of excitement before."

With the U.S. team assured a spot in the knockout round, Dorrance rested some of the starters in the following match against Japan. In front of a packed house at New Plaza Stadium in Foshan, Akers scored a brace, and Wendy Gebauer added a solo goal, en route to a 3–0 win.

The U.S was headed to the quarterfinals against Taiwan.

On this occasion Dorrance's mantra—*reach out and grab the other team by the throat and squeeze the air out of them*—was never more apparent. Playing the game of her life, Michelle Akers exploded for a record five goals en route to a merciless 7–0 pounding of Taiwan.

"'Give Mish the ball' was our game plan," recalls Jennings. "She just felt good that day and saved her moment when we needed her most."

The game brought extra attention on the frontline of Akers, Heinrichs, and Jennings. An enterprising Chinese reporter labeled them "The Three Edged Sword." The moniker stuck, and the U.S. team had their first legitimate tagline.

"I didn't buy into the hype too much," recalls Jennings. "We had Foudy, Higgins, Lilly, and Hamm in the midfield, a dynamic backline in Werden, Fawcett, and Hamilton, and an excellent goalkeeper in Mary Harvey. It wasn't only the frontline responsible for our success; it was the whole team."

Mia Hamm agrees with Jennings. The U.S. was strong, with the "Three Edged Sword" being the difference maker.

"Up top we had the three most dynamic players in '91, and they were all so different," says Hamm. "The opposing defense couldn't orga-

nize for their speed or physical presence. April could get in behind, and she's the type of player that would rip your heart out and eat it in front of you and laugh about it the entire time. You had Michelle Akers, who in my opinion is still the best player I've ever seen. She could literally put a team on her back and will us to victory, and Carin Jennings-Gabarra is the best dribbler I've seen. No matter how much you set yourself up defensively with her 1v1, you couldn't. They were just incredibly dynamic."

Having made the semis, the national team readied themselves for top-ranked Germany in Guangzhou. For Jennings, the match had a side note. Carin's boyfriend, U.S. Men's National Team member Jim Gabarra, was playing for the Tacoma Stars of the Major Indoor Soccer League (MISL). He promised Carin if the U.S. reached the semis, he'd find a way to get there, and the morning of the game, he flew over. "We weren't allowed to see family on game days, so I asked Anson if it would be okay for us to sit in the lobby. Having Jim there gave me a little extra edge in the game that day."

"Jim was captain of the U.S. Futsal National Team, so he was one hell of a male player," adds Dorrance. "Carin's training platform of playing 1v1 against him every day was extraordinary for her because there's no better example of getting to your potential in women's soccer than playing with and against boys or men."

With her future husband as witness, Jennings scored an unprecedented three goals in the first 25 minutes. Germany preferred to play with the ball on the ground, which played right into Jennings's strengths. The U.S. had pushed them high and hard, and Carin was picking off bad passes and running free on goal. Two of Jennings's tallies were breakaways, but the third was a thirty-yard scorcher from the mid-stripe. It was the performance of the tournament and showed the world why Jennings was considered world-class.

"It was our fifth game in eleven days, and so I didn't feel like running," Jennings recalls. "I was thirty yards out when I got a pass from Mia. I said to myself, Michelle always shoots from here, and I'm going to do the same darn thing. It ended up a goal; that's just the way the game went for me that day."

Despite the barrage from Jennings, Dorrance's speech at halftime

was curt and cautious. "If we can score three goals in 40 minutes, the Germans are certainly capable of scoring three goals in 40 minutes," he said. "This is not where we take the pedal off the gas."

Germany was experienced, and to beat them the U.S. needed to carry on with the intensity. Germany battled back scoring two second-half goals, but the U.S. maintained their momentum and scored two goals themselves for an impressive 5–2 victory.

"Carin Jennings had the game of her life," recalls April Heinrichs. "She single-handedly tore Germany apart. Anson told us before the game, 'The Germans are so arrogant that they'll never change what they're doing, so let's high press them.' Two of Carin's goals were with Germany building out from deep in their box, and we pounced on those opportunities. The final was 5–2, but it felt much closer. We were going to try to make it six if we could because we never felt secure. It was Germany, and you'd be an idiot to feel confident at 4–2 or 5–2."

The U.S. advanced to the finals and would be facing top-ranked Norway for the championship. The following day was Thanksgiving. Pete Dorrance and Greg Overbeck somehow found some turkeys and had prepared them with stuffing and all the fixings.

Though most of America was oblivious to the national team, the players themselves had a lot to be thankful for. In just six years they had come from relative obscurity to the brink of a historic world championship.

As Carin Jennings looked around the dining area, she knew she was with the best friends she'd ever have. They had gone through the wars together, and their successes were due to the love and trust they had for each other.

Now they were with their families, and it was Thanksgiving. Soccer great Pele was in attendance in support of the tournament and stopped by the hotel to share turkey with his new American friends. Dinner was relaxed, quiet, the calm before the storm. Norway was a hardnosed team of seasoned pros. The U.S. beat them before, but the matches in China had taken a toll. The teams had been playing every two days for two weeks. The U.S. was dog tired, but so was Norway.

The crowd at Tianhe Stadium would be huge. Sixty-three thousand, the largest the U.S. ever faced. SportsChannel would be tele-

vising back home, but whether anyone was watching was anyone's guess. But to the national team, it didn't really matter.

"We fought hard in a lot of ways, just to get where we were," recalls Jennings. "We loved that we were together and appreciated the successes that we already had. We had our team, the support of our families and new fans. But it was time to put all those pieces together. We beat Germany, and we were excited, so now let's move on. We're in the World Cup final, and we didn't come here to come in second."

10

M&M's Cup

The national team locker room was quiet and thick with tension. In a matter of minutes, they would be playing the biggest match of their six-year history. For the pregame chat, players anticipated the standard huzzahs from Dorrance, but instead of a rollicking rally cry, he inspired them with prose. While the players gathered around, he pulled a piece of paper from his pocket. "One of your mothers wrote this," he said, and then he started reading.

Years ago when you were born
Women's sports were an oxymoron
I thought you'd be a teacher, nurse or aesthetician.

The room was still. No one knew who wrote the poem. Except for the occasional sigh or sniffle, all was quiet.

But as you grew you strained our senses
Girls soccer? Sure, fine, it's okay to play
But isn't two hours enough to practice each day?

Outside the locker room some sixty-five thousand fans and factory workers awaited the finale. Inside, nineteen elite young women athletes, from a country far away, were about to put their dreams on the line.

You had to be the best
Play with boys, play up for a test . . .

They'd been through a lot together, but none of them were playing for money or even the glory, because there wasn't any. The mother who wrote this poem knew that. Win or lose these nineteen women were appreciated and loved by those who mattered most, and it was why everyone in the room was crying.

> No matter what happens I know what you are
> I didn't really have to come this far
> To see it inside you, to see it so clear
> You're a woman of course, and a CHAMPION, my dear
>
> —Mom

Thirty years later, the poem still resonates. April Heinrichs says it was a "brilliant cataclysm of inspiration."

"Shannon's Higgins's mother wrote a wonderful poem about how proud she was as a mother to come to the World Cup and watch her daughter," says Heinrichs. "But Anson said, 'I'm going to read this poem to the team as if it's from everyone's mother and I'm not going to tell the team whose mother.'

"Now that's genius. An average knucklehead male coach of men wouldn't get that. Someone who doesn't know how to coach women would say something like, 'Hey Shannon, why don't you read your mom's letter,' and it wouldn't resonate the same way.

"What's interesting about Anson," says Heinrichs, "is there is no moment off-limits for him to motivate somebody.

"You wake up in the morning and go to breakfast. You're in an elevator with Anson, and you are both going down . . . he's motivating.

"You go to breakfast . . . he's motivating.

"You're choosing whether you're having ham or turkey, or tea, or what kind of tea with him . . . motivating.

"You're walking through the hallways in the lobby . . . motivating.

"Getting off from bus rides and getting ready for warm-up . . . motivating.

"Training . . . motivating . . . every minute, every water break is a motivating opportunity for Anson, literally.

"He has the gift of gab, but he's incredibly articulate. Those pro-

fessional sports movies where they put a male athlete and coach on a video with incredibly powerful music, they've got nothing on Anson Dorrance. He doesn't even need the music, he's so freaking motivating.

"So as a national team player, you're literally in an environment where you're getting a steady diet of inspiring words, images, actions, and you're all in it for each other and to do it together.

"We've been all bought in, and buy-in was never a question with Anson. So it was just a matter of when does the whistle blow, and it's, 'Okay let's go,' because he had us excited from the start."

Poetry aside, the national team had a match to play. Dispirited legs might best describe their condition, but despite having played six matches in eleven days, game faces are on. The plan is more of the same exhausting, pressing, 4-3-4, attacking style that got them here.

"Europeans had European championships tournaments regularly leading up to World Cup, but we didn't," recalls Heinrichs. "This was the first time we were able to measure ourselves globally. Leading into the finals we felt if we beat Germany, we'd win, so there was a lot of confidence, but we were starting to get gaps, and we felt them on a personal level.

"There's emotional fatigue, mental fatigue, and the practical reality of playing every other day that by today's standards would never happen. We carried some of that fatigue with us into the game, and while we were the underdog, we still felt the pressure. We had beaten every team in the world at least once in the year or two leading up to the World Cup, so we were America compared to Europeans, and we knew it."

Assistant coach Lauren Gregg, who had been with the national team as a player or coach since its inception, says the atmosphere that night was tense, but she believed the "tougher than them" attitude the group possessed would prevail.

"What separated us from the rest of the world was our mentality," says Gregg. "We were psychologically more demanding than 99.9 percent of the teams we faced. We could impose ourselves on people, and they eventually cracked. We were intimidating with or with-

out the ball, but the Norwegians had a hardness about them too, and they were not going to roll over.

"Norway came as close to matching us as anyone we played. In those kinds of matches, when everything's on the line, it's usually the greatness of one player that makes a difference. It was all going to come down to an individual moment, and it certainly did."

Dorrance went with the same eleven starters that got them there. No last-minute substitutions. The team was not at full strength anyway. Heinrichs had a torn ACL, Higgins a bad leg, Akers a sore knee, and others like Carin Jennings were physically and mentally spent.

"I had to keep telling myself to be physically ready," recalls Jennings. "We were all expected to keep the high pressure, and if somebody doesn't do their job, we won't be as effective. Norway was hard to play against, anyway. I like playing teams who serve me balls on the ground, a dribbling, passing, technically savvy–type team, but Norway was the opposite. They're adept at hitting long balls and with their height can win anything in the air. It wasn't a style I was fond of. Norway was more Michelle's type of team."

Jennings was spot on. Norway was indeed an Akers type of team. The first half was mostly defense. The teams marched up and down the field until minute 22, when the U.S. drew a foul. Shannon Higgins would be setting up on the right side, some thirty-forty yards out. She'd be looking for Akers in front of the net.

"Shannon was our maestro, a technically gifted player, "recalls Jennings. "As our playmaker, she'd earned the right to choose what set pieces to take and where to put them. She was our brain in moving how our team moved forward."

In this instance, the maestro was flawless. She put her kick where it needed to be: right in Akers's wheelhouse. "Shannon lofted a perfect ball into the box," recalls Akers. "Four Norwegian defenders were beside me, but I got between them and jumped higher, won the ball, and stuck it into the back of the net.

"How I outjumped those 6'5" Norwegian Vikings, I don't know, but I had practiced that shot for years, specifically since Anson put me up front. That goal was the result of a lot of hard work."

"It's iconic," says April Heinrichs. "America's first goal in the first

World Cup final is classic. It's the way you dream your whole life of scoring a header. If you're a soccer player, you don't dream of an own goal, or the last minute the ball deflected off your shin. You dream of a twisting header smashing it into the back of the net. As a player you dream of a header in the World Cup final. Akers got it, and it was awesome."

Jennings's sentiments echo April's. "Michelle thrived in those moments," says Jennings. "She was so advanced and courageous in the air. It was a typical Akers goal, and she could score it more often than not."

The excitement had barely settled when 9 minutes later Norway's Linda Medalen, standing in the box, took a long pass from midfield, a high archer similar to the Higgins pass. Medalen outjumped several U.S. defenders and then headed the ball past Mary Harvey, who collided with teammate Carla Werden.

It's now 1–1, and the remainder of the first half is fraught with tension. No one wants to be the one to make a costly mistake. When the whistle finally blew, the score was still tied. For his halftime talk, Dorrance was angry and in no mood for small talk. He basically let his players know, in no uncertain terms, they'd better put it in gear.

If Dorrance had advice for Akers, she probably wasn't listening. She generally zoned out at meetings. Only when Tony DiCicco took over as coach in 1994 did Akers start to listen a little.

As a former special needs teacher, goalkeeper coach DiCicco knew that actively engaging students allowed them to concentrate better. For slide shows and PowerPoint presentations, he had Akers operate the equipment to keep her engaged.

But there were no PowerPoints or slide shows at Tianhe Stadium on this night. Only cramped legs and sore, depleted bodies. Somebody had had to step up, rise above the personal fatigue, take the initiative, and win this game on their own.

Before the second half began, DiCicco caught up with Akers as they made their way out to the field. "Tony put his arm around me and said, 'Mish, if we're going win this game, you're gonna have to do it,'" recalls Akers. "I said, 'I do?' Then I was like, 'I know I'm going to have to do it.'

"I repeated to myself: 'I'm going to do it, I am going to do it.'

"Tony hit me with a cattle prod, and my brain went—ping. I said, 'I'm going to be the game-changer. This game is mine to win. I'm going to track down every ball in the second half, and win every head ball, tackle every ball, take risks, and do everything I can to win the game.'

"It became my mission."

The second half was the same seesaw, back-and-forth defensive action. By now the pitch was strewn with players on life support, and whose legs had cramped. Everyone knew a mistake or slightest mental lapse could prove costly.

The minutes ticked by, 50, 60, 70, no score. Then in minute 78 the U.S. caught a break. With 2 minutes left in regulation, Shannon Higgins lofted a ball from the midline, deep down the field where Akers was pressing Norwegian defenders and trying to create some space. Higgins couldn't have placed the ball any better.

"At this point, I'm going to win every head ball, tackle every ball, and do everything I can to make something happen," recalls Akers." I made a conscious decision to take a risk—that's why I was able to track down that pass. Shannon's kick exceeded everyone, but Norway's sweeper ran onto the ball and collected it in on a bounce. She should have cleared it out, but she was slow, and I was chasing down every half of a chance.

"I could tell she was worried when I got to her, and so I kind of pushed her aside and got the ball. The keeper came out, so I went around her and put it in."

"It felt like it took three minutes for Michelle to shoot that ball," adds Jennings. "She wanted to run around it and put it on her right foot."

"Michelle took her sweet time getting around the outside of the goalie and making sure she had a clean shot," adds Heinrichs, "But she knew she had the time and put it in the back of the net . . . 2–1 U.S."

"I was playing center back, and I could see everything in front of me," says Carla Overbeck. "I was screaming, 'Shoot it! Shoot it!' But Mish ran around the goalie. She wanted to make sure it was going in."

"It was like time stopped," recalls Lauren Gregg. "Michelle takes this extra touch, and it just felt like an eternity for the ball to roll in.

Tony and I went, 'Oh phew.' Because we were afraid if it went to penalty kicks, we might lose.

"Our players weren't seasoned enough to want to take penalty kicks. We always had a hard time to get five players to want to take them. It was like a foreshadowing of '99. From that point on, we knew we better start working on them, in case we have to go to penalty kicks."

For the next two minutes, Norway would be bringing everything they had. Aware of the urgency, Heinrichs brought the team in for a huddle.

"The most dangerous situation in soccer is a 1–0 goal differential, and we're aware of that," recalls Heinrichs. "We took a moment to regroup, and I said, 'Focus, focus, focus, we are the fittest team, we can't let up.'"

The huddle broke. The players could hear Dorrance screaming from the bench, "No fouls! No fouls!"

Earlier, FIFA officials had informed both teams there would be no excessive celebrating. Players were expected to remain on the sidelines, maintain their cool, then shake hands when the match is over.

"FIFA took us through a PowerPoint telling us how we were supposed to stand, and walk, and what to do," recalls Heinrichs. "Going on the field was not allowed, but when the final whistle blew, we broke every rule they had in their PowerPoint. We didn't care. How do you put a protocol in place when you win the World Cup? You can't. The second the whistle blew, we were out on the field being maniacs. It was, 'F—k protocol! Let's go! We just won the World Cup. We don't have any rules! There are no rules!'"

"None of us did anything we were supposed to do," says Carin Jennings. "It was wonderful, doing a victory lap, and then seeing our families. Champagne was in the locker room, and, of course, we indulged. It was all fantastic and hard to grasp. To this day, I don't think we understood the magnitude of it. We had just won a world championship."

As the team celebrated, fireworks exploded, and Anson Dorrance collapsed on the bench. There was apparently little joy in his demeanor. "I was just glad it was over," Dorrance later said." It was more of a sense of relief and duty served. I felt like a sentry who had completed

the midnight to eight a.m. watch. I was just glad nothing screwed up on my watch."

As captain, April Heinrichs had the honor of hoisting the world championship trophy. Ironically it was presented by FIFA president Joao Havelange, who five years earlier deferred to Sepp Blatter when Ellen Wille asked him if there would ever be a women's world championship.

Jennings won the Golden Ball for best player of the tournament. Akers won the Silver Ball for runner-up and the Golden Boot for most goals scored. On the way back to the hotel, the team bus blasted "Working Girl," and everyone sang Queen's "We Are the Champions." Once inside the lobby, the team discovered Sweden had laid out their third-place medals on the floor to spell out, "CONGRATULATIONS USA."

Their Chinese hosts insisted on a victory feast. Pete Dorrance and Greg Overbeck looked on in horror as the players were served cat, ox, and dog. They passed on the main course in favor of rice, which was consumed vigorously by the carbohydrate-depleted team.

As a practicing Mormon, Dorrance wasn't permitted to drink; he was reading in his room when a tipsy Joy Biefeld knocked on the door and insisted he join the raucous team party going on downstairs.

Dorrance eventually made it down to the party. He told the team he was proud of them. "This was more than a soccer game but a validation of our way of life," he said, "and I'm goddam proud to be an American."

The next day the U.S. team took a train to Hong Kong and then boarded a flight back to New York, with the same four teams they had just beaten. For Dorrance, it didn't sink in until he returned to Chapel Hill. As he perused the papers, he noticed the victory in China was front-page news in the *Washington Post*.

Finally he let go. Cranking up the stereo, he danced around the room by himself. All the work, persistence, and what he had envisioned back in 1986 had paid off. The national team, his national team, was the best women's soccer team on the planet.

Unfortunately, not everybody noticed or even cared.

"We came home, and there were maybe three people at the air-

port to meet us," recalls Tony DiCicco. "There was a journalist, the Men's National Team coach, Bora Milutinovic, and his friend Thom Meredith, also with the men's team. They had got up at five in the morning and drove to JFK because they understood winning a World Cup is incredible.

"But most people had no idea. People in soccer knew, and they were excited, but America didn't take notice. It was a colossal stepping-stone, and it did help change women sports in America, but it took a while for it to sink in. It turns out we still had our work cut out for us."

11

Bookends

Mia and Lil were like recruiting twins; and having twins come
to your university, you get the benefit of having double.

—APRIL HEINRICHS

There was little activity for the Women's National Team in 1992. Even after the team winning the world championship, U.S. Soccer couldn't seem to find a way to keep momentum going. The federation claimed they were out of money—funds diverted from the women went to the men's team in preparation for the 1994 World Cup. The only activity for the national team in 1992 was a U.S. Amateur Association national event in August.

The lack of a livable wage caught up to the noncollegians on the team. Several veterans retired including Shannon Higgins, Wendy Gebauer, Tracey Bates, and April Heinrichs.

National team members earned virtually nothing in 1991. In the months preceding the world championships, U.S Soccer paid them $1,000 a month, but their stipends ended after their final championship match in China.

Renewed commitment from U.S. Soccer was needed for the national team to remain solvent. The next major buildup would be the 1995 World Cup, and for those players out of college, maintaining a competitive edge would take work. Unfortunately, there were no professional leagues in the United States or centralized training for the national team. A few vets like Michelle Akers and Carin Jennings

found teams in Europe, and others pursued the coaching route to make a living.

The national team was on shaky ground. Anson Dorrance wasn't even sure he'd be staying on as coach. He promised himself following the 1991 world championships, win or lose, he would step down. The USSF made his life miserable. They were ready to chew him up the moment he lost a match. Winning the world championship had proved his detractors wrong, and he was only too happy to walk away on top, but after reviewing his status with his lone ally at the federation, Art Wallis, Dorrance reconsidered. Wallis told Dorrance if he quit now there would be no one qualified to take his place. All the gains made with the national team could crumble, leaving the culture he cultivated in serious jeopardy.

Having proved U.S. women's soccer was legitimate, Dorrance felt obliged to see it through. He did have a few advantages if he stayed on. The biggest perk that came with winning a world championship was power. For now, the federation would likely give him free reign. Dorrance told Wallis he'd stick around. What he didn't tell him was he would only stay long enough to groom a worthy successor. Dorrance would not give the USSF the pleasure of firing him. He would choose the next national team coach on his terms and then hand the team off at the opportune time.

Due to the lack of funding, there would be no victory tour. The national team would play only two matches in 1992, both against Norway and sponsored by the U.S. Amateur Association. On August 14 at Tufts Stadium, in front of 2,100 fans, the U.S. lost to the Norwegians, 2–1. The second match, in New Britain, Connecticut, on August 16, generated a paltry 1,547 fans. The U.S. lost 2–1. The only starters present from the 1991 championship team were Mia Hamm, Tisha Venturini, and goalie Mary Harvey. Michelle Akers was in camp for a while, but she left when her grandmother became ill.

Not all was gloom and doom. There was one player in camp from the University of Portland, a scrappy forward, who showed significant potential. In time Tiffeny Milbrett would evolve into a national team mainstay, but for now, the 5'2" speedster from rural Oregon was another of Dorrance's talented prospects who saw limited action.

Also in camp was veteran Emily Pickering. The Massapequa maverick came in for a curtain call before hanging up her cleats. She had walked away in 1987, and it was difficult for her to get back physically. The self-professed "rough girl," who was there from the start, would move on, but to those who knew her, she would not be easily forgotten.

With little going on internationally, attention turned to the college game, where Carolina continued its unprecedented string of NCAA titles. UNC was becoming the go-to school for aspiring soccer talent, though other quality women programs existed elsewhere. In the west, Stanford, Santa Clara, and UC Santa Barbara made repeated visits to the NCAAS. Perennial leaders in the east included George Mason, William & Mary, Virginia, Massachusetts, Central Florida, and Connecticut. In the central states, Wisconsin and Colorado College were names to watch.

The array of collegiate programs guaranteed Dorrance couldn't recruit everyone he was after. He already lost Akers to UFC, Chastain to Santa Clara, Foudy to Stanford, Jennings to UCSB, and Biefeld to Cal-Berkeley. Despite Carolina's reputation, to remain dominant Dorrance still needed to vigorously recruit. Carolina was generally the school of choice, but it was just a matter of time before other universities and colleges would catch up.

To coach the national team and Carolina took considerable time and energy, and often the two entities blurred. In 1991, only six days before the World Cup in China, Carolina was scheduled to play Wisconsin for the NCAA title. Dorrance confidently left his number two, Bill Palladino, in charge back home, but to the nine current and former Carolinians on the national team, missing their alma mater's championship match was akin to treachery. Interest among the Tar Heels was so intense Dorrance monitored the NCAA final match by phone and gave minute-by-minute updates in the hotel hallway to all interested parties. Among those most invested were Lilly and Hamm, who were missing their college final to play in another final half a world away.

Lilly and Hamm would have to wait until 1992 for another shot at the NCAAS, and it was well worth the wait. Carolina played one

of the most amazing college seasons in history, going 24-0, before defeating Duke 9–1 in the NCAAs, for their seventh consecutive title.

April Heinrichs knew both Lilly and Hamm and considered them equally instrumental to the national team's term success.

"They were like bookends. Mia, a left-wing midfielder. Lil, a right-wing midfielder. Both were dynamic, fast, and effective. I never understood the comparison, and it might be simple as actual goals scored, but Kristine Lilly was every bit the soccer player as Mia Hamm, and Mia would be the first to tell you that.

"But Mia got more of the attention because of goals scored. But if you quantify all the things Kristine did from a young age, including her durability, attacking, and defending, and she also scored goals and assists, the two were bookends.

"It was like blonde and brunette, left-footed and right-footed, fast on the left and even faster on the right. Both players were dynamic, durable, and totally in control of ball possession.

"Both were quiet and shy, but Mia had a punctuation mark to her play and a sensitivity that meant you being a little bit more careful around her. Lil, on the other hand, had a steadier presence and was a bit more consistent on and off the field. Both players were about nine years behind me, but in terms of maturity, it was more like three years.

"Their work ethic, which is the essential thing in soccer, was impeccable. The point of the game is to compete for ninety minutes. There is no relaxing, resting, or taking time off, and these two had a professional work ethic going at sixteen years of age.

"For me, they were bookends or twins, mirror images of each other, with only a slight difference between the two. And we got them both at the same time, which is remarkable."

Hamm's breakout year in college came in 1992. Carolina won every game by at least two goals, outscoring opponents, 132–11. At the NCCA final versus Duke, they won 9–1, setting records for goals scored and margin of victory.

Hamm had 32 goals in 1992, including 16 in the NCAAs, with a record 33 assists. Mia finished her career at Carolina in 1993 with 103 goals, 72 assists, and 278 points, setting records in all categories. She

was player of the year (Mac Hermann Award) in 1992–93 and first-team All-American in 1990, 1992, and 1993.

Lilly wasn't far behind. She won four consecutive NCAA titles, scored 78 goals, and had 41 assists. Unlike Hamm, she didn't redshirt in 1991, and despite missing the NCAA final, she was recipient of the Mac Hermann Award.

If Hamm had a weakness, it was that she could be overly self-critical and hard on herself. Assistant coach Lauren Gregg, who knew Hamm since she was fifteen, watched her closely, especially after she moved from midfield to forward, where there was more pressure on her to score.

Gregg says being self-critical is common in soccer, particularly for forwards, and it wasn't only Mia who experienced it. With the intense competition in the national team culture, any young player coming into the program felt enormous pressure.

"As a forward, being hard on oneself is much more pronounced because you have to fail," says Gregg. "It's a matter of who's going to outlast who. Is the defender going to tackle me one last time, or am I going to get around you that one last time?

"Players are continually failing, and it's true of every player, past or present. Part of the ascension of this women's program to this day is to be self-critical, and it's one of the things that makes them world-class.

"But honing that critical quality and not having it destroy you is an art. Most great qualities are also our weaknesses, and navigating that balance with all of the players and specifically with Mia, and the pressure she felt as a goal scorer and beacon of the team took on a heightened intensity."

Gregg feels Hamm's desire to be her absolute best is what gave her the fire to overcome her obstacles. She credits Dorrance's mentoring as the reason Hamm transitioned smoothly from a part-time back into a starting forward, and then into a stand-alone star. Another reason was her will and self-discipline. Gregg says what Dorrance did exceptionally well with Hamm was give her the room to fail.

"You have to have this inner-depth fortitude that allows you to fail ten, eleven, twelve times, and you may or may not be successful. But it's within that process that she became great."

Gregg maintains as good as Hamm was, she wasn't perfect and was a constant work in progress. "Mia could run like the wind and take on players, but one thing she wasn't very good at was the final pass and finding other players and getting her head up," says Gregg.

"We waited two years to address the issue because you didn't want to harness what made Mia so special, which was her ability to go one versus one, and willingness to fail. For that period I credit Anson for recognizing that she needed room to grow, and similarly for her teammates to buy into that."

Through trial and error, Hamm adapted and emerged one of the best defending forwards in the world, but it was Lilly, says Gregg, who was the engine behind the national team.

"Lil's ability to sustain her game, for as long as she did, at the level she did, is unprecedented," says Gregg. "Anytime a player might have felt tired, they couldn't back down because Kristine Lilly is running five times more than they were.

"She had this way of doing whatever the team needed to be successful. Whether it was prominent defensive role, leading a player, or scoring a goal, she was the one to rely on.

"Lil was like the engine or the heartbeat, and you don't feel your heart beating in your chest, but without it, you're nothing. Lil was this constant presence that was comforting to have because you knew she'd figure out a way to help you win."

By the time 1993 kicked in, U.S. Soccer had opened its purse strings, and the national team was back on track. Lily and Hamm saw considerable action that season, playing all seventeen matches, with Hamm leading with ten goals, and Lilly named Player of the Year.

The mid-1990s were transition years for the national team. For the first time, they played the majority of matches at home. They went 13-4 in 1993 and undefeated in 1994. The long lapses between World Cups gave players like July Foudy and Carla Overbeck time and space to hone their leadership styles, and new players to refine their talent. Familiar names began to emerge including Shannon MacMillan, Tisha Venturini, Tiffeny Milbrett, and goalie Briana Scurry.

Interestingly, it wasn't Akers, Lilly, or Hamm who surfaced as cap-

tain. Akers was offered the captaincy, but she felt awkward wearing the band and had to deal with the onset of chronic fatigue syndrome. Hamm and Lilly were both more at ease leading through their actions; thus the captaincy was left to Carla Overbeck and Julie Foudy.

Overbeck, in particular, had a way about her that demanded respect. She would reprimand anyone, including scrubs, superstars, and coaches. But she was never overbearing in her criticism. She didn't hold grudges and always had a teammate's back. In turn, players didn't want to let her down.

How she became captain is a story in itself. On a team with big egos, someone besides the coach needed to police things and help guide the ship. How this once shy Californian turned Texan morphed into one of the national team's, and the sport's, most influential leaders is a tale worth telling.

12

A Captain's Tale

A player who makes the team great is more
valuable than a great player.

—JOHN WOODEN

Richardson, Texas, June 1979

Bill Kinder was in a quandary. Tryouts ended, and the thin little girl
nobody took seriously did so well on her routines that she made the
team. But when Kinder glanced at her registration card and saw the
girl was only eleven, he realized somebody made a mistake. The cut-
off for the league was fourteen.

Kinder was in a pickle. He didn't have the heart to tell the girl she
couldn't play, but rules are rules. Still, she showed talent, and Kinder,
though kindhearted, was a bit of a maverick. He had launched the
Dallas Sting and Spring Valley League in 1973, with nothing except
the radical idea that girls like this one could have an opportunity to
play soccer and follow their dreams.

When Kinder formed the Sting, there weren't many places for
girls to play soccer in Texas, but by 1979 he had youth teams spread
all across the Dallas metroplex. He formed the league to introduce
girls to the joy of competition and camaraderie. It wasn't designed to
dampen spirits to the point little girls like this one may never want
to play again.

Kinder noticed how hard the girl had worked, how badly she
wanted to play. But she's just too young. Having arrived at his deci-

sion, Kinder looked over at her one last time. She was standing by the bleachers, with her dad, wearing a crazy grin like she'd just done something big and important.

Kinder glanced at her card. "CARLA WERDEN" she had written in big, bold letters.

Oh, boy.

Kinder took a deep breath, plodded over to the bleachers, and pulled Carla's dad aside.

"Mr. Werden, I'm Bill Kinder . . . you got quite the athlete there."

"We're proud of her, thanks."

"Mr. Werden . . . I . . . ah . . ."

"Is there a problem, Bill?"

"Well, sir, your daughter's got talent, but she's kind of on the small side. I'm afraid she might get hurt. Girls in the league are a little bigger and we have an age limit. Bottom line, we can't have eleven-year-olds playing against teens."

Carla's dad, Art Werden, usually didn't say much. A straight shooter, he knew the value of an honest day's work. Art had come up the hard way and never backed down when he knew he was in the right.

"My girl did what you asked of her and her scores were as good as anyone's," Art said. "If you feel that's good enough to make your team, then she should be on your team."

On the far corner of the field, the sprinklers came on and bursts of water exploded from their heads like rockets.

Psst, psst, psst.

Kinder looked at the card, then back at Carla. She was wearing that same sly grin and held her soccer ball tightly to her chest like it was a baby.

Kinder looked again out on the field.

Psst, psst, psst.

A thin cascading curtain of mist floated by. Somewhere between the mist and the fading Texas sun, Kinder saw the light.

To hell with rules—this league's about the kids, he thought to himself.

He looked at Carla, then her dad. "Mr. Werden, tell you what I'm going to do. I'm gonna to make an exception. We're gonna allow

your daughter to play. But understand, she's going up against girls a lot older and stronger."

"Don't worry about Carla, Bill. She's got brothers. She may be small, but she's tough as nails. Whatever happens out there, she'll handle it."

"I started with the Sting when I was eleven and played through U-18," recalls Overbeck. "It was important because a lot of girls couldn't even play soccer during this time. I know Kristine Lilly could only play with boys, but I came from a big metropolitan area, and we had more opportunities. I could play with the Sting, and it made a big difference."

The Sting team Carla played for was groundbreaking. By the time she joined they had played all over the country and to record crowds in Mexico City. When Carla was in high school, her Sting club got invited to a major tournament in China, but her school said she and her friends couldn't go because they'd miss too many days. When Carla's dad got the news, he was disappointed. It would be the first time a girls' club team from America went to China, and it would be an experience of a lifetime.

"They said I would fail a grade if we went, but my dad was adamant that I go," recalls Overbeck. "He said he'd drop me out of school and then reenroll me when I come back. But he kept after school until they let us go. It was a big deal because no girl's team had ever made a trip like that."

In a lot of ways, the Dallas Sting were precursors to the national team. Credit Bill Kinder and his partner, Lamar Hunt, for having the wherewithal to bring girls soccer to the forefront.

"We found that the girls loved playing soccer," recalls Kinder. "It was the first time they could do an outdoor sport that had some contact and running, and the team concept had great appeal. There was a good deal of pushback because girls weren't supposed to do anything like play soccer, and no one would referee their games. It was beneath referees' dignity to ref girls' games. But the girls loved it, and it started to grow extremely popular. It became a sport that parents wanted their daughters to have an opportunity to play because of the life lessons and teamwork."

Carla played with the Sting through high school, but midfielders and defenders didn't attract the kind of attention a flashy, high-scoring forward might, and colleges for the most part ignored her. Then one day Anson Dorrance showed up at one of her local matches.

"I played on the North Texas State Soccer team, and Anson coached the North Carolina State Soccer team," recalls Overbeck. "We would go to a regional camp as a state team and play each other. He was the regional coach and became the youth national team coach, so he saw me play."

When Dorrance took an interest in Carla, other coaches suddenly joined the bandwagon. She got letters but had little desire to play college soccer. A self-professed homebody, Carla wanted to stay near home and go to Texas A&M like her older siblings and play on the university club team.

"Anson called as often as the rules allowed," recalls Overbeck. "He was the only one really calling, and I was shocked he even thought I could play at his school. I was nervous about going away from home, but my parents said this was an opportunity I needed to take advantage of."

Carla isn't sure what Dorrance saw in her. She hadn't developed leadership skills and certainly wasn't a scorer. "I had three older siblings, and I had to fight them for everything I got," says Overbeck. "They'd beat and tease me as often as they could, but it made me resilient, tough, and competitive. I knew I had it in me, and maybe Anson saw those qualities."

Carla's freshman year at Carolina was a disaster. She was chronically homesick, and her game suffered. It wasn't that she couldn't excel, as much as she refused to show it.

"I didn't assert myself because I wanted to fit in," says Overbeck. "It was a new environment, and I didn't know many people and didn't want to be a jerk. Besides, I was still homesick. I must have cried every night for a year and a half. My teammates probably thought I was the biggest baby on the planet, like, 'Okay Carla, get a grip!'"

Part of the anxiety was because the entire Carolina back line had just graduated. Carla was slated to start and play right away. Usually, it's a slower process for first-year students. Carla was a shy girl thrown

into a situation where tough, experienced players were competing hard and weren't afraid to let Carla know if she was making mistakes.

It turns out one of those mistakes had major ramifications. In Carla's freshman year, Carolina had just two goals scored against them all season, and one was an own goal made by Carla. She was so consumed by grief afterward that she stormed off the field crying, intent on quitting the team.

"I went in the Hut, changed into my street clothes, and walked back to my dorm," recalls Carla. "They were all chasing after me, and I was still crying, and our assistant coach Bill Palladino was laughing.

"Anson must have felt so sorry for me because he invited me over to his house for dinner, and now I feel even stupider because he saw me crying. I am sitting over at my coach's home with his wife and family eating pizza, and they're all telling me, 'It's okay, Carla, it's okay.' And I just felt dumb."

After her sophomore year, Carla's inner angst reached its peak. For her first two years, the team didn't need her leadership because they had older players to carry the team. But by her junior year, the veterans were gone, and the coaches expected the juniors to help lead.

"Dino and Anson would always try to get me to talk. They'd say, 'Carla, you're the last one on defense. You can see everything in front of you and all the breakdowns. If you saw them before, then your job is easy. You don't have to do anything but tell players what the setup is.'

"It was hard because I was intimidated by the program. Carolina won championship after championship, and if I'm not comfortable in my own skin playing in the back, how can I lead these players who have won championships?

"I felt like I had to earn their respect before I could speak, but after my sophomore year, it was like, 'Okay, Carla, you're a rising junior and supposed to be a leader, so grow up and start acting like you should be here.'"

Carla emerged from her shell, and when that happened, players starting gravitating toward her. Her natural charisma and soccer smarts prevailed. Carla's emergence as team leader was an evolving process. She didn't assert herself until she was ready, but once she'd committed, never looked back.

In her four years at Carolina, 1986–89, the Tar Heels went 89-0-6, including a record 92-consecutive-game winning streak. The team won four NCAA championships, and Carla was named NSCAA All-American in three of her four years.

Carla joined the national team in 1988 and played every match of the 1991 Women's World Championships in China. When April Heinrichs and Tracy Bates retired in 1992, there was a leadership void, and Carla was confident enough to step in.

April Heinrichs believes the unique partnership Carla shared with Anson Dorrance allowed her to break free of herself and helped fulfill her true potential.

"You put Carla in any other university, and I'm not sure she's as successful," says Heinrichs. "You put Carla with Anson for four years at Carolina, and then put Carla with Anson on the national team, and now she's world-class.

"There are players with less talent, and they just couldn't make it happen. But having Anson and Carla together every day at Carolina, and then the national team, watch out.

"Everybody loved Carla," adds Heinrichs. "Her likeability was off the charts. She prided herself on being the fittest player on the pitch and had a relentless work ethic.

"Carla was generally quiet, not Joy Fawcett quiet, but on a spectrum, more toward the quiet. But to be a leader, center-back, and sweeper, you've got to become a vocal leader, so Anson was on her about that. He took her under his wing, coached her every day of the week for four years until she took it upon herself to grow into the part.

"That's where the environment that Anson created at Carolina and with the national team made a huge difference. He started to hone and assign players and take them to whole different levels. When Carla left Carolina she wasn't even close to the same player when she first arrived. Exponentially the player that improved the most from her first year to her fourth year was Carla Overbeck.

"Carla was a phenomenal captain. I'd say she was the best captain the U.S. Women's National Team ever had. Every day you're competing your ass off. Every practice you're getting your uniform ripped

off, and if you don't fight to keep it, you lose it. As Jill Ellis says, 'Iron sharpens iron,' in the sense every single day of training at Carolina and the national team is a physical, psychological, technical, practical, emotional, social, competitive battle.

"The rest of the world hasn't figured it out yet. When Pia Sundahge, who played against us and coached in our pro leagues, when she became the head coach of the senior women's national team program in 2008, her first week, she's like, 'Oh my god, April, I don't believe how hard they train.'

"A lot of that started with Carla and Anson. It goes exponentially what I said earlier: Carla, her likeability; Akers and I, we didn't exist on earth to walk on eggshells to be liked. Carla didn't either by the way. It wasn't like she was walking around on eggshells, but her likeability was so high that it was natural for players to gravitate to her. Carla was a thoughtful role model, a role model that turned into a leader."

The national team went 12-0-1 in 1994. Michelle Akers led with eleven goals and seven assists. Mia Hamm was named Best Athlete. For the first time, the team participated in the Algarve Cup in Portugal and the Chiquita Cup, and they won both tournaments.

In June the national team attended the CONCACAF World Cup Qualifiers in Montreal, defeating Mexico, Trinidad and Tobago, Jamaica, and Canada, outscoring them, 36–1. The sweep earned the U.S. the number one regional seed for the upcoming 1995 World Cup in Sweden.

It's worth noting during the Trinidad and Tobago match, Carla went in hard after a player, was fouled, and in retaliation decked the Tobagoan player, leading to an all-out brawl. Thori Staples of the United States received a red card and got ejected. Tony DiCicco, in only his second match as head coach, was sent off also, for cussing the referee.

During the fiasco Anson Dorrance was sitting in the stands having the time of his life. After the melee, he left for a hot dog and a drink, only to find DiCicco sitting next to him when he returned. The two friends sat there the rest of the match, content to let Lauren Gregg coach the U.S. the remainder of the game, for the win.

For Dorrance, 1994 would be his final season with the national team. He promised himself he would retire when he felt ready and had a successor in place. Just before the CONCACAF qualifiers in August, Dorrance informed Tony DiCicco the team was his.

Until now, Tony DiCicco's life had been a series of improbable improbabilities. The highest coaching level he'd attained had been a boys' soccer coach at a Catholic middle school in Connecticut.

Following a coach of Dorrance's stature wasn't for the faint of heart, and DiCicco never had a natural calling to coach women. He actually might have even been happier on the men's side, but wherever he landed, he figured if he was in position to grow the game, it was a positive step.

Tony's eldest son, Anthony, recalls the day his dad took the job. "He had seated us around the kitchen table," recalls Anthony. "This is a family decision," he said, "and I want to talk to you guys about it because it's going to impact you and Mom.'

"He always approached important matters as a family, and how he treated us at that moment was how he treated his players on the national team. Of course, we said yes, and it began the most wondrous journey of all our lives."

Lauren Gregg says the transition from Dorrance to DiCicco had lasting implications.

"Coaching required everything of Anson, and you can't give everything to two programs. He had given the national team what he could, and now it was time for new energy. Tony was there to pick it up where Anson left off, and neither one of them ever looked back."

PART 2

THE DICICCO METHOD

13

Improbable Improbabilities

It was 1976, the year of the nation's bicentennial, and Tony DiCicco was living out two of his dreams. During the day he was a middle school physical education teacher in the small Vermont town of Bellows Falls. In the afternoons, nights, and weekends, he was a professional goalkeeper for the Connecticut Wildcats in the American Soccer League (ASL).

In the third-floor apartment of an ageing house in the nearby town of Ludlow, he lived with no heat, but the price was right, about $25 a month. Typically, at night he would be curled up under his army surplus wool blanket with his dog, Yashin, named after Lev Yashin, a dynamic Soviet goalkeeper of the era, but "she was a lady," DiCicco would say, dignified and graceful with the right temperament for their challenging routine.

Following a morning run, they would leave for school and arrive just before 7:00. The middle school team didn't have a practice field of their own, so many of DiCicco's days involved driving a school bus back and forth the two miles to the high school south of town.

After his last class of the day, he and Yashin would pile into his 1971 green Ford pickup truck, and together they would cruise 126 miles down I-91 through Massachusetts to train with his team in Windsor, Connecticut, keeping pace with the big rigs that churned up and down the highway.

DiCicco felt like he had unlocked the secret of having the best of both worlds. His identity as a teacher was central to the person he

was and the coach he would become, and his ego was boosted by his life as a professional goalkeeper.

DiCicco had always been a star athlete. At Wethersfield High in Connecticut (1962–66) he lettered in baseball and basketball before taking up goalkeeping during his sophomore year. But it was at Springfield College that he started making waves in soccer. As an All-American goaltender, he took pride in his growth in the game and his consistency and relentless study of the position and the sport.

DiCicco graduated from Springfield in 1970 and for the next four years taught school and played with the Wildcats, but he still wasn't sure what he wanted to do with his life. He realized he probably couldn't make a living as a player, but that didn't deter his ambition to stay in soccer. That search led him to daily 250-mile round-trip commutes. On April 7, 1974, he was trying to be everywhere at once, burning the candle at both ends. It couldn't last.

The night of April 7 was overcast and dark, and I-91 was bustling with trucks and commuters. DiCicco and Yash were in the Ford, heading home from another long day of travel and practice at Loomis Chaffee College.

He should have pulled over, but his stubborn streak won out. They were passing by Pleasant Valley in Massachusetts when DiCicco's eyelids grew heavy, and his head dropped toward his chest. In a flash, the truck abruptly swerved off the road. There was the gut-wrenching sound of metal on metal as it struck the guardrail, but the noise didn't trigger the necessary responses from DiCicco.

The Ford kept barreling toward the opposite side of the highway. Then it reached the narrow median between the north- and southbound lanes. The truck bounced as it hit the grass, and DiCicco's head banged against the roof of the cab.

The jolt was as significant as cold water, and in an instant DiCicco was back, but he was on a trajectory to collide with the oncoming traffic. A wreck was imminent. His goalkeeper's reflexes served him well, and he yanked the wheel to the right, but he needed to be careful. Too much pull, and the truck would roll. Not enough, and an eighteen-wheeler would flatten him.

Traffic roared mere feet from the driver-side door, but somehow

Tony was able to regain control. As the Ford fishtailed to a stop in the depression of the median, loose soccer balls in the back bounced against the truck's metallic bed, and Yash was slammed hard against the passenger side door.

Then there was stillness. The confused dog was emotionally intelligent enough to know something significant had happened. Still, the dog was only able to give DiCicco the soft, reassuring eyes that told him, no matter what it was, she always loved him.

In the silence, DiCicco regained his senses. A car slamming him from behind was his immediate concern. Glancing back, he was relieved to see lights from the oncoming traffic far to the right of him. The headlights illuminated the cab, and DiCicco stared at his reflection in the mirror. His eyes were wild with fear, and beads of sweat poured from his forehead. He straightened up and began shaking. His hands were trembling as he inched his way off the median and back into the flow of northbound traffic.

His hands shook for the remainder of the ride and were still shaking when he arrived at his small apartment in Bellows Springs. He ran upstairs, dived fully clothed onto his bed, and tried to sleep, but sleep didn't come, and wouldn't for a long time.

When he awoke at 5:30, he was grateful to be alive but dreading another 250-mile round-trip commute. Something had to give, he thought. What he was doing now was insanity. In his heart, he knew his dual life as player and PE teacher was killing him. Something had to give.

He could have died, but he hadn't. He had avoided disaster, but the mishap required some soul-searching. Tony had always pushed himself to be the best: the best teacher, the best goalkeeper, the best teammate, and the best outdoorsman. Interstate 91 was a wake-up call that forced him to consider his true calling. He concluded that playing soccer satisfied his competitive drive, but athletes have a finite amount of time they can play. Sooner or later, the need to make a living takes precedence.

Coaching came as naturally to DiCicco as the changing colors of the New England fall. Even at an early age, he showed signs of being a coach and facilitator. When he was ten, baseball was his passion,

and he wanted to manage in the major leagues. Twenty years later, soccer was his preferred vocation. Unfortunately, jobs in soccer were virtually nonexistent in the 1970s. He pondered how he could put his varied skills to use once his playing days were over.

It took a special woman to help push him forward. In 1975 DiCicco was playing for the Wildcats at Hartford's Dillon Stadium when he laid eyes on former Windsor Locks High School cheerleader Diane Dombrowski. "Our eyes met, and that was it," DiCicco liked to say.

Their first date was the day after Thanksgiving that same year. DiCicco had purchased two tickets to a Hartford Whalers hockey game but wasn't sure if Diane would go. As a backup, he put his kid sister Joan on notice. If Diane said no, would she go to the game instead? He asked, and Diane agreed to go.

Was she his catalyst for change? In all likelihood, yes. In June 1976 DiCicco submitted his letter of resignation to the superintendent at Bellows Falls. The core of the message is as follows:

"Although my term at Bellows Falls Middle School was both a learning and fulfilling experience, this move allows me to attend graduate school and follow a full-time soccer career."

DiCicco's commitment to soccer was bold and perhaps foolish. The ASL was still a fledgling men's league, and there was no such thing as a professional women's league.

Despite the odds, DiCicco forged ahead. On March 18, 1978, he married Diane and moved back to Hartford, where he pursued his masters in PE at Central Connecticut University and assisted the men's soccer team. Part of the reason he went into coaching was that he got his degree paid for by being a graduate assistant, but his paycheck barely dented his expenditures. To help with costs, he continued to play professionally for the Wildcats and Rhode Island Oceaneers.

But the hardships and dual career tracks didn't deter him from his dream. Soccer was his lifeblood. The reason DiCicco was successful in so many aspects of the game was because of his desire to compete at the highest level. He never had a stated goal of being a World Cup champion coach. He only knew that he wanted to make a significant impact on the growth of the game and support his family.

DiCicco's work ethic was legendary—how he would stay long after

practice, teaching himself the disciplines needed to be an elite goal-keeper. The soccer fields of Loomis College in rural New England where the Connecticut Wildcats practiced became his second home. The fields are located on the floodplain between the Connecticut and Farmington Rivers; the tributaries flood in the spring, and the campus is green with foliage. In the fall the surrounding meadows burst in a blazing kaleidoscope of color from the autumn leaves.

For a young man with soccer dreams, the setting was idyllic. Eight soccer fields set to the tree line, as far as the eye could see. After practice, the fields would be empty except for a lone goaltender doing pressure goalkeeper training. He'd be on his side, tossing a ball up, quickly reloading to his feet, collapsing, and then diving to the other side. He'd do the drill over and over, pushing himself to acquire the stamina needed to maintain proper technique late in games.

He used habits ingrained from his training and his parents. One day he would carry those traits to the national team, but for now, he'd fill his hours perfecting his craft and solidifying his commitment, a commitment born in the promise of spring and hardened in the chill of a New England fall. It was a commitment that would some-day change the culture for women and women athletes.

With aspirations for a family, DiCicco was more determined than ever to make his soccer vision a reality. In 1980 he started the first soccer program at Hartford's South Catholic High School. He left the school two years later when his oldest child, Anthony, was born, and they moved into a home on Church Street in Wethersfield, Connecti-cut, the town where he grew up and would live the rest of his life.

During this time, he met two soccer visionaries from Connecti-cut with similar aspirations. Dan Gaspar was a former All-American goaltender who would someday coach local college teams, club teams, and then internationally with Portugal and Iraq.

DiCicco found a kindred spirit in Gaspar. They agreed soccer was on the cusp of catching on big in the United States. They had wit-nessed its growth at the grassroots level and knew Connecticut was hungry with boys and girls eager to play soccer at an elite level.

The question they asked was how they could capitalize from the

soccer boom and help the sport grow. Before 1982 there were two soccer camps in the United States with any reputation. The most well-known camp was Vogelsinger Soccer Academy, run by Hubert Vogelsinger. Connecticut native Joe Machnik's Number #1 Soccer Camps was a distant second.

A former pro player from Vienna, Vogelsinger arrived in the United States in 1960 with dreams of coaching soccer and growing the game. Following a stint as an assistant coach at Middlesex School in Concord, Massachusetts, Vogelsinger found himself at Yale, where his prowess as a shooting coach eventually led to the head coaching job of the men's soccer team. As his reputation grew, so did requests for his services. To quell the demand, he began conducting shooting clinics at private schools and public parks. The gatherings soon evolved into larger, more organized settings, and in 1966 he started his first camp with sixty players, primarily boys. The camp offered intense technical training, and for the first time, young players looking for quality coaching from proven professionals could do so in a quality setting.

Around that time, DiCicco met Machnik, a former professional goalkeeper who ran a camp in New Haven. "Dr. Joe" was instrumental in DiCicco's career, but he was also a force in international soccer. Joe would go on to become a highly regarded coach, teacher, referee, broadcaster, and facilitator. His impact on the sport is still felt and is why he was elected to the National Soccer Hall of Fame in 2017.

Through Vogelsinger's and Machnik's successes, DiCicco and Dan Gaspar began to see the possibilities in conducting camps of their own. Since both men had unique goaltending knowledge, they decided that an elite goalkeeper camp was the way to go. In 1982 DiCicco and Gaspar started SoccerPlus Goalkeeper School in Glastonbury, Connecticut, and set up their pro shop at Oakwood Sports Center, Farmington, in a commercial plaza along the river.

The first SoccerPlus camp took place over a long weekend in August 1982 in Uncasville. The following year SoccerPlus partnered with Vogelsinger, and their schools quickly became the place for players serious about their sport.

SoccerPlus was a weekly residential program, with one of the most intense goalkeeper-training environments in the nation. It was built

on a curriculum and manifesto that DiCicco started to develop in 1977–78 when he was running clinics for the Rhode Island Oceaneers. The camp used his background in teaching to create what would become the DiCicco Method. The camp also served as a means to an end. For the first time, DiCicco was able to focus all his energies into one soccer entity.

A typical day would see him leaving the house at the crack of dawn in his black Mazda truck with "SoccerPlus Camps and Retail Store" on the side. His first stop was the store, where he spent mornings dealing with customers and planning camps. After leaving the office around 2:00, he'd go directly to the fields, where he trained goalkeepers until dark. When he got back home, Dianne would shove one-year-old Anthony into his arms because she needed a break.

The store, camp, and home life all looked effortless, but DiCicco was incredibly disciplined and neat. In his spare time, he'd submit articles to soccer journals or any other publication that would print what he had to offer. He was marketing himself and SoccerPlus, selling cleats and goaltenders' gloves out of the back of his truck, and being available all over the county to do clinics and camps.

His transition from player to coach was fluid. Instead of doing drills and exercises, he was now facilitating them. Rather than being the one catching the ball against an opponent, he'd be serving and kicking balls to campers.

In the late 1970s and early 1980s, his life became a whirlwind. In four years he went from being a player to retiring as a player to focusing entirely on growing soccer and the business of goalkeeping. With his drive and budding reputation, it didn't take long for soccer's movers and shakers to take notice, among them a developing women's soccer coach from Santa Clara named Jerry Smith, and one from the University of North Carolina, Anson Dorrance.

It's fair to say that without SoccerPlus, DiCicco would never have developed into national prominence as an instructor, nor would he have caught Anson's eye and got on his radar. But that was still a few years away. For now, it was running camps, building a family, and developing his reputation as a leader in the growing world of youth soccer.

Things were going smoothly until an incident in the summer of 1984. While DiCicco was conducting a camp in Minnesota, Dianne had a miscarriage. When Vogelsinger became adamant that DiCicco not leave camp to return home to look after her, a heated argument ensued, resulting in an invective-laden tirade against Vogelsinger as DiCicco brushed by him on his way to the airport.

As his plane sat on the tarmac in Minneapolis, DiCicco smoldered. Vogelsinger was running the field player camps, and DiCicco the goalkeeper camp, and he was worried the row could end their corporate partnership.

But to DiCicco, the family was more important than the camps, and he was disappointed that he was working with someone who didn't share that value. Eventually tempers subsided, and the rift put aside, but when the camp's brochures, which were the company's primary marketing materials, were shipped to the printers in December, Soccer Plus Goalkeeper School did not appear in the program.

Vogelsinger had dumped DiCicco and SoccerPlus. When he called to demand an explanation, Vogelsinger said, "Tony, I know you're angry with me right now, but believe me, this will be the best thing that ever happens to you."

DiCicco was crushed but determined to move on. That afternoon, he and Gaspar began calling coaches all over the country to find fields and book facilities. In a flurry of activity over four days, they put together the 1985 SoccerPlus schedule at school campuses nationwide.

It took DiCicco several years to forgive his mentor, but he eventually came to the conclusion his dismissal had indeed been for the best. It freed him to become his own man and set the course for his future success. By going on alone, he was able to maximize his talents and soccer knowledge and catch the attention of other soccer visionaries like Jerry Smith and Anson Dorrance.

The national team Tony DiCicco inherited from Anson Dorrance in the summer of 1994 was by no means a well-oiled machine. U.S. Soccer had allotted all available funds to the U.S. men's team for their World Cup run. Left in the lurch, the women's team struggled.

There were no funds left over for residency camp and training, and the team languished.

"The mistake U.S. Soccer made was resting on their laurels," says Lauren Gregg. They said, 'Oh, the women were so dominant in China in '91 that we don't have to do anything with the team.'

"It's true, we had set a new bar for women's soccer, but other teams were starting to beat us at our own game. Instead of elevating what they had already provided for the women's team, U.S. Soccer paused. Other teams went to work, and we stood still for a couple of years."

Despite the cash crunch, Dorrance believed it was the right time to leave. He waited a few days before the start of the Chiquita Cup on July 29 to inform the team of his retirement plans. When he told them his decision, players were shocked, and some cried, but Dorrance reassured them he was leaving them in capable hands and that change was required to keep the team viable and fresh.

Although he remained on the bench, it was DiCicco's team when the U.S. defeated top-ranked Germany, China, and Norway for the tournament sweep.

Dorrance's aggressive vision for the team remained intact with DiCicco, but he also knew that someday he would need to find his coaching style and voice.

"It was tough at first," recalls DiCicco. "I took over for a legend, and I had to find my way. I couldn't coach the way he coached—I had to coach my way, and it took me time to sort it all out.

"Anson is the father of women's soccer in America. His philosophy is hell-bent for leather, and I was more tactical. I wanted to keep what he gave the team, but I also wanted us to be more tactical and possession-oriented. I don't think I got it right in '95 but after that . . ."

Notable newcomers in 1994 included twenty-one-year-old midfielder Shannon MacMillan from the University of Portland and a talented alum from DiCicco's SoccerPlus Goalkeeper School, twenty-three-year-old Briana Scurry.

Scurry would become a fixture between the pipes, but what makes her story unique is that she was just the third African American to play for the national team. The first was Kim Crabbe, a forward from

Virginia, who got on Dorrance's radar after her George Mason University team defeated Carolina in an epic 1985 NCAA final.

Impressed by Crabbe's speed and tackling, Dorrance gave her a few national team looks. Though she never capped (that is, played in an international game), she paved the way for future players like Sandi Gordon, who became the first African American to cap for the U.S. in 1987, and then Scurry in 1994. Scurry was arguably the best goalkeeper the national team ever produced, and her rise to the top is an inspiring tale.

14

The Only

In 1961 Ernest Scurry was living with his family in Galveston, Texas, when Hurricane Carla came through and tore up the Gulf Coast. Everything Ernest owned, including his house and furnishings, was gone. Desperate and broke, Ernest left his three kids and wife behind and departed the Jim Crow South for Minneapolis, where a cousin boasted life wasn't as oppressive and work was plentiful.

Scurry lived with his cousin for a year, and with help from the GI Bill, he built himself back up. A series of menial jobs led to employment as a machine operator supervisor. With his earnings, Ernest bought a house and sent for his family. Over time Ernest would remarry, move to the suburbs in Dayton, and have six more children. Briana, the youngest, was born in 1972.

Athletic and gifted, Briana thrived on sports. When she was eight, an event on TV changed her life. She was on the couch with her parents watching the U.S. Hockey team play the Soviet Union at the 1980 Lake Placid Olympics, and for a young girl with Olympic-sized dreams, the "Miracle in Ice" was all that and more. The excitement, pageantry, and youthful vigor of the American players struck a nerve.

It didn't matter the U.S. hockey team was lily white; all Briana focused on was that they were young and inspiring. "I want to be an Olympian," she screamed to her parents. "That's so cool."

Stronger and more athletically gifted for her age than her peers, Briana excelled at every sport. Softball, track, and football were her best, but it was goalie Jim Craig, leading the United States to Olympic

glory, who intrigued her most. Even when she played other sports, she couldn't get the goalie out of her mind.

One day after school she was in her room daydreaming about what Olympic sport she'd be best suited for and what year she'd be ready. It wasn't going to be ice hockey; her parents said it was too dangerous. Doing the math, Briana made her way to her desk, got out a big piece of paper and a marker and figured what Olympic year she would most likely be eligible. She wrote out, "1996 I have a Dream," and pinned it to the wall.

"Every night before I went to bed, I would see that sign," recalls Scurry. "Day after day, week after week, month after month, that sign was there. I remember saying to my parents this is what I want to do. I want to be an Olympian, and they said, 'Yes, you can, honey. Yes, you can.'"

During middle school, Briana was competitive in baseball, basketball, and tackle football. Wary about the physical contact, her parents pulled her from football into boys' soccer, and believing as goalie she would be away from harm, her coach and parents agreed to put her between the pipes.

"They thought it would be the safest place for the only girl on the team to play," recalls Scurry. "As we all know it's the most dangerous position, but I loved it."

As far as racism went, Briana's reputation as an athlete for the most part protected her from schoolyard bigots, but not completely. At her bus stop, some of the white boys could get ugly, but Briana's older sister policed the situation.

"I never had an issue on the pitch of any kind," recalls Scurry." I had not yet grown to 5'8" and was the best athlete in Dayton, so I did have some issues in my personal life and the bus stop, but my sister took care of any problems, and there were never repeat offenders."

As Briana matured, her prowess as an athlete protected her against racial biases. Even though she was the only person of color at her events, she rarely if ever was targeted and everyone was glad she was on their team.

"I was always the only African American in every sport I played, in every league and on every team," explains Scurry. "My first expe-

rience on the boys' team, the boys were very good about it. I think they had more issue with having a girl on their team than they did having an African American girl on their team. But when they saw I could play, then it was something else entirely different, and then they were all for it.

"So it was interesting for me growing up because I've always been 'the only.' My entire youth career and for much of my intermediate career as well. I think the way people perceive me is because I'm quality and athletic, and I have talent. It's almost like color blindness, which isn't necessarily better, it's just different. I think because I was their girl, it was, 'Go Bri, go! You're awesome, you're amazing,' and you're this, and you're that.

"It would be interesting if the shoe were on the other foot and if I wasn't their girl, then maybe it would have been something else. But I never had an issue on the pitch at any time. I've had issues off the pitch in my personal life when I was a twelve-year-old girl trying to catch the bus with all the older boys. There I had problems. They used to call me darkie or chocolate, or something like that, and the next day I'd go home and tell my family, and my sister would handle it, so that was the end of that. She, of course, corrected it, and it was one and done, and it would never happen again."

At Anoka High, Briana won All-State in basketball and track. As a senior in 1989, her soccer team won the state championship, and Briana was named Minnesota's "Best Female Athlete." Upon graduating she received seventy scholarship offers for basketball, soccer, and track. She eventually chose soccer because she felt goalie best exemplified her talents. Briana accepted a partial soccer scholarship to the University of Massachusetts at Amherst on the basis that her family would foot the bill for the remainder of her tuition.

Briana excelled at UMass, and in her junior year, 1993, she was one of the highest-ranked college goaltenders in the nation. Her thirty-seven shutouts in sixty-five starts helped get UMass to the NCAA finals, where they faced Carolina in the semifinals. The Tar Heels prevailed 4–1, but Scurry's competitiveness and presence had impressed the opposition.

"Nice game, keeper," Mia Hamm told Scurry following the match, within sight of Anson Dorrance.

"Thanks," Scurry answered, nodding at Dorrance getting interviewed. "I hope he noticed."

"He did," Hamm replied.

Mia apparently wasn't kidding. Dorrance brought Scurry to the national team camp the following week. "My first camp was brutal," recalls Scurry. "The players were the elite, the best of the best, not just in this country, but in the world. It was a very humbling experience. I'm sure I must have dug the ball out of the back of the net no less than a thousand times that week."

Despite the rocky start, Dorrance stuck with her. A few weeks later, Tony DiCicco invited Scurry to his goalkeeping school in Connecticut. Under DiCicco's guidance, Scurry refined her game and, when she returned to the national team, was named the starting goalie.

"Tony took her raw talent and evolved her into one of the greatest ever," recalls Lauren Gregg. "In Bri's case having a former goalkeeper like Tony as your coach helped tremendously."

According to those close to her, Scurry's thoughtful disposition was in stark contrast to her on-field persona. An intense competitor, Scurry wasn't shy about barking orders at defenders if she felt they were slacking off or weren't listening.

"The team wanted to be the best and recognized Bri was like-minded," adds Gregg. "She worked hard and wanted to win, and that's how you got respect on the national team. If you were moving toward the same goals as everybody else, you were accepted; those who deviated from the greater good didn't survive very long."

According to DiCicco, Scurry had weaknesses, but when compared to other national team goalies he had worked with, he felt Scurry was the best.

"Bri wasn't a great soccer player, but she was a great goalkeeper," says DiCicco. "She wasn't very good with her feet, and we minimized that, but she was a freaking competitor. From Bri, I looked for certain aspects of female goalkeepers like athleticism and mental skills. I can teach technique and tactics. Hope Solo was a great athlete, but Bri was a better athlete, and Bri, like Hope, had unbelievable mental skills.

"Late in the game when you're up a goal, the other team looks like they have four extra players on the field. They're pressing and pushing everybody forward, and it's all helter-skelter. But for Bri, the game slowed down and she got calmer. Late in the game, she made potentially difficult plays look easy, and it calmed her teammates. It was an unbelievable quality to have, especially for a goalkeeper. She was the best in the world for that period. There was no one even close."

In terms of leadership, DiCicco maintains Scurry had a style all her own. She would use her intense persona to help motivate and make sure the players in front of her were all on the same page.

"On the field Bri took charge," says DiCicco. "Carla was in front of her organizing, but Bri was vocally in charge. She would scowl at you if you made a mistake that she thought avoidable, but the players loved her. They knew that she saved them from time to time, and they were happy she played for the USA and not somebody else."

"Bri, like most goalkeepers, was a little bit crazy," adds Shannon MacMillan. "You have to be able to stand in goal and throw your life and limbs at people running full speed at you or trying to take your head off with a shot.

"In my prime, I could kick the snot out of the ball, it would knuckle, and it drove Bri up a wall. If I were hitting free kicks or shooting on her in practice on those rare occasions when one went in, I would always give her my little cackle because you knew if you beat Briana Scurry in a shooting exercise, that's a good day.

"Bri was very private and kept to herself, but was solid. If you had Briana Scurry behind you, it was going to take something phenomenal to beat her. If there happened to be a breakdown defensively, Bri was going to step up. It was that intensity in her, that passion and work ethic that made the difference. She's awesome, and I love her to death."

As a woman of color, Scurry became a beacon to those who viewed her as a role model and unifying force. Although she was not the first African American to cap on the national team, she was by far the most influential.

The first woman of color to don a USA jersey was Kim Crabbe in 1986. The forward from George Mason University first caught the

eye of Anson Dorrance at the 1985 NCAA final match when Mason defeated Carolina for the title. Crabbe was all over the pitch that day and impressed Dorrance with her speed and agility. The coach invited Crabbe to the national camp the following spring, but on a roster loaded with forwards, Crabbe didn't make the cut.

The first African America to cap for the national team was Sandi Gordon, a talented club player from Tacoma, Washington. Dorrance spotted Gordon at the 1987 Olympic Sports Festival in Raleigh. From there Gordon was invited to the national team camp in Blaine and made the squad. On July 9 Gordon made her debut in Sweden at the North American Cup. She would go on to cap seven times the next two years before being cut in July 1988.

Scurry also helped paved the way for other African Americans like Staci Wilson, who was a reserve defender for the U.S. in the Atlanta Olympics in 1996.

The U.S. went 12-1 in 1994, with the only loss against rival Norway, 1–0, at the Algarve Cup in March. All in all the team responded well to DiCicco, who went undefeated after taking over.

But it turns out DiCicco still had a learning curve when it came to coaching women.

The year 1995 was a Women's World Cup year, with the usual pre-tournament buildup and tensions. As defending World Cup Champions, the U.S. team had a lot at stake. DiCicco was about to find out what overcoaching meant and the ramifications it had on himself and his players.

15

Le Passion Play

It was April 11, 1995, U.S. versus Italy, the first match of the Tournoi International Feminin, and for 22 minutes Mia Hamm and Tony DiCicco had been jawboning. Thus far, it had been all team USA. Goals by Akers, Tisha Venturini, and Carin Jennings had them up 3–0, but the score was incidental to what was happening on the sidelines. DiCicco had been barking orders all game. Finally, Hamm had enough.

"You got to shut up and let us play!" she cried. "You're overcoaching."

"Your mark got by you," DiCicco fired back. "Let's get going!"

The barbs continued into the half and carried over into the locker room. Hamm headed straight to DiCicco's office, and players outside could hear swearing and screaming. Neither backed down, and it was escalating, going from bad to worse. When DiCicco threatened to bench her for the second half, Carla Overbeck decided she'd better step in and stop it.

"I was like, 'What the heck's going on here?' I heard shouting and yelling, and Mia crying. I knew she had a fiery personality and Tony's Italian, and he can get upset too. So finally I got between them. I was like, 'Whoa, whoa, whoa, we're all on the same team here.' Eventually, they hugged it out, there were no grudges, or so it seemed, and Mia went back in the second half, and things were fine."

But everything wasn't fine. DiCicco crossed the line. He had just alienated his top scorer and was in danger of losing the team's respect.

"I was mad and had no intention of leaving Mia in the game,"

recalls DiCicco. "But Carla came over and calmly said, 'I know you guys had a thing, but trust me, we need Mia in the game.'

"And so I left her in the game, and it was all because of Carla's leadership. I had unbelievable respect for Carla. She was our number one leader on that team. I said, 'Okay, Carla, I'll keep Mia in, but she and I are gonna have to talk.'

"We had another game in two days, and I had a policy of meeting individually with all the players between matches. Now, I'm dreading this meeting, and Mia's dreading this meeting. But I had played this thing over in my mind a hundred times, and I kept coming up with this terrible conclusion that I was wrong and she was right, I was overcoaching.

"She came into the room, and I said, 'Mia, we have to talk.'

"She goes, 'I know, and I'm sorry for what happened.'

"I said, 'I'm sorry too, but I need to say this. I think you were right and I was wrong.'

"Mia's attitude immediately changed, and I discovered if you validate how players feel, that's a powerful thing. So we talked a little bit more and went over the game plan. Then she went out and scored a hat trick and had a couple of good assists.

"After the game, the staff and I went out for a beer, and they're all coming up to me, 'What did you say to Mia? What did you say to her?'

"I said, 'I told her I thought she was right.'

"After that, Mia wanted to play for me, and I loved coaching her. It wasn't always easy because she was hard on herself. If she came off the field and didn't think she played well and you went up to her and said, 'Good game,' she'd be angry with you because she thought you weren't honest with her.

"So you had to protect Mia. One time she had gone seven international games without scoring a goal. The press was really on her because that's a lot of matches for Mia not to make a goal.

"I go, 'Mia, I have no problem, you're going to score goals. Right now you're creating penalty kicks for us and getting assists. Just go out and enjoy the game and play the game you love.'

"A game or two later, she scored a goal against Japan, and if you

saw her, it was like taking the monkey off her back. She was brand new again."

As far as leadership, DiCicco maintains Hamm had her own way of influencing the team, and it wasn't only her on-field play that inspired, but her off-field demeanor also.

"Mia was a fantastic team player because she was the number one player in the world, and the team looked up to her," says DiCicco. "But when the media asked Mia, 'What's it like to be the best player in the world?' Mia would answer: 'I'm not the best player in the world. If I could compete like Michelle Akers, or run all day like Kristine Lilly, or I could lead the team like Julie Foudy and Carla Overbeck, then maybe I'd be the best player in the world. But I can't. When I play, I'm on the best team in the world.'

"Now from a coaching standpoint, you can't pay for that kind of leadership. Because whenever a young stud came onto the team, they understood the team's philosophy was the number one star's position. For Mia the team was always number one, and she put herself below that somewhere. And that is unbelievable leadership.

"Mia was out in front of the wedge. The media always wanted to speak with her, the fans always wanted her autograph. She didn't enjoy that or want all the notoriety. She just wanted to play the game she loved. Mia was the media darling and had to do deal with all their demands, but she led from that place of team first and let her teammates support her when she needed it."

For their 1995 World Cup buildup, the national team went 12-2, but in their only match against Norway at the Algarve Cup, they lost in penalty kicks. As defending world champions, the U.S. ranked number one seed. Still, other teams had improved since 1991, including Norway, who'd be out to redeem themselves from their devastating loss against the U.S. at the championship final.

DiCicco knew he had his work cut out for him. He kept Dorrance's aggressive, 4-4-3 attack mode offense intact but shuffled Michelle Akers to midfield to take some of the pressure off her. She hadn't been feeling well, and her energy was off. It was worrisome, because without Akers at full speed, the team knew anything could happen.

16

"Michelle, Get Up"

By the time the national team arrived in Sweden for the 1995 World Cup, they were no longer starry-eyed kids just happy to be there. Much changed since the M&M's Cup in China. The hundred or so or so family and friends who had watched them play at high school pitches swelled to four thousand to six thousand fans in major venues all over the country. Match by match, interview by interview, and autograph by autograph, the national team had constructed a fan base. Fan interest in the national team was growing, and no one marked the team's emergence better than Mia Hamm.

Every successful sports franchise needs a face. The national team discovered theirs in Dallas on May 19, 1995. On that day, Hamm was greeted by thousands of high-pitched adolescents all screaming, "Miaaaa, Miaaaaa." Their cries permeated Franklin Stadium, where six thousand gathered to watch the United States play Canada. But the kids in the crowd were there to see Mia. Her down-to-earth demeanor and wholesome beauty appealed to them, and to top it off, she had world-class talent and charisma.

A face had emerged, a face to launch a thousand screams. To her credit, Mia embraced the attention; she didn't shy away because she knew it's a faster road to legitimacy, acceptance, and respect for her team. Mia was more concerned about the team than herself. The newfound fame was a distraction, but she wasn't going to let it interfere with the task at hand and growth of the game.

In June when the national team arrived in Sweden for the World

Cup, the foreign crowds hadn't caught on to Mia Mania yet. She was an American entity for now.

Day 1, USA vs. China, June 6, Strömvallen, Gävle, Sweden

The atmosphere in Sweden was far different from the World Cup in China four years earlier. For one, the tournament hadn't been publicized, and the event was low key. Venues were on the small side, ranging from high school pitches to midsized stadiums scattered over the country, which made for some logistical nightmares. Teams traveled by train to sparse crowds. Only 112,000 tickets were sold for the entire tournament. The event was initially scheduled for Bulgaria to host, but the country pulled out at the last minute, and Sweden became the benefactor.

The tournament featured twelve national teams from six continental federations, three groups of four teams. The United States played in group C, which included China, Denmark, and Australia. The U.S. faced China first, and the match set the tone for the remainder of the tournament.

Eighteen minutes into the match, China fired a corner kick, a looping line drive in front of the U.S. goal. Fan Yunjie and Michelle Akers rose together, but as they went up their heads collided. Yunjie, posted slightly behind Akers, inadvertently speared her in the back of her skull with her forehead.

As Akers fell, her right knee twisted awkwardly beneath her body. She was unconscious before she even hit the ground. As she lay there like a crumpled sack, an eerie silence permeated Strömvallen Stadium. The reaction was visceral; players and fans were visibly concerned. Akers was down for the count, and all anybody could do is pray she gets up. From the bench, substitute forward Tiffeny Milbrett echoes the sentiment.

"Get up, Michelle, get up, please get up," she says, and then repeats it several times, "Michelle, get up."

Milbrett is aware, like everyone else on the team, without their workhorse in the mix they're in big trouble,

But Michelle doesn't get up. It's the opening minutes in the first match of the 1995 World Cup, and Akers the Lionhearted is still down.

Someone calls for a stretcher, but Akers stumbles to her feet, and shrugs it off. She'll limp away on her own, thank you. Departing the field, Akers flashes the thumbs-up sign to her concerned stepmom in the stands. In walking off, she sends a message, instilling hope to her beleaguered teammates. She's subtlety telling them they will need to carry on without her. Akers instinctively leads by example. She doesn't need the captain's armband. She's a walking embodiment of one.

"Milbrett! Warm up!"

Suddenly a voice—it's Tony DiCicco, letting his team know the match goes on. Milbrett is DiCicco's choice to replace the franchise, and it proves to be a good one. Her unorthodox play, defined by an uncanny skill set, is uncanny but effective. Her ability to race through defenders like they were practice cones was unique, leaving friend and foe equally impressed.

As a young girl, born and raised in rural Oregon, Tiff tagged along at her mom's adult club soccer matches. Sometimes mom would slip Tiff into the game and have her play forward, while she defended. When she was eight, Tiff caught the eye of the legendary coach Clive Charles, who smoothed out Tiff's rough edges. Charles brought her to the University of Portland and turned her into one of the nation's top scorers. Eventually, she slipped onto the radar of Anson Dorrance, who in 1991 brought her into the national team fold for a look-see, but the two didn't mesh, and Tiff languished. It would take four seasons with the U-20s and a new national team head coach before she finally broke through.

Milbrett shunned the playbook. She preferred intuition. Even Tiff wasn't sure where she was going when she got the ball, which spelled trouble for opposing defenders.

At 5'2" Tiff was a giant in waiting. If Akers was Mustafa, then Milbrett was the Tasmanian Devil, small in stature but big in heart and a little bit crazy.

But Tiff was unproven in big matches. She had started in ten of the national team's twenty-one games so far in 1995, usually spelling Akers or Jennings-Gabarra later in the game. She was not expected in the match against China until maybe the second half. But with Akers done, DiCicco needs someone who can supply instant offense.

"I remember a mix of emotions at the time," recalls Milbrett, "First and foremost, I'm thinking, 'Michelle, get up, get up, get up.' What's most important is to win the World Cup, and we need to have Michelle healthy to do that.

"I was just hoping she was okay. I never want to go into a game because somebody gets injured, but on the same vein, I'm there, I've been preparing. I can't say I was exceptionally nervous when Tony called me to start warming up, like, 'Oh my gosh,' but then I go in and I'm like, 'Okay, it's my turn, I'm ready to go,' and it all starts from there."

It takes a moment for the team to adjust without Akers, but at minute 22 they strike back. Tisha Venturini fires a shot into the back of the net from the left side, and it's 1–0, U.S. Twelve minutes later Milbrett makes DiCicco look like a genius when she scoots by two Chinese defenders, fires the ball past the goalie, Zhong Honglian, and its 2–0, U.S. Afterward, Milbrett cracked a little grin. "The ball went near post, and I beat her near post, but I was aiming far post."

The U.S. can't afford to rest on their laurels. China is relentless. Four minutes later Wang Liping answers with a goal of her own, making it 2–1, and it remains there for the rest of the half.

At minute 52, Mia Hamm scores, giving her fan base back home something to scream "Miaaaa" about, and its 3–1 USA. The question is, can the national team finish strong? The answer is unequivocally no. Wei Haiying and Sun Wen score in minutes 74 and 79, tying the game. The U.S. makes the cardinal sin of letting an opponent score in the last five minutes of a match. DiCicco isn't happy. It's a lack of concentration on his players' part.

The game ends in a tie, but it could have been a whole lot worse. The U.S. survived without Akers, and Milbrett stepped in like a pro, proving her mettle. But ties don't win World Cups. To move on to the knockout round, the U.S. will need to play better.

Day 2

It's been twenty-four hours since Akers passed out in her hospital room. Her concussion, medication for chronic fatigue syndrome, and sore knee have all taken a toll. She awakes surrounded by stuffed animals and dozens of notes from teammates expressing their admi-

ration and encouragement—Mustafa tears up but not for too long. There's still work to do, and her team needs her. The central drama of the tournament for the U.S. anyway, is just how fast Michelle Akers can return to the pitch.

Amanda Cromwell, her roommate, teammate, and consummate best friend, is determined to help Michelle get back on her feet, but Akers was as incoherent as a practice cone. The typical conversation went like this: "Hey Amanda, are we playing Denmark today? . . . Oh, that's tomorrow . . . What's that? How bad is the head? Oh, it's just a concussion . . . The knee? An MCL, I think . . . How many times now? I don't know. I've lost count . . . Amanda, do you have anything to eat with sugar in it?"

Cromwell and the doctor take Akers outside for a twenty-minute walk. The doc tries to get some food into her to no avail. Michelle is forgetful and has little appetite. Exhausted, she forsakes the team workout and rests for the remainder of the day.

Day 3, USA vs. Denmark

The morning of the Denmark match, Akers is back at the hospital for a precautionary cat scan. Nothing bad to report, but her right knee bothers her. "Push through it, "the doctor says, "Playing through the pain is the best medicine."

Akers attempts a series of straight-ahead sprints. The goal is to be ready for the quarterfinal the following Tuesday. But first her teammates need to get through Denmark. Akers won't play against the Danes but will suit up and sit on the sidelines. Upon her arrival, she is astonished to find everybody's written "Mustafa" or "#10" on their sock tape. Akers is grateful to be wearing sunglasses to hide her tears.

For the pregame team huddle, Carla Overbeck gathers the troops near the side of the pitch. "If you get tired out there today, or feel like giving up, I want you to look at the bench and see Michelle," Overbeck tells them. "She never gives up, and we won't either. We play for each other from this moment forward, OOSSAAA."

There are more tears from Akers, even more grateful for the sunglasses.

The U.S. has an easier time with the Danes than China. In the

ninth minute, Kristine Lilly gets the U.S. on the boards with her first goal of the tournament. Forty minutes later it's Tiff Milbrett, stepping up again, to make it 2–0. As the team mobs Tiff, Akers nods in silent approval.

For the second half, DiCicco rests his starters. Thori Staples subs in for Linda Hamilton, and Debbie Keller replaces Milbrett. In minute 75, Sara Rafanelli comes in for Carin Jennings Gabarra.

It's 2–0, and the national team is coasting, when the unthinkable happens. Briana Scurry retrieves s a garden-variety loose ball and punts it downfield, a play she's made a thousand times, but on this occasion she inadvertently crosses the end line of the penalty box. Usually this is a marginal infraction, but the referee flips a red card, resulting in Scurry's ejection and an automatic two-game suspension.

DiCicco was furious. "It's a handball, if anything," he screams, but his pleas fall flat. Scurry is out, and the U.S. must finish the match with just ten players. Even worse, the U.S. is without a goalkeeper. Backups Saskia Weber and Mary Harvey are available, but the three-substitution rule means they'll have to remain on the bench. While DiCicco sorts it out, coaching staff member April Heinrichs calls Mia Hamm to the sidelines. Placing a reassuring arm on her shoulders, Heinrichs explains. "Mia, we've used all our substitutes, and we're going to put you in goal. How do you feel about that?"

"What about a real goalkeeper?" replies the beleaguered Hamm.

Heinrichs hands her Scurry's gloves and jersey. "We've used all our subs, Mia."

Up until now, Hamm's experience in goal has been playing around in practice. While Hamm slips on the jersey, five sizes too big, Heinrichs assists with the gloves. As she jogs back onto the pitch, Hamm comes to the realization that the goal is much smaller from the outside looking in than it is from the inside looking out. Mia suddenly had a new respect for goalkeepers.

Denmark is allotted a penalty kick from twenty-five yards out. Looking like a toddler in a potato sack, Hamm takes her place behind a nervous wall of U.S. defenders. Denmark's Kamma Flaeng, well known for a lethal right foot, will attempt the kick. The referee blows

her whistle, but Hamm is buried too far back in goal to see the strike. All Flaeng has to do is put the ball on frame, and it's 2–1.

Flaeng steps in, and strikes, and there is sudden movement all around. Hamm does her best to concentrate, but the kick is high, and the ball sails over the crossbar and into the stands, Hamm dodges a bullet, literally.

Mia handles two more balls with relative ease, and when the game ends, she stoically makes her way toward her jubilant teammates. Of course, it's just a matter of minutes before jokes emerge, with the best line going to Carla Overbeck.

"Hey Mia, I was pretty much confident with you back there until I turned around, and you looked about the size of a peanut back there," Overbeck says. Mia cracks a half-smile and quickly returns the goalie gear to Scurry.

Day 4

For the next round, the U.S. faces Australia at Olympia Stadion in Helsingborg. The venue, located at the far southern end of the country, means an early checkout time and nine-hour train ride. It's going to be a long day, and Kristine Lilly is ready for some hijinks. At the depot in Gävle, Lil asks Akers if she can hold her bag while Lil uses the bathroom. Akers obliges, Lilly hangs the bag on her shoulder and scampers off. Julie Foudy approaches with a similar request, and Michelle obliges. A parade of players follows until everyone on the team has draped their bag around Akers, who looks like a human luggage rack. It's the players' way of showing their love and affection. Akers will go to war for them and they know it. The bag joke is their way of saying how much they respect and appreciate her.

Day 5, USA vs. Australia

China and the national team are tied in the standings. That means the team with the most total points scored will win their group. China is currently ahead in the total goal count, so depending on what China does, the U.S. will probably need to beat Australia by at least four goals. China, meanwhile, will be playing Denmark, and DiCicco will

receive minute-by-minute accounts of their game by phone and in turn provide scoring updates for his players.

The Matildas score first on a goal by Lisa Casagrande in the 54th minute. The match remains 1–0 until the 69th minute, when DiCicco begins subbing starters he's been resting into the game.

"I didn't start Foudy because we played our first two games up in Stockholm, and there was an airline strike," says DiCicco. "We had a nine-hour train ride to Helsingborg, which is on the southern end of the country, and I wanted to shorten some of the minutes for some of the players.

"Anyway, we go down the second half, 1–0, Julie's warming up, and I'm trying to get her into the game. She's cheerleading on the sideline, and I'm yelling for her to go in, but she can't hear me. Finally, I get her attention; she comes in the game and scores the tying goal. That's Foudy.

"She was another player we needed on the field. She wasn't fast but could cruise the midfield at a high rate and covered a lot of ground. She wasn't a great scorer, but she scored great goals for the U.S., plus she kept everyone light off the field.

"You couldn't help but smile when Julie was around; her personality was contagious, and she'd say anything. But on the field, she was a vocal leader, the type of player who would rally the troops during the game. That's why I put her in when I did. She was vital to the team. I had to have her on the field."

Meanwhile, the minutes are ticking down, and a nervous DiCicco is relaying China's goal count to his players, letting them know where they stand. With 18 minutes remaining Joy Fawcett scores, putting the U.S. ahead, 2–1. Up in Gävle, China maintains a 2–1 lead. The U.S. will need two more goals to win their group. A penalty kick by Overbeck in extra time makes it 3–1, but they're still short a goal. Then in the 5th minute of extra time, at the 95-minute mark, Debbie Keller slips one past the Australian goalie, making it 4–1. Somehow the U.S. pulls it off and will play Japan in the quarterfinals instead of powerhouse Sweden.

Day 6

At the press conference the following day, the scribes probe DiCicco incessantly, "Will Akers play? Will she be ready for Norway?"

DiCicco says Akers will be on the bench for Japan, and he is inclined to save her for Norway. But whenever she plays, it won't be at full capacity. Chronic fatigue syndrome robs its prey of energy, but Akers won't play the victim. It anything, she becomes more resolute. The day before the Japan match, Akers is seen with Amanda Cromwell passing a ball on the hotel grass. She's sluggish but insists she'll be ready for the semifinal.

Day 7, USA vs. Japan

The national team is back in Gävle, where 3,756 fans have gathered to see them play Japan. A brace of goals by Kristine Lilly and solo goals by Milbrett and Venturini produce a 4–0 win. Japan's elimination paves the way for the highly anticipated semifinal match against Norway in Vasteras. For the tournament so far, the U.S. has outscored their opponents, 10–1, which means nothing to Norway, which will be the best team to play against the U.S. thus far.

Day 9, USA vs. Norway

The morning of the match, Akers expresses her innermost thoughts in her journal.

"I start tonight, and for the first time, I'm terrified to play. I don't know what I'll be able to do. My knee is sore from only thirty moments of light running yesterday. What will it be like after an intense forty-five? Tony says he doesn't expect me to 'fly in and rescue the team,' but I think a lot of people do. I just want to make a small difference. That's a lie. I want to make a huge difference. I want to score goals, to be a threat, to be the best player out on the field. And it's killing me knowing I won't be."

The diary is a blueprint for the match. Not only is Norway technically superior, but they also have several world-class headers, strikers, and defenders who all are well coached. The six-foot Ann Kristin Aar-

ones is currently the tournament leader in goals. DiCicco implores his players to mark her closely and not to let her roam free near the goal.

Marking Aarones proves to be a tall order. Ten minutes into the match she shirks her defenders long enough to head a pass in front of the goal past Scurry and into the back of the USA net for the only score of the match.

Try as they might, the U.S. can't penetrate Norway's' stonewall defense. Only in the last few minutes, when Norway is down a player because of yellow cards, can the U.S. muster any semblance of an attack. A flurry of attempts follows, the most noteworthy by Joy Fawcett, who kisses the crossbar bar twice.

Akers plays the entire match but is sluggish and ineffective. Having Milbrett start might have helped, but what the national team lacked was power up top. Someone like a Shannon MacMillan and her powerful right leg would have been the ideal replacement for Akers, but sadly Shannon was cut just before the tournament.

Another player they could have used was Brandi Chastain. Cut two years earlier by Anson Dorrance, Brandi might have supplied the needed spark the U.S. was lacking.

It's easy to second-guess, but who would have imagined losing Akers for almost the entire tournament? But it takes foresight to win World Cups. The lesson learned by DiCicco was that he would never again rely on only one player to win a major tournament.

Following the match, the Norwegians celebrated like they usually did, with a celebratory wormlike crawl, with everyone on their knees, hands on each other's shoulders, screaming incoherently. The U.S. National Team took the "in their face" gesture personally.

"Remember how you feel, ladies," Heinrichs told the team as they watched the elaborate display. "Remember how you feel!"

Tears flowed, but Akers remained steadfast. She refused to let the "Viking Bitches" see her weep. Instead, she filed the memory, vowing to meet again someday.

DiCicco later reflected on the lessons learned from the tournament. "My players didn't blame me for coaching bad, and I don't think I coached great in the semifinal. But they didn't blame me and

didn't blame Mia Hamm, the most prolific scorer at that time, for not scoring in a 1–0 loss. They didn't blame Briana Scurry for getting beat on a head ball by a 6'3" Viking woman, Kristin Aarones. Instead, they looked internally and told themselves, 'I should have been better, and I could have been better, and I will be better for the Olympics next year.'"

Critics have analyzed the match to extremes, but at the end of the day, Norway was probably the better team. The two crossbar kisses by Fawcett late in the game may have been a way of saying it was Norway's time.

One thing is certain; right or wrong, the agonizing Norwegian victory crawl following the match had a lasting effect. "Norway did not do the Worm to humiliate the USA," says DiCicco. "It was a team-building exercise they had done leading up to the World Cup and in their exhilaration of winning decided to go with it.

"Our team however, took the crawl as an in-your-face gesture of humiliation. I never corrected the players because I loved the motivation my team got from it. When I was doing fitness, and they were hurting, and somebody would say, 'Remember Norway!' Their body posture would change, and they'd go after it again."

When Mia Hamm and Tisha Venturini shared a condo at their Olympic residency camp in Florida the following year, they posted a photo of the Norwegian worm crawl by the front door. Each morning, on their way to practice, they made a point to pound the image with their fist. DiCicco was right. "Beating Norway" became their rallying cry for the 1996 Olympics, and it fed their fury.

DiCicco took a lot of heat for not winning the 1995 tournament. He had been expected to win the World Cup, and there was already talk of a new coach. Fortunately, the captains had his back.

"We met with Tony and told him we think you're the right guy to coach our team," says Carla Overbeck. "We had full trust in his capabilities, and if he changed our style, we'd make sure the team responds in the way that we're responding."

DiCicco did some soul searching and came to the realization that in his zeal to match up to his predecessor he overcoached. "Carla later

told me we didn't peak at the World Cup because we had done too much traveling and we were at residency too long," says DiCicco. "I learned that a four-week residency was the limit. Players need breaks to reconnect with their boyfriends and families. We adjusted going forward largely on Carla's feedback to me."

DiCicco understood that to continue winning the team must improve and make subtle changes. He moved Lilly off the flank into an attacking midfield spot and switched Akers from center-forward and into the number six position, basically a holding midfielder. He reconfigured the backline, doing away with the sweeper and replacing that position with a three-back flat zone.

"He eliminated my position," recalls Overbeck. "I never played anything but sweeper, but teams were doing away with the position. For Tony to change our system took guts, but he had the insight and courage to do that with this group."

DiCicco added Brandi Chastain and turned her into a defender. It would be players like Chastain, written off by Dorrance, who helped make up the deficits.

"I would have Brandi Chastain and Joy Fawcett on either flank, and they were goal scorers," says DiCicco. "The players responded positively to the changes, and we played some of our best soccer ever between '96 and '99."

The resurrection of Brandi Chastain is a story unto itself. She hadn't played for the national team since 1993, when Anson Dorrance unceremoniously cut her, and she wanted back on the team in the worst way. Perseverance would be the best word to describe her journey. Chastain was determined to prove her critics wrong, but most of all prove to herself that she was good enough to play on the national team. She only needed a second chance.

17

Perseverance

Brandi Chastain's road back to the national team started in a bar-restaurant in Salt Lake City. She was in a booth with some of her club teammates watching her friends lose to Norway in the 1995 World Cup semifinal. Brandi swore when Norway scored in the 11th minute and then cursed even louder when the Norwegians celebrated their win by crawling around the pitch, inked up like a giant worm.

"Utah was a dry state," recalls Chastain. "There were no drinks in the bar, and it probably would have been easier if there were drinks. I felt I belonged on the team, but that wasn't the worst of it. I care about people, and when I saw my former teammates having hardships, it hurt me, too."

At the time Brandi wasn't sure about her future or resigned to the fact she wouldn't be on the national team again. She was in limbo and didn't know if she would ever be back; she just knew she wanted to be back.

Before the tournament began, Chastain called DiCicco and asked for a chance to return. He said he appreciated the call, but the team had been set, and she should stay in touch. Strangely, the conversation left Brandi with some hope, and when the team returned from Sweden, she tried again. She told DiCicco she had watched the team lose to Norway and felt she could have helped. Tony said he was in the process of retooling and reminded her about her fitness but said he would keep her in mind.

Fitness had been a sore spot for Brandi since her college days at Santa Clara. It was why her coach, Jerry Smith, almost cut her as a

sophomore. It was also the reason Anson Dorrance tossed her from the national team in 1993. Brandi admits that when it came to her fitness, she could be stubborn.

"Was my fitness the priority at the time? Absolutely not," says Chastain. "I fancied myself a soccer player first and then a runner. But running was a necessary part of the job, and I wasn't as good at it as other people. There's a mental capacity to handle the work, and it was not my strength."

DiCicco had given Brandi a hint of hope, and following their conversation, she went to work. Determined to change her abysmal fitness perception, Chastain filled her days with sprints, sit-ups, and weights. If DiCicco was seriously considering taking her back, she needed to be ready if he called.

In some ways, Chastain had prepared for this moment. Since being cut she had played in Japan, had stayed busy with club teams, and was a more sophisticated player. All she needed was a break.

The 1996 Summer Olympics were coming to Atlanta, and for the first time women's soccer would be included. The national team was at war with U.S. Soccer over pay and conditions. A lot was riding on the Olympic advertising revenue, and the players finally had some leverage. After weeks of debate, they decided to strike.

Believing they could bring in lesser players and stay competitive, U.S. Soccer initiated plans to draft an alternate team. They looked down the list of qualified players, and one of those was Chastain.

"I told U.S. Soccer I was in solidarity with the players and would strike for a better contract," says Chastain. "Then I got a call from Tony inviting me to camp.

"Now it was like, Oh crap. The soccer player in me wanted to go, but my heart was with the players. I kept telling myself to strike, but another voice was saying this could be my only chance to be on the national team. What happens if I don't go?"

Unsure, Chastain called co-captain Julie Foudy. "I'm standing by you, Julie, but I've been invited to camp, and this might be my only chance to get back on the national team," Chastain said.

"Then you have to go," Foudy told her.

"But I'm with you—"

"No . . . not now. But you will be. Go in and show Tony that you deserve to be on this team. Let us do the busy work, you do the fieldwork."

Chastain was impressed with how Foudy handled it. "She recognized two things," says Brandi. "One, you have to give power to those people who need it and show your support for those people, and two, you never put yourself above any player. Julie never said, 'Brandi, you're going to strike, and you have to stand with us.' She understood that having me on the team was more important than me striking. Julie's faith in me gave me confidence. I promised her I would be the best player I'd ever been and the best player in camp, and I was."

DiCicco and the captains understood the pay dispute was significant, but for them to hold a grudge against Brandi for trying to earn her way back in would have been petty.

"They moved on without creating drama where there didn't need to be any," recalls DiCicco. "By accepting Brandi, we became closer as a team. Would that have been possible if they didn't already know Brandi from earlier roles on the team? Hard to speculate, but I do know it was never a factor once the team reassembled."

Brandi excelled on the replacement team, but she still had to prove herself with the regular squad. When the strike ended in January, DiCicco moved the team to a new camp in Florida. This time he would have his starters. Of the twenty-six players invited, eighteen would make the Olympic roster.

Brandi competed hard and gave the starters more than they could handle. Impressed, DiCicco offered her a spot on the roster, but with a caveat. "Tony said he wanted to change the team's style," Chastain says. "We were no longer going to be a team of offensive destroyers: we were going to play differently, and he wanted me on the team. When he said that, my heart rate doubled; then he added, 'But not as a forward—as a defender,' and my heart rate almost stopped.

"Two thoughts rolled around my head. First and foremost, I was a forward. It's where I wanted to play and where I should play. My next thought was based more on reality. How badly do I want to be on this team?"

Chastain had a striker's mentality. She loved the exhilaration of

charging the net. She jokes she would have had more goals than Mia Hamm had she remained a forward, but never had the chance.

"When Tony said 'defender' I didn't get it at first," says Chastain. "It was like, what the hell are you saying? When I was growing up, my philosophy was, when I don't have the ball, somebody better get me the ball. I never defended and didn't know how to adjust."

Chastain had to accept the new assignment, or she wasn't going to make the team. She had to learn to play defense, or her soccer career was over.

With the Olympics a few months away, Chastain turned to the only person with the knowledge and understanding to help her fast— boyfriend turned husband, Santa Clara coach Jerry Smith.

"Jerry challenged me in ways coaches had never done," says Chastain. "It wasn't just Xs and Os with him. It was the nuances and the subtle looks, the change of pace, the texture on the ball, and the timing of a step or a lob. He taught me the specific proactive communication that made it all make sense for me. He forced me to see soccer in a way I never had before. I have Jerry to thank for my success. He and Tony made it possible for me to continue with my career, and I love them both dearly for it."

Chastain's efforts paid off. During the team's final residency camp in Orlando, DiCicco notified Brandi that she had made the team as a defender. Nothing symbolized the moment better than the day she arrived at the makeshift storage shed in Orlando serving as their locker room and saw the stack of men's XXL Olympic T-shirts on the table. It didn't matter that her shirt was ten sizes too big. It was a tailor-made validation. When Chastain put on her jersey, a calm swept over her. She was back with her sisters, competing again at the highest level, for a new coach who valued her.

Brandi looked around the makeshift locker room. Julie Foudy, as usual, was center stage, trying to sing and make everybody laugh. Over to one side, Michelle Akers, with her towering mop of blonde curls, was talking smack with their salty-tongued captain, Carla Overbeck. In the far corner, Mia Hamm was doing imitations and laughing it up with a cluster of players. There was Shannon MacMillan, sitting alone with her thoughts, and the quiet Joy Fawcett, reading a

newspaper. On the floor, goalie Briana Scurry was doing stretches, listening to her Walkman. Over by the door, rookies Cindy Parlow and Staci Wilson were looking a little unsure of themselves.

Brandi was just like them in a way: a rookie with something to prove. The difference, underneath her oversized Olympic T-shirt, was a seasoned vet with a body chiseled by thousands of sit-ups, wind sprints, and weights. For a player who once shunned fitness like the plague, Chastain had come into camp determined to make a difference.

Chastain recalls this period when she talks about adversity. "You have to be open-minded because you never know when someone is going to say, 'Hey, you may be a left-wing, but you're going to be a right-back from now on.' I didn't realize at the time that it was Tony's second gift to me. It changed my approach to soccer and helped me realize my dream."

It turns out Chastain wasn't the only former player struggling for second life. Not unlike Brandi, Shannon MacMillan had been cut and was fighting to get back. DiCicco had challenged Mac on her conditioning, and she was determined to prove him wrong. No one knew it at the time, but DiCicco's decision on Shannon would have ramifications for the team going forward. The question was, would she get the opportunity to prove she belonged?

1. A true maverick in every sense of the word, Emily Pickering personified early national teams with her aggressive play and leadership. Michelle Akers said that Pickering's competitive spirit raised the bar for others to follow.
Courtesy of Emily Pickering.

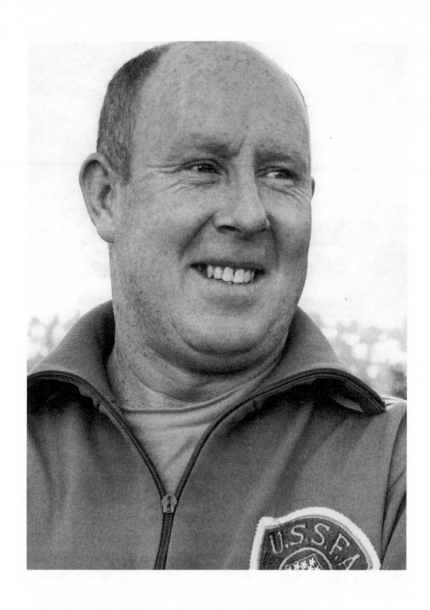

2. To coach the first national team the USSF chose Irish expatriate Mike Ryan, whose Seattle-based club teams dominated women's soccer in the 1980s. Courtesy of the author.

Anno III N. 10 - Agosto 1985
Mensile della Federazione Italiana Giuoco Calcio Femminile
L. 2.500

Mundialito Femminile '85

3. For their first match in August 1985, at the Mundialito Cup, the national team
took on host country Italy. Unfamiliar with the aggressive European style
of play, the U.S. lost. This is the original tournament program.
Courtesy of Emily Pickering.

VP, Fed of US

Chuck Blazer

South	Kim	Wyant	— UCF
South	Michele	Akers	— UCF Washington
North	Ruth	Harker	— UMSL
North	Linda	Gancitano	— UCF
West	Denise	Bender	— Wash
West	Kathy	Ridgewell	— Wash
West	Denise	Boyar	— Wash
South	Stacey	Enos	— UNC
South	Emily	Pickering	— UNC
West	Lori	Henry	— Wash
East	Ann	Olson	— Va
East	Tala	Buckley	— UConn
East	Pam	Baughman	— George Mason
West	Lori	Bylan	— West
West	Sharon	Riemer	— West
West	Cindy	Gordon	— West
West	(Lucka) Margaret	Healy	— California

Roger Rogers — General Psychology alabama

Mike Ryan — (W N S) private school

4. & 5. The hastily constructed national team included several West Regional players picked by Mike Ryan. East Regional players were chosen by an assistant coach, Roger Rogers. Emily Pickering's mother tracked the national team's schedule, hotels, roster, and scores. These are her handwritten notes from the period. Because of the Italian siesta, matches were played at night, the majority starting at 9:00 p.m. Courtesy of Emily Pickering.

Hotel Le Caravelle *Alitalia* via Leventina
170 Jesolo
Tel 0421 / 961482

Italy 1-0					
Den. 2-0	8/18/85	Jesolo	6 p.	Italy vs. USA	
	8/19	Caorle	9p	Eng v. Denmark	
2-2	8/20	Jesolo	9 p	Italy v. England	
2-2	8/21	Jesolo	9 p.	USA v. Denmark	
Italy 1-0	8/22	Caorle	9 P.	Italy v. Denmark	
Eng. 3-2	8/23	Caorle	9 P.	USA v. England	
USA vs Den. 0-1	8/24	Jesolo	9p.	Final 3 vs 4	
Eng vs Italy 3-2	8/25	Caorle	9p.	Final 1 vs 2	

6. Mike Ryan's tenure with the national team lasted only one tournament. Waiting in the wings was Anson Dorrance, whose University of North Carolina women's team dominated the collegiate ranks. Jarrett Campbell, CC Attribution 2.0 Generic, https://creativecommons.org/licenses/by/2.0/deed.en, via Wikimedia Commons.

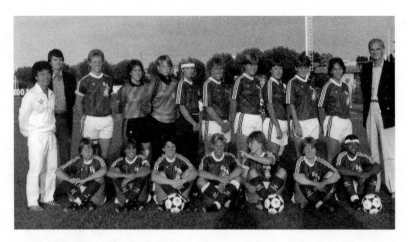

7. The national team returned to Italy for the Mundialito Cup in 1986, winning the tournament. Notables included Michelle Akers from Central Florida, captain April Heinrichs from UNC, and the team's first African American, George Mason's Kim Crabbe. *Back row left to right*: Anson Dorrance, Michelle Akers, Gretchen Gregg, Janine Szpara, Joni Dunlop, Betsy Drambour, Chris Tomek, Marcia McDermott, Debbie Belkin, Ann Orrison, Roger Rogers. *Front row, left to right*: Hank Leung, Stacey Enos, Emily Pickering, April Heinrichs, Lisa Gmitter, Lori Henry, Cindi Gordon, Kim Crabbe. Courtesy of Emily Pickering.

8. Emily Pickering, April Heinrichs (with bubbled water), Lisa Gmitter, and Chris Tomek relax at halftime during a match at the national team's second Mundialito Cup in 1986. With her no-holds-barred style, Heinrichs would become the prototype of the next-generation national team player.
Courtesy of Emily Pickering.

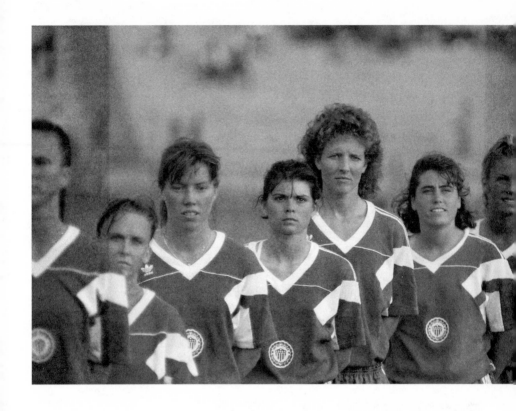

9. The national team gathers in war-torn Port-au-Prince, Haiti, for the 1991 CONACAFF qualifiers. The U.S. won the tournament, earning the right to play in the first Women's World Championships played later in the year in China. *Left to right*: Brandi Chastain, Tracey Bates, Amanda Cromwell, Mia Hamm, Michelle Akers, Julie Foudy, Carin Jennings-Gabarra. Photo by Tony Quinn.

10. The national team's first trip to China was in August 1991. Here, Julie Foudy, Amanda Cromwell, and Wendy Gebauer gather at the Great Wall. The Tony DiCicco Collection.

11. The national team tours China, August 1991. Mia Hamm, Michelle Akers, and Carin Jennings-Gabarra are among players taking in the sights. The Tony DiCicco Collection.

12. November 30, 1991—Norway and the United States stand for their respective national anthems before the final of the M&M World Championships (World Cup) in Guangdong, China. Michelle Akers led the way for the U.S. with two clutch goals to defeat Norway 2–1. The Tony DiCicco Collection.

13. Anson Dorrance, goalkeeper coach Tony DiCicco, and assistant coach Lauren Gregg look on from the bench during a national team match sometime in 1993. The Tony DiCicco Collection.

14. The year 1993 will mark Anson Dorrance's last full season as head coach. The following year he'll hand the coaching reins over to Tony DiCicco. Lauren Gregg will stay on as assistant coach. *Left to right*: Anson Dorrance, Tony DiCicco, Michelle Akers, and Lauren Gregg. The Tony DiCicco Collection.

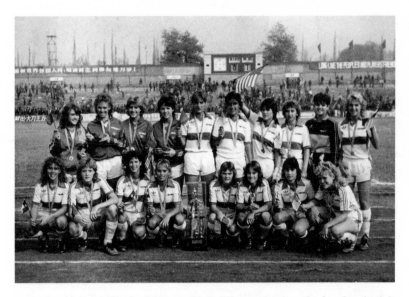

15. In 1984 pioneering girls club team the Dallas Sting became the first female club team sanctioned by FIFA to visit China. Accompanying the team is the future national team captain, fifteen-year-old Carla Werden (Overbeck). Carla is in the bottom row, third player from the right. Courtesy of Michelle Conaway Kimzey.

16. In 1993 Tony DiCicco invited Briana Scurry to his Soccer Plus goalkeeper school in Simsbury, Connecticut. Within a year she would become the national team's starting goalie. The Tony DiCicco Collection.

17. No one dominated women's soccer in the 1980s and 1990s like Michelle Akers. One of the most courageous athletes in history, female or male, her ability to maintain her competitive edge through chronic fatigue syndrome and numerous injuries is a story unto itself. The Tony DiCicco Collection.

18. In 1995 Tony DiCicco invited into camp Dr. Colleen Hacker, a mental skills coach and performance enhancement specialist from Pacific Lutheran University. Dr. Hacker would become a key ingredient in the team's successes at the 1996 Atlanta Olympics and beyond. Courtesy of Dr. Colleen Hacker.

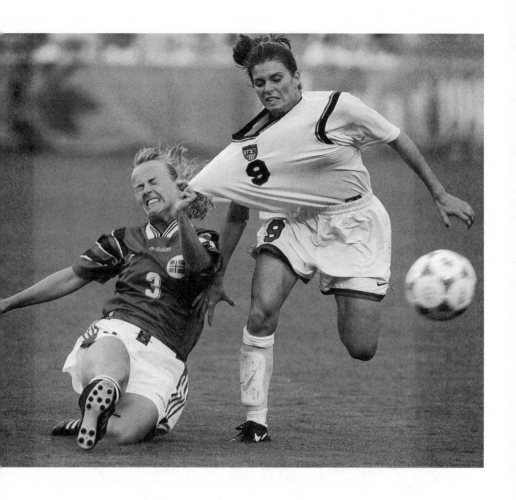

19. Mia Hamm's athleticism and speed on the ball wreaked havoc on the opposition. Teams went out of their way to disrupt her momentum with little success. Here Norway's Gro Espeseth does all she can to bring Mia down in the semifinal match at the 1996 Atlanta Olympics. REUTERS / Alamy Stock Photo.

20. & 21. In 1996 Shannon MacMillan came to the national team as a last-minute replacement at the Atlanta games. In the crucial semifinal match against Norway, Mac came off the bench in extra time to assist on Joy Fawcett's clutch game-winning goal, forever earning her the nickname "Super Sub." Johnmaxmena2, CC BY-SA 4.0, https://creativecommons.org/licenses/by-sa/4.0, via Wikimedia Commons / Johnmaxmena at English Wikipedia, CC BY 3.0, https://creativecommons.org/licenses/by/3.0, via Wikimedia Commons.

22. With her unorthodox style and goal-scoring ability, forward Tiffeny Milbrett shredded opposing defenses. Tiffeny played sixteen years for the national team, becoming one of its all-time great playmakers and scorers.
PA Images / Alamy Stock Photo.

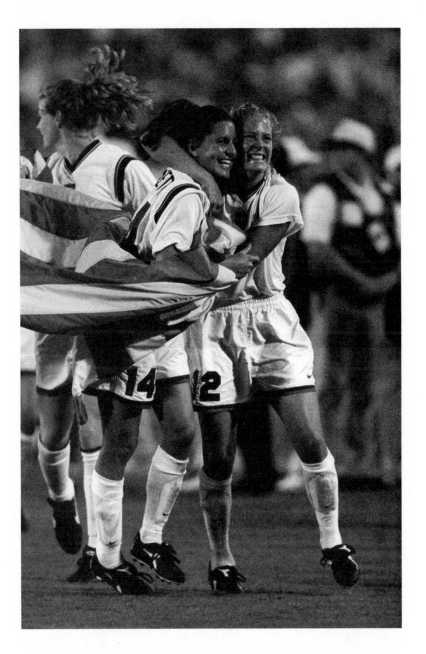

23. Joy Fawcett and Carin Jennings-Gabarra celebrate the U.S. gold medal win over China in the 1996 Olympics final. The national team drew sold-out crowds at major venues, proving women's soccer could fill large stadiums.

24. With the Olympics, Mia Hamm's stature grew along with her fan base.
As one of the first legitimate superstars in women's soccer, Mia became not only
the face of the rising national team but also a recognized figure worldwide.
She is shown here at the 1998 Goodwill games in New York.
PCN Photography / Alamy Stock Photo.

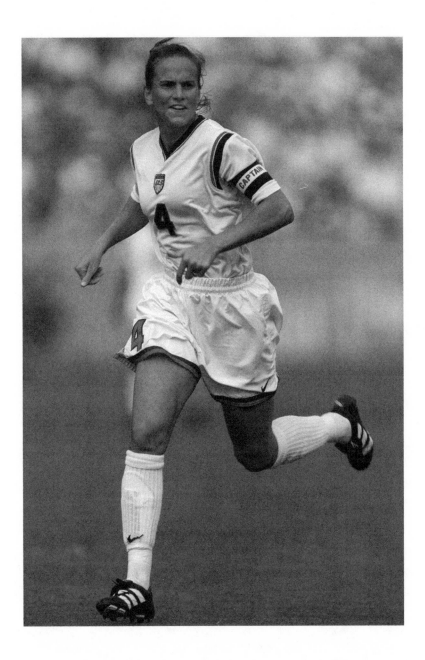

25. With her charisma and presence, Carla Overbeck emerged as the
on-field leader and the heart and soul of the national team. From the coaches
to the greenest rookie to the team's biggest stars, everyone revered and
respected her. PA Images / Alamy Stock Photo.

26. As the "heartbeat of the national team," Kristine Lilly played with distinction
for twenty-three years. Her consistency and work ethic is unparalleled.
In all likelihood, her record 354 caps will never be matched.
PA Images / Alamy Stock Photo.

27. Julie Foudy's instinct for advocacy and leadership turned the star midfielder into the national team's off-field captain. A fighter for team equality and women's rights, Julie's impact went far beyond the pitch.

PA Images / Alamy Stock Photo.

28. The core of the national team in the 1990s consisted of some of the greatest women soccer players in the world. Here, Brandi Chastain, Mia Hamm, Kristine Lilly, Julie Foudy, and Joy Fawcett gather around mental skills coach Dr. Colleen Hacker. The Tony DiCicco Collection.

29. National team starters before one of their Olympic group stage matches at the Citrus Bowl in 1996. *Top row, left to right*: Tiffeny Milbrett, Joy Fawcett, Julie Foudy, Michelle Akers, Brandi Chastain, Briana Scurry. *Bottom row, left to right*: Tisha Venturini, Kristine Lilly, Mia Hamm, Carla Overbeck, and Shannon MacMillan. The Tony DiCicco Collection.

30. Michelle Akers celebrates her successful penalty kick with Shannon
MacMillan in the 80th minute of the 1999 World Cup semifinal against Brazil.
Akers's goal put the U.S. up 2–0, clinching a berth in the final.
REUTERS / Alamy Stock Photo.

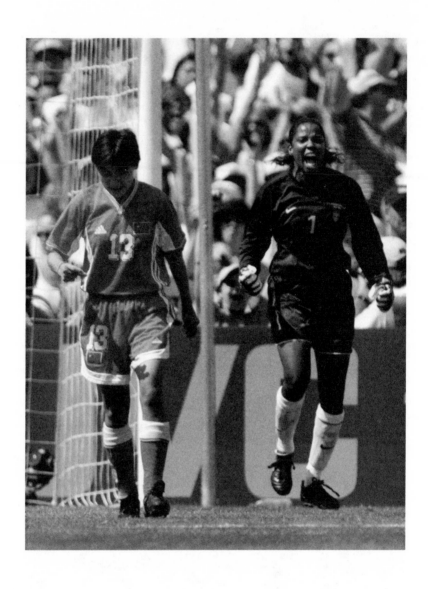

31. The '99 World Cup final vs. China at the Rose Bowl was played in 100-plus degree heat to a record forty million viewers. After two overtimes the match went to penalty kicks. Here Briana Scurry reacts to her stunning save off the third Chinese kicker, Liu Ying. REUTERS / Alamy Stock Photo.

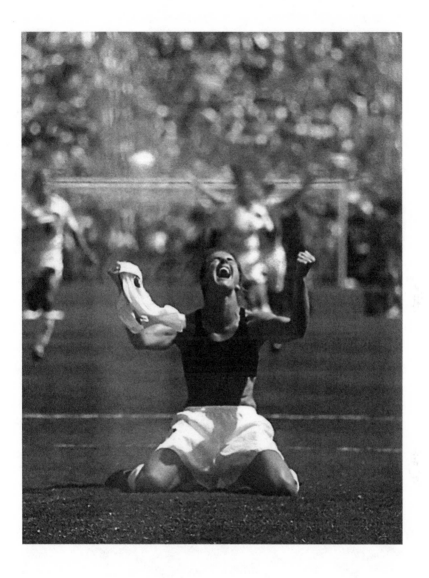

32. Scurry's save set the stage for Brandi Chastain to win the cup. Brandi successfully struck her left-footed kick into the side netting. Then in an act of unbridled enthusiasm, Brandi, nicknamed "Hollywood," tore off her jersey, exposing her sports bra for the world to see. ZUMA / Alamy Stock Photo.

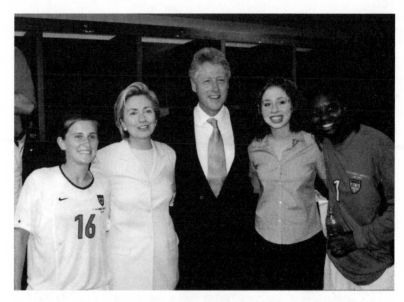

33. Following the World Cup win, President Bill Clinton along with First Lady Hillary and daughter Chelsea make the rounds of the winning locker room. Here they pose with Tiffeny Milbrett and Briana Scurry. The Tony DiCicco Collection.

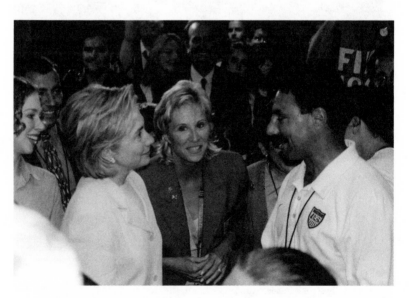

34. Hillary Clinton huddles with the head coach, Tony DiCicco, and 1999 World Cup organizing chairwoman, Donna DeVarona. The Tony DiCicco Collection

18

Mac Attack

Shannon MacMillan was so distraught she would have probably kicked in Clive Charles's door had it been locked. Mac was in a world of pain and desperate for someone to hear her out. Tony DiCicco just cut her, and because it was an Olympic year his timing couldn't have been worse.

She departed the national team's Chula Vista training camp in California in a huff and sought sanctuary back in Portland, where she hoped her former coach might magically fix things. After all, Shannon had been one of the greatest players the University of Portland ever produced, and Charles guided her successes. The former British soccer star had been coaching both the women and men at Portland for several years, but it wasn't until Shannon arrived in 1992 that either his women's or men's team got to the NCAA final four.

No one knew Mac's value better than Charles. Under his watch, Shannon led the Pilots to NCAAs twice in four years. She won the MAC Hermann Trophy Award for best player in the nation in 1995 and was a finalist three times. In addition, she won the Honda Award for the nation's top scorer in 1995.

Mac's collegiate credentials were impeccable, but none of that mattered anymore. DiCicco had cut her, and she wasn't going to the Olympics. Her career in jeopardy, Shannon turned to the only person she knew who would listen and calm her nerves. She had left her parents' home in Escondido, California, for Portland a week before presea-

son started and chose to fend for herself. Shannon emerged from the ordeal more determined to succeed than ever. During the Far West regional tournament with her club team, she'd impressed several college coaches with her speed and offensive skills. Shannon knew her parents couldn't financially support her at college, so she needed a full ride. There was interest, so she shopped several schools, but only after meeting Portland's Clive Charles did she sense a connection.

Charles invited Shannon on an official visit to Portland to train with the team for a weekend. During her stay, Charles detected something in the youngster besides speed, power, and intensity. Shannon had one intangible all world-caliber forwards possess, and that's a nose for the goal. Anson Dorrance detected it too, albeit too late. He wanted Mac for UNC, but by the time he got around to recruiting her, she had committed to Portland. Even if Dorrance had spotted her earlier, it's doubtful Shannon would have gone to Chapel Hill. She felt a kinship with Charles, a trust she didn't feel with any other coach.

"Clive wasn't trying to sell me anything," MacMillan recalls. "I asked if he was going to start me. All he said was, 'We think you'd be a good fit here.' He made no promises to me except I'd get the chance to prove myself."

Under Charles's watchful eye, Shannon's college career took off. A four-time All American, she led the team twice to the NCAA playoffs and won every major college award possible.

But her glory days appeared to be over. DiCicco cut her twice; the first time she had a foot injury before the 1995 World Cup, and the second time was just ahead of the 1996 Olympics. What hurt most was that she was the last player cut. Clive Charles had been around long enough he knew that when a player gets emotional, it's best to get out of their way, allow them to spell their guts, and just listen. Throughout Shannon's tirade, Charles remained silent in his chair surrounded by his numerous photos, awards, and trophies, and he just listened. Among those photos was a vintage black-and-white shot of Charles as a defender for West Ham United. At the time he was one of only several Black players in England's First Division, and this was during a time when English hooligans could be as just as biased as any racist in the Jim Crow South.

But Charles blocked out the haters. For twenty years he played football in the best leagues in England and the United States. He retired as a player in 1983 and coached high school for two years before taking over the Portland's men's team in 1986 and the women's side three years later.

Clive was considered one of the sport's greatest college coaches, and when he retired in 2002, he'd racked up 439 wins, twenty NCAA tournament berths, one championship, and seven final fours.

Throughout his journey, Charles learned patience and compassion. As a Black man, cut from teams for no reason except the color of his skin, Clive developed empathy for the underdog. Turning negatives into positives was in his DNA, and it was in Shannon's too— only she didn't know it.

So as Shannon went off, Clive didn't say a word. Instead, he listened, and what he heard loudest was between the lines. He didn't hear her sobs and complaints as much as her tone. Here was a young woman, he sensed, not yet ready to surrender her dream.

"I was bawling my eyes out," recalls Shannon. "Only a month earlier, I played my last collegiate game. We had gone to the final four and lost in triple overtime. The national team was it for me. There were no pro leagues and not much overseas. All of a sudden soccer was gone, and I found myself completely devastated.

"I sat in Clive's office, bawled my eyes out, swore up and down, and used lots of colorful language, saying how uneducated the national team coach is and how cruel the world was.

"'It's not fair, Clive!' I screamed. 'What am I going to do? Oh god . . .'

"I was a never a cocky player, but I just won the Hermann Award and was the most confident I've ever been. I had a great senior season, from winning awards to scoring and assists, I had found my zone, and when I got cut, I was just at a loss. I just sat there in his office and bawled my eyes out. It was a good forty-five minutes before Clive put out the box of tissues he kept for me in his drawer in his desk. Then he just looked at me. 'Are you done?'

"I said, nope, and I went on another twenty minutes. I did the whole 'Woe is me, poor me' routine. Finally, Clive looked at his watch. 'Okay, Shannon, you have twenty-four hours to mope. Tomorrow

I'm going to see you out on the field, and I'm going to kick your ass like never before.'

"I looked at him. 'Have you lost your mind?' And then I asked him why.

"He said, 'Because you're going to get an opportunity.'

"'Clive,' I said, 'the national team has called in twenty-four players at their Olympic camp. They have to get down to sixteen, and I'm not even on the roster.'

"'You're going to get an opportunity,' he said, 'so you can either feel sorry for yourself or be prepared to take advantage of that opportunity.'

"I just kept looking at him. Finally, he said, 'I'm going to give you twenty-four hours to mope and feel sorry for yourself. Tomorrow at this time, I'll see you on the field.'

"I remember going back with my friends that night and telling them how Clive's lost his mind, and then did the woe-is-me act all over again.

"But I slept on it, and I woke the next morning and thought about our past. Clive shaped me who I was as a player and a person. No one ever invested in me as he did, and he never steered me wrong. I had nothing but love, respect, and trust for this man, and so I went out to the field and that afternoon and Clive started kicking my butt.

"A few weeks later, when nine core members of the national team went to the federation and demanded we make more than per diem, U.S. Soccer started calling in players for a scrub team, but when my phone rang, I was mixed. My career with the national team began in 1993. I'd been around those women a long time and had nothing but respect and trust for them.

"I called Julie Foudy. 'Jules,' I said, 'I don't know what to do. They want me to go to Brazil for this tournament, but I support what you guys are doing. If you tell me not to go, I won't.'

"She said, 'You need to go down there, Mac. You need to show what you can do.'

"So I went to Brazil and joined the second team. Up to that point, I've always played forward, but Tony said we need somebody to play right midfield.

"Had I not been cut, I probably would have laughed and said,

'Good luck with that,' but after having worked a solid month with Clive, and wanting and willing to do anything and everything to get on that team, I said, 'I'll try it.'

"So I started learning a new position, and by the time we had finished with the tournament in Brazil, the leadership had come to terms with U.S. Soccer, and I got another ticket back to Oregon. U.S. Soccer said they would try to get me in as a floater, so I went back to Portland and waited and waited and waited, and finally they called. 'Mac, you need to be here.'

"So I went back to Florida and stayed in residency. When the starters went out to play a friendly, I stayed behind with the group who didn't travel. We trained on our own and waited and waited and waited. Then slowly, I started getting invites to go on trips with the starters.

"When the Olympic roster was announced, I was in the group of sixteen. By the opening game, I was a starter and finished with three goals, including the semifinal winning goal against Norway in double overtime.

"I have Clive to thank for all that and Tony for giving me a second chance."

For the Brazil trip in January, DiCicco brought his nine veteran holdouts into camp on a pay-per game basis. As it turned out, staying united forced the hand of the secretary general of U.S. Soccer, Hank Steinbrecher. He realized the national team couldn't compete in Atlanta with a B squad because fewer people would watch and that meant fewer sponsors. The holdouts had leverage, and the two adversaries settled quickly. The national team got raises for finishing both first and second and a few other perks. It was the first time the national team had yielded their collective power. Their victory empowered the captains, Julie Foudy and Carla Overbeck, but it made DiCicco, who silently stood by the players, a semi-pariah with U.S. Soccer, which led to serious ramifications down the road.

With the lockout over, the team started to jell. With Chastain and MacMillan on the squad, the national team was no longer reliant on Akers to carry them. If Michelle had an injury or if her chronic fatigue syndrome limited her playing time, others could take her place.

But there were still other voids to fill. One of DiCicco's finest attributes was not being afraid to bring in people who knew more than he did, and motivational speaking was not his strength.

In 1995, except for the Chicago White Sox, no professional team carried a team psychologist, and during the 1995 World Cup DiCicco believed one would have helped. When they played Norway, the team lost its mental edge and lost a game they might have won.

Earlier in the year, on a western swing to the Pacific Northwest, DiCicco invited a psychologist from Tacoma, whom he'd met through the United States Olympic Committee (USOC), to join the team. Her name was Dr. Colleen Hacker, and she was an expert in peak performance and team building.

DiCicco was impressed with how Hacker connected with the players. When the trip ended, DiCicco and Lauren Gregg asked U.S. Soccer if they could bring in Hacker for the upcoming World Cup in Sweden.

"Tony and I went to U.S. Soccer and showed them a ten-year vision plan," recalls Gregg. "We requested a residency program, a professional league, and a team psychologist. They met the first two requests with consideration, but when we brought up the sports psychologist, two of the administrators got down on the floor, put their feet together yoga style, and said, 'Yeah, that touchy-feely stuff.'"

In retrospect, Dr. Hacker might have been helpful in Sweden. The U.S. players were flat in the semifinal. They only came to life late in the game when Norway was down a player.

"A couple of our younger players were not in the right place mentally," DiCicco later said. "We lost 2–1 and finished third in the tournament."

DiCicco was convinced that if a mental skills coach been there, it might have made a difference. He tried convincing U.S. Soccer again the following February, to no avail. Then he caught a break. The USOC informed DiCicco that there was some grant money available, and if there was anything extra he needed, he should let them know.

Tony didn't hesitate. "I need a video editing system and a sports psychologist," he said. The USOC approved, and within minutes of their decision, he was on the phone to Dr. Colleen Hacker in Tacoma.

19

Power to Be Bold

Never believe that a few caring people can't change the world.
For, indeed, that's all who ever had.

—MARGARET MEAD

Dr. Colleen Hacker knew a thing or two about a winning mindset. As a student at Pennsylvania's Lock Haven University, she lettered in basketball and field hockey. Upon graduating in the late 1970s, she took her playing experience to Tacoma's Pacific Lutheran University in Washington and coached the women's field hockey team to its first winning season in thirteen years, qualifying them for their national championship tournament.

When the school dropped field hockey two years later, Hacker, who didn't play soccer because Lock Haven didn't have a team, helped create PLU's first women's soccer program.

Serving as their coach from 1980 to 1995, Hacker set NAIA precedents by leading the team to five consecutive NAIA Tournament appearances and winning the championship three times.

Having fulfilled her coaching goals, Hacker turned to her second calling: sports psychology. After years of graduate study at several universities, Hacker became an expert in mental skills and peak performance. By the time she met Tony DiCicco in 1995, her experience was vast and her office walls plastered with degrees, including two PhDs, an MS, and a BS in health and physical education.

As a former player, teacher, and coach, Hacker had the skill set

DiCicco and Lauren Gregg were looking for when they entered into their Olympic buildup in 1996.

The timing couldn't have been better. Hacker had been looking for a place where she could put her expertise to use. So when her office phone rang on that winter day in 1995, and it was DiCicco, she was elated.

DiCicco got straight to the point.

"How would you like to help us win a gold medal?" he asked.

Hacker didn't hesitate. "I'm in, I'm in," she ecstatically replied.

Having Hacker on board was a major coup, and for a team with several psych majors who extenuated the positive, Hacker was a welcomed respite.

For DiCicco, Hacker was the answer to a much-needed void. When it came to the Xs and Os DiCicco knew his stuff, but he admittedly knew little when it came to mental fitness and motivational speaking. Hacker came ready-made to fill that void.

"Colleen became a sounding board when the players wanted to complain about me," recalls DiCicco. "She dealt with issues within the team, and everything was confidential.

"Every time she came into camp, we went through each player and reviewed where I thought she was confidence-wise. Together with Colleen, we all agreed on the best course of action and how to approach each player."

In the chaotic pre-Olympic atmosphere, Hacker became a calming influence. The Atlanta games were more prominent in scope than the two previous World Cups. The team would be showcased as never before. Only sixteen players would make the cut, and competition for starting positions would be fierce—but the team was built on trust and sacrifice. Hacker's job was to build on those attributes.

"Tony and I agreed we could best lead by serving others, which is different from the militaristic inspiring the troops, beating your chest on your white horse approach," says Hacker. "We were after true servant leadership: our mantra was how we could serve the players that we were privileged to coach and better serve the game. We wanted to impact future generations through the great game of soccer."

Hacker was available to players for every game and practice. She

was considered part of the coaching staff and was ready on the sidelines for any player needing a consultation.

"Colleen was something we never had before," recalls Julie Foudy. "If we needed help in different areas of mental preparation, she'd talk with us. It wasn't like we were talking to a sports psychologist as much as someone who has great wisdom. Her approach wasn't psychoanalyzing, or lying down on the couch, as much as we had a friend we could go to who is part of the staff and who is helping us tremendously. She's an incredibly gifted speaker so she'd get us going. Every time I walked out of a meeting, I felt like I came out of church ready to face the world."

Players called her "Hack," and she became noted for Hackerisms, memorable phrases designed to encourage and motivate.

"Colleen would tell us, don't sweat the small things is a misnomer," says Foudy. "Instead she'd say, 'You have to sweat the small things.' At the time a book of the same name was a best seller, but Colleen would tell us it wasn't true. She said unless you sweat the small things you're not going to win. Her belief was the margin of winning is so small, and you have to pay attention to the little details."

Dr. Hacker would continually reinforce her directives with examples. Her quotes included, "People all wrapped up in themselves make tiny packages: Pay more attention to responsibilities and a little less attention to your rights: A rising tide lifts all ships: When somebody succeeds we all succeed. So it's in everybody's best interest to highlight the good, and the success, and to provide proper resources."

Even the notoriously guarded Mia Hamm tapped into Dr. Hacker's sphere of enlightenment. Mia was hard to crack, but the doctor was patient. The two bided their time, feeling each other out, and over time a trust emerged. One day at practice, DiCicco saw the two conversing on the sidelines, and he knew Mia had bought into the program.

Rarely did anyone get through her defenses, and coaches traditionally gave Hamm a lot of space. But Hacker was able to penetrate the walls and help Mia, which paid huge dividends down the road.

Lauren Gregg says DiCicco's ability to bring in Dr. Hacker is an example of his strength and confidence. "Tony thought you should surround yourself with the best people you can," says Gregg. "We

weren't afraid of bringing in the best players, the best nutritionist, the best strength and conditioning coach, and the best sports psychologist and not feel threatened."

"Tony's vision to work with a sports psychologist was brilliant," adds Brandi Chastain. "All our players were adept at physical work, and everyone had stamina, speed, skills, technique, and passion. The differentiator was our mental skills. Through Colleen, we learned to rely more on each other when things got tough.

"Before Colleen, our team mantra had been, all of us are tough, hardworking, and blue-collar, and so we'll figure it out. But to maintain that excellence, we had to have something else. Being sturdy and strong wasn't enough. We also had to be smart and confident, and mental discipline gave us that edge."

With regard to leadership, with the Olympics approaching, Julie Foudy came into her own as the team's off-field captain. Her sense of justice and advocacy heightened, and as she became more and more frustrated with the petty conditions and abuses the federation imposed on the team, the more determined Foudy became to address them.

In December 1995 Foudy and the national team leadership decided to test U.S. Soccer's resolve over matters of equal pay. They decided to use whatever leverage they had to get badly needed concessions on the table.

Foudy's advocacy didn't materialize overnight. When it came to fair treatment, she'd always been a thorn in somebody's side. Still, it wasn't until she met Billie Jean King in the mid-1990s that she started flexing her intellectual muscle in ways she had never done before.

20

The Advocate

Power concedes nothing without a demand.
It never did, and it never will.

—FREDERICK DOUGLASS

Julie Foudy hadn't originally planned on being at the Atlanta Olympics in 1996. She was scheduled to begin medical school at Stanford in August, but as the entry date for school neared, she started getting second thoughts. Unsure on what direction to take, she sought advice from friends in the medical field and listened to her heart. "I love science, I love biology, but it didn't feel that was necessarily my calling in life," recalls Foudy.

Since her debut with the national team in 1987, Julie Foudy had been nothing short of spectacular. As roving midfielder, Foudy could cover a lot of ground and was a superb overall leader. DiCicco called her the team's business leader, but she led from the field also. When it came to advising, inspiring, and guiding, Foudy and Carla Overbeck proved time and again they were the team go-tos, both on and off the field.

Interestingly, Foudy was never content with being involved only in athletics. It's why she'd planned on medicine as a career. It satisfied her in a way playing soccer and sports couldn't.

"I know Julie deferring from Stanford medical school and choosing soccer was difficult," says Lauren Gregg. "Some people didn't understand it, but there was another part to Julie besides playing soccer. She desired an intellectual and leadership challenge. She wanted to

make a difference in other ways besides playing, and her role as a sports foundation leader and getting Billie Jean King on board, and the collective bargaining agreements were big steps forward for us."

By choosing soccer over medicine, Foudy had made a personal statement, but she still had to find a way to fulfill her intellectual calling in a way playing could not. It had been that way with her ever since she was a kid growing up in northern Orange County, California. It was on the wide expanse of fields near her home in Mission Viejo that Julie Foudy first discovered herself and formed the character and drive to become not only a great athlete but also one of soccer's great ambassadors and advocators.

"I was a tomboy and a hyperactive kid who wanted to run and move," says Foudy, "but I was also competitive and social, and soccer gave me those outlets, and it wasn't' that I played because I loved soccer, as much as I loved the environment and the awesome girls that I surrounded myself with. For ten years, I was on this fantastic team called the Mission Viejo Soccerettes, and those girls are still some of my best friends, but I wasn't just into soccer. There were other sports I was into before I got to Stanford. I also played softball, basketball, and ran track.

"But at some point I realized if my life were soccer twenty-four hours a day, I wouldn't be happy. I also needed to be intellectually challenged. If I were a soccer player all the time, I would have been like, 'Oh my gosh, shoot me.'

"To be happy I needed a diversity of thought and experience. I also needed to be intellectually stimulated, and that's why I took on those other roles with the national team. It bothered me that we had to fight for certain things, but it bothered me more nobody was paying attention.

"In 1995 I had the good fortune of meeting Billie Jean King. I got involved in her Women's Sports Foundation, which became a strong advocate and mentoring group for me. Soon after her, I met team lawyer John Langel, and we worked with him for over two decades.

"I always had an activist side, and I was willing to speak out when things didn't seem right. But being an advocate took a ton of work, but

we were ready to do it because we were passionate about the issues, and we had a great leadership team.

"Carla, Mia, I, and some of our veterans put in a lot of hours. We scoured through federation budgets and wondered why 80 percent of our funds were going to twelve-year-old boys, and only 20 percent was going to twelve-year-old girls, when our federation's mission statement is to grow the game.

"When the contract for the Olympics came up in 1995, I started becoming involved in team issues like better pay and travel conditions. I didn't understand how we were always broke and why players had to quit the team to survive.

"When I got to meet with Billie Jean King, she spoke to us about a lot of topics, but when she explained her battles with U.S. tennis officials over equal pay, it hit a nerve. We were going through the same struggles with U.S. Soccer. The federation had offered us bonuses if we won gold at the Olympics, but we also wanted rewards for winning the silver and bronze, the same as the men, but the federation refused to listen to us.

"When Billie Jean told her story, I just sat there and absorbed it. I was like, 'Oh, my gosh, this is us.' What she did by breaking away and unifying all these women to form the Women's Tennis Association was similar to what we were going through on the national team.

"On my flight back, I thought about what she said, but when we approached U.S. Soccer again about better pay and conditions, they were just as adamant. I called Billie Jean and asked for her opinion.

"'You just don't play,' she told me. 'It's the only leverage you have. U.S. Soccer depends on you, you're representing them, and you make them money. You have to say no.'

"So I ran back to the team, and I yelled, 'Guys listen, we can't sign this contract, Billie Jean said . . .'"

It didn't take long for Foudy to convince the nine veterans on the team to cross off the bonuses and written guarantees of a percentage of the prize money on the contracts and send them to U.S. Soccer. On December 5, 1995, the federation responded by revoking

their plane tickets to California and locking them out of their pre-Olympic camp in Chula Vista.

Battle lines had been drawn. On December 7 U.S. Soccer's executive director Hank Steinbrecher explained his side of the story to the *LA Times'* Grahame L. Jones.

"The federation had made a generous offer of the previous January, but of now, the contracts are off the table. The only way they can play is on a per diem basis, provided Coach DiCicco asks for them."

"Some of the players were already making $80,000 to $90,000 a year, plus endorsements. U.S. Soccer will only reward bonuses if they win the gold medal, second and third will not qualify. We cannot reward mediocrity. It seems some players are more concerned about how green their shoes are, instead of bringing home the gold."

Steinbrecher's terse response only strengthened the players resolve. They had already considered striking, but Steinbrecher decided the matter for them. In truth, the lockout proved advantageous for the team. In the public's eyes, their own federation locking out players seemed more callous than the players striking. U.S. Soccer was perceived as the oppressor, and it fueled public sympathy for the national team.

The nine holdouts stood firm: if the federation didn't meet demands, Julie Foudy, Mia Hamm, Carla Overbeck, Michelle Akers, Tisha Venturini, Joy Fawcett, Kristine Lilly, Briana Scurry, Carin Jennings-Gabarra, the core of the national team, all agreed to miss the Olympics.

Their bold stance was risky. Going head-to-head with the federation could have serious ramifications, and there were times when the dissenters doubted their resolve. Carin Jennings-Gabarra held off on retiring so she could play in the Olympics, and Kristine Lilly wondered if she'd ever play again.

Still, the players were tired of being second-class citizens. All of the sacrifice, training, and maneuvering they did to get to this point was no small feat. And with the Olympics so close, walking away now seemed somewhat extreme. Nonetheless, Billie Jean King explained to Foudy that future generations would be affected by their decision, so they persevered.

In truth, the players realized they had the upper hand. Sooner or

later the federation would have to fold. Without the national team's most prestigious players at the Olympics, stadium attendance and TV viewership would be drastically diminished, and sponsors would undoubtedly back away. The lockout was a PR disaster in the making, not to mention a potential financial flop for U.S. Soccer.

At the same time, DiCicco had a team to field. The first tournament of 1996 was scheduled for January 15 in Campinas, Brazil, which meant DiCicco had less than a month to muster up a scab team. The only veterans presently in camp were Amanda Cromwell, Mary Harvey, Jennifer Lalor, Sara Rafanelli, and Saskia Weber. To fill the roster, DiCicco needed to recruit new players. U.S. Soccer had a dozen nonroster candidates in mind, including Brandi Chastain and Shannon MacMillan, and both players had been eager to get back to the team. Still, to return now, they'd have to cross an invisible picket line.

Shannon and Brandi's only option was to call July Foudy and get her thoughts. Foudy recommended they both come into camp. The holdout would be short-lived, and she wasn't going to deny two friends a chance to redeem themselves and make the team.

Dr. Colleen Hacker considers Julie Foudy and Carla Overbeck monumental leaders who in moments of turmoil and doubt made sure the national team didn't lose their bearings or lose sight of their long-term goals. In Hacker's eyes, Julie Foudy was also a visionary, someone who looked beyond the here and now.

"You had to have a rearview mirror to understand what you saw in Julie," says Hacker. "We didn't yet know she was going to be the president of the Women's Sports Foundation or a leading advocate for women's equality in sports, or founder of the Julie Foudy Leadership Academy for girls. We have the benefit now of understanding just what a massive figure she is on the national and international stage, but the seeds planted in 1996 and '99 came full bloom years later.

"We saw those same qualities and awareness then, that same desire to create more opportunities for people coming after her. She was willing to put in the time and effort to sit with reporters, get off a bus and shake hands, and fly all night and meet with the public.

"Julie and Carla put their actions where their values were. Their

philosophy was if you want to be a leader, carry the bags. Their leadership was actively and daily living the example, not telling people what to do as much as modeling what to do.

"They both literally and metaphorically carried the team's bags. They did the grunt work. They weren't just in front of the camera glamour, they were modeling it. At practice, they were the ones racing to move the goals that needed to be moved and staying after practice and running extra fitness. What do their actions say to a player who is far less in stature and accomplishment, who hadn't yet met fitness standards?

"It says here are the most accomplished and decorated among them coming early and staying late to run fitness, with people who haven't yet met national team standards.

"In ways big and small, they carried the team's bags."

"Julie would talk to our team at dinners and tell us how we were the beneficiaries of Title IX legislation, and they must never forget that. She lifted the Billie Jean Kings and Senator Birch Bayhs of the world. She wanted us to know our history and the people who made our careers possible, and you can't fabricate that, and that's visionary leadership.

"Why are those two captains? Tony knew something.

"We all shared that vision, and you can't say that about most teams, and that vision was explicit, and not after-the-fact, Monday morning quarterbacking. These iconic Tony DiCicco–coached teams were actively aware in the moment.

"Julie Foudy, consummate leader: her nickname was Loudy Foudy. She led and was very vocal and visible. She was very comfortable in terms of carrying the conversation, and the responsibility, and the current and future generations of the national team have her to thank."

To her teammates, Foudy was a multitalented, charismatic leader who could play, inspire, sing badly, and make everybody laugh. "People always talk about Julie's leadership off the field, but she was a great player too," says Kristine Lilly. "She always wanted the ball, almost to a fault, and we'd tease her about that. But the fact was she wanted the ball, made you feel good because if Jules wants it, we knew we could do this.

"She also had this glowing optimism about her. If things got rough on the field, we could look at her, and she'd make you laugh. She was passionate about life, and in our quest to grow the game, and for equal rights. Because of that passion, we jumped on board with her. She's intelligent, levelheaded, and had a voice. Having those three things in one player was pretty awesome.

"Julie could also be crazy, she could give it, but we made sure we gave it back. One year, just before we took our team picture, we had T-shirts made of her head. This was during a time she had one long eyebrow, rather than two.

"So we made shirts of her face and the eyebrows, and we put them on underneath our jackets. Just before they took the picture, we all took off the jackets, and Julie was the only one wearing her jersey. The rest of us all had T-shirts with her face on it.

"Julie just laughed, but that's Jules. She can be a jokester, and she can take it too."

When one looks at the overall makeup of the national team, it was quite a diverse bunch. The various characters and personalities all seemed to mesh. However, there was one individual who most definitely walked to the beat of her own drum. She was, for the most part, embraced by her teammates, but because of her hardscrabble background, and the long, windy road it took to get on the national team, she considered herself something of an outsider. For her, the national team wasn't a sisterhood, in the true sense of the word.

Of all the players from the Dorrance-DiCicco era, Tiffeny Milbrett was indeed a stand-alone. No one had quite taken the path she took to where she got to be, and few players in women's soccer, then or now, can match her speed, agility, and improvisational skill she had on the ball.

21

The Outlier

"I'm a very independent person," says Tiffeny Milbrett. "I grew up with a single mom who raised my brother and me in rural Oregon. It wasn't your typical, cookie-cutter type existence. I didn't grow up in a way you would assume most families grew up. We were blue-collar, hard workers. My mom was an extension of what my childhood was, and I was an extension of how her childhood went. She was from a farm family, and her dad worked in the mills in the forests of Oregon. They had thirteen kids, and she was the fourth oldest. Her summers were spent on bean and berry fields, making money for the family.

"I did the same thing growing up, but my time in the fields lasted only one summer. It was horrible and I hated it, and it was my first realization of the sheer amount of work that life can bring to some people. I invested and sacrificed for the job. I got up every day at 4:30 in the morning. We'd meet at a bus stop, and the berry farmers would pick us up at and take us to work the fields. There were other kids my age, and we were all in the fourth or fifth grade. You'd work with your friends, but of course you rarely saw them because you're in different rows.

"It may seem hard, but that's kind of what we did in rural Oregon. It was a hardscrabble life, and working in the berry fields was what was expected. I think there's a law now about working underaged kids, but this was during a time when they could still get away with it.

"I remember going out to the fields in the morning, and how wet the plants were. Not only did your fingers get wet and look like prunes, but you had to work with your head down in the strawberry plants.

It was back-breaking, suffocating work, and when the heat came up, it was almost unbearable. Picking berries is not like going out and running miles, or doing anything sports related. It's hard challenging work.

"The berry picking season lasted about a month, and you only got paid when the season was over. After my thirty days of strawberry picking were done, I turned in my overalls and punch cards and got paid. I got ninety dollars, and I gave to my mom.

"I said to her, 'This is not worth it.'

"She said, 'Well, its ninety dollars more then you had.'

"I said, 'It's not worth ninety dollars for what I just went through for a month.'

"I never went back to the fields after that, but the memory of it is seared into me.

"We pulled up in the bus to the fields, and there was this woman there to greet you. She was the matriarch of the strawberry farms. I just remember saying to myself, 'I'm never doing this again. It's not even worth it.' That's when I knew I was not going to be a laborer.

"I had a lot of responsibility growing up, which I learned wasn't a negative thing. It helped get me through the trials I faced in life, both with youth soccer and the national team."

In 1991 Tiffeny Milbrett was a nineteen-year-old freshman at the University of Portland when she was brought over to the national team. Coming from the soccer hinterlands onto a team of soccer elites would be enough to send any newbie packing, but the training Milbrett received from Portland coach Clive Charles kept her in the running.

Milbrett didn't make the cut that year, and despite being named *Soccer America*'s Freshman Player of the Year, she saw limited action in the ensuing years.

After she was cut by Anson Dorrance in 1991, Milbrett returned to Portland and u-20s. It would take her another four years of call-ups for her to earn a starting berth on the national team. During those intervening years she placed second in the nation in goals (1992) and led the University of Portland to their first trip to the NCAA's final four (1994).

Even as a highly touted prospect, it took Milbrett longer to break into the national team culture than most of her peers. She finally became a spot starter in 1995, and her career took off. She was a starting forward at the 1996 Olympics and in time became one of the greatest forwards the national team ever produced, but why did it take so long for Milbrett to find her niche? Why did lesser players get fast-tracked while she languished on the U-20s, and when she did emerge, why didn't the media embrace her? Why wasn't the national team's seventh-leading all-time scorer and fourth all-time assist leader, a future Hall of Famer, more acknowledged?

"I was somebody plucked out of relative obscurity," says Milbrett. "No one from the national team ever came out of Portland, Oregon, before. I was young, inexperienced, and I entered a system not designed to assimilate new players. I had never been subjected to this level of competition before, and it shouldn't have been left to my teammates to incorporate new players like myself into the program. It was the responsibilities of U.S. Soccer and the coaches, but I didn't get much assistance from them.

"I was recruited for UNC but declined because I wanted to go to the University of Portland. Clive Charles had coached me since I was eight, and I knew where I was heading. At Portland, I proved I could play at a high level and had the numbers to prove it, but I'll never know if my decision to go there weighed in how I was later treated. If you ask U.S. Soccer, I'm sure the answer's no, but when you have a conflict of interest that's to be expected."

It was from Clive Charles that Milbrett learned her soccer chops. Unlike Anson Dorrance and Tony DiCicco, Charles had played soccer professionally for the English club West Ham United and several pro clubs in the United States, which Milbrett says gave him an edge over his contemporaries.

"I always believed Clive treated me more professionally on my youth club and at Portland than I was treated on the national team," says Milbrett. "With Clive, I learned what professionalism was because he had been there. He was a Black man who played in the top tier Premier League. He endured racism in England and got more of it when

he played professionally in the North American Soccer League. Clive was top of the top, and I learned to play from a real pro."

Milbrett says having Charles as a coach was a great gift, but ultimately a source of sadness. "I played for Clive's FC amateur women's team when I was fifteen and his U-16 for my youth club soccer," says Milbrett. "There is something to be said to be trained by an ex-pro who can connect with you on a human level. As my career progressed, I always had Clive to compare with. Some people said I wanted everybody to be like Clive. I said, 'Sure, why not?'"

Milbrett believes the coaching she received with U.S. Soccer was not on par with that of Charles. It was true, no national team coach could match his résumé, but to dismiss DiCicco and Dorrance is not entirely just. They brought intangibles to the national team and helped guide them to unparalleled success. Milbrett's argument could be more to do with the personal treatment she received as she struggled for acceptance.

"I was recruited by Anson Dorrance to go to UNC but declined because I wanted to go to Portland," says Milbrett. "I'll never know if that decision weighed in how I was treated. I'm sure the answer given by U.S. Soccer would be no, but how are managing two hats, a college program and a national team, not a conflict of interest? I don't trust anybody that has a conflict of interest—I don't care who you are. It was awkward for me to be playing under a coach I had declined. It was a challenging process to overcome, and it shouldn't have been held over my head."

Milbrett makes an interesting point. When Dorrance stepped down in 1994, his handpicked successor was Tony DiCicco. As far as we know, no other coach was considered. It speaks to the national team culture at the time, and how much power Dorrance yielded.

"Anson said publicly, he was able to appoint his successor," says Milbrett. "I don't know of any other situation like that. Why is a national team coach able to appoint his successor? When I entered the Hall of Fame in 2018, I said in my introduction speech, 'It's a miracle if you make it to the top level because there are so many things that can go against you.'

"The kind of player I was, at the level I was playing, with the num-

ber of goals and the number of games I played, I should have been treated and respected like anyone else would have on the men's side of the game. Any male player that has goals galore are the ones who are going to get the attention and be noted for their accomplishments, but it didn't happen to me.

"Even when Tony came on board as head coach in 1994, the challenges were still there. Tony was the one who gave me my starting role, and I was supported to a point, but not entirely.

"Everybody has perceptions of their struggles and challenges. The question I have, was the process vetted to open up the coaching search to get the best coach possible?"

Despite her challenges, Milbrett became a star under DiCicco. She played with distinction on the national team for another twelve seasons. Her one hundred goals are seventh best of all time. Also noteworthy are her sixty-four assists, fourth highest of all time. In a match against Australia in 1997 she had a team record of five assists.

But goals and assists are secondary to what Milbrett accomplished in the national team's biggest matches. Tiffeny was a proven winner, a big game player who played in three World Cups and two Olympics, playing twenty-eight matches and scoring twelve goals.

One reason for her high number of goals and assists was that she played alongside Mia Hamm for seven years, and during that time they became one of the national team's greatest scoring tandems.

"Mia and I were never close friends, and I never went to school with her, but we were consummate teammates, and we connected on a lot of pieces. For whatever reason, our playing styles meshed, and as many assists that she gave me, I tried to return the favor. She was the one player I had the most ease of connecting with on the field. We had a complimentary cast of characters on the national team, and it's why we were so strong. But with Mia, for whatever reason, I connected with her on the pitch."

Milbrett's frustrations weren't with her teammates as much as things she had no control over. When it came to media preference, Milbrett feels she got shortchanged, in comparison to some of those teammates.

"In our sport, the pretty ones get the attention," says Milbrett. "It comes with being in a high-level, performing occupation. Being a

model never was my life goal or dream. I wasn't built that way aesthetically. Still, in our sport it's the media that decides who the pretty ones are and aren't, and that was certainly true of this team.

"With our ascension came the media darlings, the ones the press always wanted to talk to. I was on a team of exceptionally talented athletes, and everyone deserved media attention, and I have no animosity toward them. It's not my teammates' fault. It's more my frustration at the system and the process."

"By 1996, the media really started picking up on us," adds Milbrett. "There were hundreds of writers reporting on us at the '99 World Cup, and some of the questions they asked were demeaning, infuriating, and sexist. They asked stuff they would never ask of the men. I'd like to think they were just naive, having never covered soccer before, but it still doesn't excuse it.

"We were a new breed of professional women athletes, and our team defined that. I would like to believe a player of my caliber coming into the scene today wouldn't have to deal with the challenges we faced. I'd like to believe the system is different now, but the current team is still being treated the same as we were back then, and that's infuriating."

Milbrett believes systematic, sexist elements were at play, and it wasn't just in women's soccer. Dr. Colleen Hacker, who helped the national team work through some of these issues, says the challenges Milbrett faced were more about power than anything else.

"There's a wonderful quote, 'a rising tide lifts all ships,' when a team is successful on a platform of high character and in regard for things greater than themselves. Doesn't that benefit everyone? When somebody succeeds, we all succeed, so in our view, it's in everybody's best interest to highlight the good and the success and to provide proper resources.

"But we are aware everybody doesn't think like that, 'a rising tide lifts all ships,' so we are equally perplexed, as we were motivated and driven, to make sure that happens because we all believed that that's the case.

"But let's call a spade a spade. We live in a gender-bifurcated society. For many people, especially in positions of power and author-

ity, we differentially advantage male sports to female sports. We also differentially advantage in money, pay, benefits, staffing, resources, media, and sponsorship.

"There are systemic reasons for that resistance, and it's not just with women's soccer. In any facet of culture, people with all the power are rarely excited about giving up that power. Whether if you look at that geopolitically, or you look at that socially, people in power are not the first in line to say, 'Let me share some of my power with other people.' So there are systemic reasons for wanting to maintain power and control. And that's not just in sports is my point. So it's a power issue and it's still relevant today."

Tiffeny Milbrett is a good example of someone who, because of her background, training, and personality, didn't mesh with the system. She didn't relate to the concept of the sisterhood the same way her teammates did. Milbrett was and is an independent thinker who questions the status quo and controversial issues.

Despite her unconventionality, during the 1996 Atlanta Olympics, Milbrett could no longer be denied. The outlier from Oregon proved her merit on soccer's biggest stage. In some of the biggest matches in the national team's eleven-year history, it would be Tiffeny Milbrett who helped get them to the Promised Land.

The rift between the national team and U.S. Soccer over medal bonuses in early 1996 ended quickly. The national team took on their own federation and showed it they wouldn't be bullied or coerced. Now it was time to play soccer.

From January through June, the national team went 13-0. They played Norway twice during the period, winning one and losing one. Both teams were tournament favorites, and the gold medal for either team probably hinged on the unquantifiable 3 to 5 percent differential Dr. Coleen Hacker said stood between a gold medal and third place.

22

The Atlanta Olympics

The 1996 Atlanta games was the brainchild of advocate and business-man Billy Payne, who initiated the movement in 1987. Atlanta mayor Andrew Young got behind the drive and, along with fans petitioning Congress, put pressure on the Olympic Committee to beat out San Francisco and Minneapolis for the right to host the games.

As chief administrator for the '96 games, Payne had the formida-ble task of transforming Atlanta into an international city. He hired sponsors, built venues, and took a drug-infested section of down-town and turned it into Centennial Park, the epicenter for visitors to celebrate the games and its pageantry.

On July 27 tragedy struck when a terrorist's homemade bomb exploded in the park, killing one and wounding over a hundred peo-ple. The disaster delayed events but didn't diminish the Olympic spirit, and the games pushed on.

For the national team, Atlanta was the culmination of fifteen years of sacrifice and hard work. Everyone involved understood a success-ful showing could act as a springboard, and the players didn't make light of the opportunity.

As interest in including women's soccer in the Olympics grew, some cynics in the press got on the anti-women bandwagon; they called the national team unqualified and even used derogatory terms such as "amazons." Still, overall support for the concept was positive.

"We were starting to get a groundswell," recalls Tony DiCicco. "Of course, some people would say, 'Well, that's the Olympics. People

in our country rally around the Olympics, and people are going to support their Olympic Team,' so we still lived under this skepticism.

"But without question, we were building momentum and bringing in new fans. We had this debate on traveling to the opening ceremonies in Atlanta or staying in our training camp, where we'd be better rested and prepared. After talking with the leadership, we decided we couldn't deny the players the chance to experience the Olympics, so we went to Atlanta."

The opening ceremonies of the XXVI Centennial Olympiad took place in the newly constructed Centennial Olympic Stadium. As a worldwide audience looked on, athletes from all over the world paraded into the venue. As the host country, the United States was the last to enter.

Lining up in the stadium parking lot, the U.S. contingent weaved up a long flight of stairs before emerging into view through the tunnel. The athletes in their snazzy red blazers and white cowboy hats remained orderly upon entering, but as the crowd noise grew, they burst into the scene like kids on their last day of school. Fans inside cheered as everyone awaited the lighting of the Olympic Torch.

Suddenly the lights dimmed, and former Olympic champion swimmer Janet Evans emerged from the tunnel. Torch in hand, she sprinted to the opposite end, climbed a tier of stairs and handed the torch to another former Olympian, Muhammad Ali. Trembling from the effects of Parkinson's disease, the former champ lit the gas stream, and the flame shot toward a giant cauldron above. As the flame erupted against the dark Atlanta sky, athletes and fans roared their approval.

For one player in the U.S. congregation, the ceremonies were bittersweet. Michelle Akers, suffering from chronic fatigue syndrome, preferred rest over travel and remained in Orlando while her teammates flew to Atlanta. She tried watching the ceremony with friends but fell asleep.

Akers's stamina was a big concern. DiCicco had moved her to midfield, where she wouldn't receive as much punishment, but even with her strength diminished, Akers was still a threat. Back in February, the team had been sharing their training site with Bayer Leverku-

sen, the renowned German men's team. One afternoon after practice Akers and a few others decided to watch the German team work out.

"We were walking by, and Michelle was with us," recalls DiCicco. "The Germans knew who she was and so brought her in for a little pedestrian game. She ended up playing in their scrimmage and scoring a goal. Michelle's ability allowed her to play with the men. She couldn't play long term with the men, that's unrealistic, that's like the best WNBA player trying to play in the NBA, but for short periods, she could keep up."

Heading into the games, DiCicco knew Norway would be a difficult challenge, and his strategy evolved from the devastating loss at the previous World Cup and resulted in several innovations.

"The primary change I made was moving Lilly off the flank and putting her into an attacking midfield spot," says DiCicco. "I switched Akers from center-forward to the number six position, which is a holding midfielder. We kept three forwards with four defenders but had Chastain and Fawcett on either flank because they were like goal scorers."

Brandi Chastain's road to Atlanta had been an epic one. She knew she finally had arrived when she entered a conference room for a team meeting at their new Olympic facility at Sanford Stadium in Athens, Georgia. On the floor was a mountain of bags with the official U.S. Olympic Team logo on the side.

"It was like Christmas a hundred times over," recalls Chastain." At the time, I didn't know how amazing the Olympics were going to be. All I knew it was just special being a part of the Olympic family and national team again."

To reach the knockout round, the U.S team had to first get through the preliminaries held at the Citrus Bowl in Orlando and the Orange Bowl in Miami. Their group included China, Denmark, and Sweden. Before the opening match with the Danes, DiCicco held practice with rock music blaring from loudspeakers. "It got so loud the team couldn't hear each other," recalls Chastain. "Tony said, 'This is what it's going to be like at the Olympics, so you'd better deal with it.'"

Except for the 1991 World Cup final in China, the national team

had never played before twenty-thousand-plus crowds. With Olympic fever sweeping the country, interest had grown, and fans gravitated to the team. And for many, the focal point was Mia Hamm.

Mia-mania may have started a year earlier in Dallas, but it was about to peak in Atlanta. Shrieks of "Mee-aaa" echoed across venues every time she stepped on the pitch. The media fed the phenomena, and the national team had its face. Credit Mia for embracing the newfound fame. It was a distraction for sure, but one Mia could handle.

It would take more than one player to capture gold in Atlanta, though. The national team had worthy opponents with China and Germany, who would later win two consecutive World Cups in 2004 and 2008, but their main adversary was still Norway. To get to the finals, the teams would have to go through each other. Since the 1995 World Cup, the U.S. had been hot to avenge the loss in the quarterfinal. The teams despised each other. The U.S. named the Norwegians the Viking Bitches, while the Norwegians called the U.S. stuck-up whiners. Whenever they faced off, it promised to be epic.

The competition in Atlanta consisted of eight teams representing four confederations, with two groups of four teams. Group E included China, the United States, Sweden, and Denmark. Group F consisted of Norway, Germany, Japan, and Brazil.

Following the round-robin group stage, the two top teams in each group would advance to the knockout round at Sanford Stadium in Athens.

The group stage would be held in Miami, Orlando, Birmingham, and Washington DC. It would be the first time women participated in Olympic soccer, and matches would be tape-delayed on national TV.

The warm weather could prove a factor. Sweden and Norway weren't used to the sultry Georgia summers, but the U.S. practiced half the year in Orlando and had developed a tolerance.

Game 1, USA vs. Denmark, Citrus Bowl, July 21

Some twenty-five thousand fans greeted the national team in Orlando, which up to that point was the largest crowd ever to see them play in the United States. Tisha Venturini scored the first ever U.S. Olympic goal, a right-footed rocket from twenty feet out in the 35th minute.

Four minutes later, prior to a Denmark goal kick, Michelle Akers informed Mia Hamm she was playing too wide and to pinch in a few feet. Akers's thought was to take the ball off her head and send it downfield to Hamm, sprinting ahead in anticipation of the pass.

The play went off as planned. Akers directed the header to Mia, who dribbled through a wall of defenders and with a left-footed flurry drilled the ball into the top of the net, making it 2–0. In the 49th minute Tiffney Milbrett made it 3–0. The score stood, and the U.S. advanced to play Sweden.

Game 2, USA vs. Sweden, Citrus Bowl, July 23

In front of twenty-eight thousand fans in the 102-degree heat, Sweden did everything they could to slow down the speedier U.S. They were handed down eighteen fouls for their efforts, but their bunker-style tactics proved futile. It was Venturini again getting the U.S. on the boards first, in the 15th minute with her second goal in as many games. Shannon MacMillan, in her second start, also scored in the 61st minute, and Carla Overbeck's own goal in minute 64 made it 2–1 U.S. The U.S. had a scare late in the match when Hamm sprained her ankle and had to be carried off the pitch. Despite having qualified for the knockout round, the team was concerned. Without Hamm in the lineup, chances for gold diminished considerably.

Game 3, USA vs. China, Orange Bowl, July 25

DiCicco rested Hamm for the third match, but by now interest in the national team was building. Fifty-six thousand fans were on hand at the Orange Bowl, but without Hamm, the U.S. was notably flat. Despite outshooting China 19-7, the match ended in a scoreless tie. The higher total goal count thus far went to China, and that meant they would face Germany in the semifinal, while the U.S. took on the Group F winner, Norway.

Akers played three tough matches in six days, and following each game she collapsed in the locker room and was put on an IV. She was showing extreme courage and guts, and her teammates appreciated the effort.

With the move back to the Olympic Village in Orlando for the semi-

final, Akers had an extra day to recoup and get her knee drained. The upcoming Norway match was creating a stir, and the national soccer team, along with the U.S. women's gymnastics team, suddenly were the hottest tickets at the Olympics. Dr. Hacker had the foresight to put a program in place where players could concentrate entirely on performance. At the 1995 World Cup, ticket requests by families and friends got out of hand, but this wasn't the case in Atlanta.

"Families understood they weren't to come to us with ticket concerns or anything else," recalls Julie Foudy. "We had a system in place and a person to call with the information they needed. It eased the chaos from Sweden the year before of dealing with family to get them sorted and all the distractions."

Earlier in the year, the team adopted an "intern," Tony's son Anthony DiCicco, into their circle, and he was present the entire Olympics. Anthony's insider recollections are useful, particularly when it comes to Norway and the pre-match atmosphere.

"The team has been training in the Florida humidity every day for several months," recalls Anthony. "There had been long fitness sessions in the sun, and the whole time there's a chip on their shoulder to beat Norway. The team understood Norway is the team they have to beat. There are other teams, like China, that come into the picture, but Norway is the prime motivator. They never again want to feel the way they felt in Sweden after the World Cup, and this is a big part of the process coming into the Olympics."

As captain, Carla Overbeck reminded the players that Norway had been the tougher team in Sweden. Conditioning, therefore, was a priority. If the team was lacking, or the coaches wanted more, she wasn't afraid to let the team know it.

"During interval drills, they'd be dying, and I'd be, 'F—king Norway is doing something just like this, so we're doing five more!' I'm sure they hated me for it," says Overbeck.

Dr. Hacker's approach was equally effective. Her preparation included blindfolded trust walks on mountain cliffs, game playing, and team bonding drills.

"I didn't come in with a pre-prescribed program," says Hacker. "I wanted to meet the athletes where the athletes were. The Olympics

was going to be their moment, and I'd try to devise games, challenges, experiences they could participate in that weren't soccer related.

"They would have to communicate, deal with frustration, and overcome failure or difficulty, and they'd laugh at themselves because they would not be the best in the world in something. It was humbling."

As the pressure to win grew, media demands grew also, but the team went along. After all, it's what they had strived for all these years.

"The team had never experienced this kind of an exciting atmosphere," recalls Brandi Chastain. "After years of fighting for acceptance, we were like, 'Oh my God! Is this real? This moment is what we have been striving for.'"

Game 4, USA vs. Norway, Sanford Stadium, July 28

Historic Sanford Stadium in Athens, with its ivy-strewn walls and nearby rolling hills, served as an elegant backdrop for the semifinal match, and a record sixty-five thousand fans were on hand. In the previous matches, DiCicco started Akers at forward because he didn't want to tip Norway to his plan to use her as their center midfielder. Akers was there to disrupt play by deflecting head balls and distribute passes. She took on the challenge aware that with chronic fatigue syndrome she'd be in for a rough ride.

Norway drew first blood on a goal by Linda Medalen in the 18th minute. Midway through the half, Brandi Chastain injured her medial collateral ligament (MCL). At halftime, still down 1–0, staff coach April Heinrichs approached Brandi. "Can you play?" she asked.

"I need to have the knee taped," Brandi said, "I'm not sure."

"We'll take you with one leg," Heinrichs told her. "You're good enough with one, so you'll need to tough it out."

The atmosphere inside the locker room at halftime was tense, with the team down 1–0, and Akers was already showing signs of fatigue. Disrupting Norway's momentum every time they got the ball took its toll, and she'd hit the wall.

Ripping off her jersey, Akers fell to the floor in a heap and started moaning, "I can't do it." The team trainer, Steve Slain, rallied Michelle the best he could, fueling her with power bars and Gatorade. "You will finish, Mish," Slain said. "They need you."

Slain's words hit a chord. Somehow Akers mustered the strength and made it back to the pitch for the second half. She was running on fumes now, but she was needed. Norway's cut and run offence thrived on chaos, and with Akers bottling their momentum, they couldn't find their rhythm.

Despite being down by one coming into the half, the national team was confident. Even with Akers reeling, they maintained a mental edge. "We were down 1–0, and if you walked into our locker room in halftime, you thought we were up 3–0," recalls Mia Hamm. "There was no panic, Dr. Hacker just took all of us to a new level, and she just brought this infectious positive energy to everything we did. We walked out of that locker room, and we couldn't wait for the next forty-five minutes."

The U.S. tried to muster an equalizer quickly but couldn't penetrate Norway's defense, and then in the 77th minute, Norway's Gro Espeseth, a late substitute, was whistled for a handball in the box off a strike by Kristine Lilly. The ref called a penalty kick, and DiCicco surveyed the field to see who wanted it.

"Before the game, I named two or three players to take a penalty if we earned one," recalls DiCicco. "I looked out, and the other two walked away, but Michelle Akers looked back at me, saying, 'I want this.' She took it, and she buried it."

Akers fired a volley into the side of the net that had Norway's goalie Bente Nordby leaning the wrong way. A jubilant Akers did a series of leaps and then raised her arms in triumph. She had fought off pain and fatigue and stepped up when the team needed her. But with ten minutes remaining in regulation, and the score tied 1–1, the national team was not quite out of the woods.

Norway had been keying on Hamm all game, pounding her with body shots anytime she got near the ball, and in the final moments of regulation their dirty work caught up with them. In minute 75, after yet another flagrant hit, the referee whistled Norway for their seventh foul, resulting in a red card and immediate ejection. For the remainder of the match, the U.S. would have a one-player advantage.

While all this unfolded, Shannon MacMillan had been cheerleading. Mac had started all three games in group play, but today DiCicco

tweaked the lineup. He wanted a speedster to shadow Hegga Reesa, Norway's biggest threat, and assigned Tiffany Roberts the task. To make room for Roberts, he sat MacMillan.

"Tony figured we shut down Reesa, we disrupt their rhythm, and that would be to our advantage," recalls MacMillan, "and so I was on the bench the whole game. A few times Tony would say, 'Get up, you're going in,' and then say, 'Sit down you're not.' I was up-down-up-down, for most of the game."

Still tied, the match headed to golden goal: whoever scored first would be the winner. DiCicco waited six minutes into the period before calling on MacMillan.

"I was subbed in for Tiffeny Milbrett and was nervous," recalls McMillan. "On my first touch, the ball bounced off my knee out of bounds. Not the cleanest first touch, but it got the nerves out.

"Minutes later I see Foudy make a screaming run with the ball. She's crossing midfield, and I came in from the left side and made a long diagonal run. Foudy played me the most perfect paced ball. I didn't have to touch it. As I watched Foudy's ball slide through, I took a peek at the goalkeeper, and on my first touch guided the ball past her. After it went in, and I remember turning and sprinting and meeting Kristine Lilly. I leapt in her arms, and the rest of the team joined in the celebration. Suddenly I was at the bottom of a pile with the entire team on me. Tiff Milbrett, who I went in for, was actually on the bottom of the heap. How she got there faster than the people who were playing I have no clue.

"The whole time I was screaming underneath the pile, 'Is this happening, is this happening?' We're in the first Olympic games for women's soccer, going to the gold medal game, oh my gosh!"

MacMillan's heroics electrified the team, the crowd, and the nation. Not only had the national team avenged their dismal 1995 loss to Norway, but they were headed to the Olympic finals.

Game 5, USA vs. China, Sanford Stadium, August 1

To capture gold wasn't going to be easy. The national team had to take on powerhouse China, who just defeated top-ranked Germany. Another record 76,481 fans crammed into Sanford Stadium to watch

the rivals face off. Shannon MacMillan continued with her torrid pace, scoring early on a cross from Kristine Lilly in front of the goal and getting the U.S. on the boards first.

"It was one of those balls that just set up too perfect," recalls Mac-Millan. "I first-timed it with my left foot land buried it. After it went in, I turned, starting sprinting, and did a belly slide and then everyone came in over me. I helped put my team ahead, and it felt incredible."

China's Sun Wen responded with a goal in the 32nd minute to keep close, and the teams went into the half, tied one apiece.

Throughout the Olympics, Tiffeny Milbrett had been a model of consistency. As mentioned earlier, the 5'2" forward was as straight-forward and unorthodox as her play. She never got the notoriety of some of her teammates, but she was every bit the competitor. Frequently ranked among the team's top scorers, she was passed over by the press in favor of the more prominent names. Part of the problem was that Milbrett wasn't from Carolina. Tony DiCicco elaborates.

"We had a team full of UNC players, and if you weren't from Carolina, you were probably rivals and naturally hated each other," says DiCicco. "I had Shannon MacMillan and Tiffeny Milbrett from the University of Portland, two great players, but they weren't from Carolina, and I was having trouble integrating them in.

"What turned it around was Shannon loved kids, and Joy Fawcett had two. Shannon became close with Joy Fawcett's daughter Peggy. When that happened, she became Joy's best friend on the team, and they even had a house down in Florida they shared with the kids. Once Joy accepted Shannon, the team accepted Shannon, and once Shannon was accepted, Tiffeny was accepted. They figured if Joy likes you, you got to be a pretty solid person. Tiff and Shannon were both great goal scorers, so having those two integrated into the team was pretty important. I always thought Joy was the catalyst for that."

MacMillan credits Clive Charles, their coach at the University of Portland, for turning Milbrett into the player she became. "Tiff would come up with the most outlandish things," says MacMillan. "At Portland, we gave her the name 'No Tact Tiff,' and kudos to Clive, because he knew Tiff was a player. If you yelled at her, she was going to get pissed off and prove you wrong. I would probably cry and become

lost for five days, but Clive always knew how to get the most out of everyone.

"Tiff was also a character," adds MacMillan. "She was 'Queen of River Dance.' Foudy would be in the dining hall making her best-worst dance impressions, and we'd go, "Millie, give us a little River Dance." It was hilarious how those little legs of hers moved along with her facial expressions. Tiff was an original thinker, so she and Akers got along incredibly well."

Everyone agrees no one on the team could improvise on the ball like Milbrett. She also thrived in big tournaments like the Olympics where the pressure to produce was at its highest level. "Tiff was an incredible goal scorer," says DiCicco. "She had an overdrive gear where defenders thought they were closing on her, and she'd go back into that gear and just glide by them. She wasn't always the easiest to coach, and sometimes she wasn't as fit as I wanted her to be. I'd take her out at 70 minutes, and she'd be angry at me. I'd say, 'You're not 90-minutes fit yet,' but eventually she got there.

"She loved Clive Charles, and Shannon did too. I never reached that level with them, but I did reach a place where we would talk, share things, and build trust. I loved coaching Tiff because she made us so much better."

Milbrett admittedly had a rough go with her national team coaches early on, but once she got her chance to prove herself, she became a clutch component.

"I was there to do a job," says Milbrett. "I did it selflessly and wasn't an egomaniac. If I drove coaches crazy it was because I was a strong woman who had my own opinions, but I never let that impact my day-to-day performance and the job I had to do. That's the kind of player I was. I didn't change anything going to the national team, and I was always just me.

"I played the same way in college and as a youth player. Clive didn't try to fit me into anything. He said, 'Just go out and play your position,' and that's what I did. If there were certain things I needed to do, in terms of tactics, okay, I get that. I just played to my strength and to my physical capabilities, my instincts, and how I read the game."

In the 68th minute of the gold medal match vs. China, Tiffeny Milbrett finally got her just due.

Shannon MacMillan: "A pass came to me at midfield, and I played it through to Mia, who led Joy perfectly. Joy made this spectacular overlapping run. She's sprinting down the opposite side and plays this beautifully weighted ball across to Tiff."

Milbrett: "I was holding out, staying high. I'm not part of the direct piece when suddenly we're out of China's pressure, and I'm like, *what the heck, time to join the play*. I get myself in scoring position. I'm open, part of the play now. Joy slides the ball across, and it's in my zone. I'm laser focused. My thoughts are to finish well, keep the ball low and away from the goalkeeper."

MacMillan: "Tiff puts it away cleanly and we go up 2–1. She starts doing some forward rolls and stuff, so we celebrated with Joy for the great pass, while Tiff was off doing her own celebration."

Milbrett: "We're ahead now, but it's only the 68th minute, and we still have a chunk of game to play, and being up 2–1 is one of the most dangerous scoring lines in soccer. I got subbed out at some point, and it was up to the team to hold on and protect the lead."

MacMillan: "The vibe on the field now was 'let's finish it off.' For 18 agonizing minutes, we did everything we could to hold off China. Finally, Brandi picked up a loose ball and kicked it downfield to Carin Jennings-Gabarra, who replaced Mia, as a show of respect for the last match of her career."

As Jennings-Gabarra hustled to the ball, the final whistle sounded, the U.S. bench erupted, and they charged the field. Meanwhile, security was upgraded following the Centennial Park bombing, and the FBI circled the pitch.

MacMillan: "When that whistle blew, it was like, 'Man, we won, what a relief, and there you go.' Having never been a part of an Olympics, I'd never come close to seeing an Olympic gold medal, and now we're just about to get one. It's really kind of life altering. It's not like all of a sudden we go from D list status to A list status, but we could feel the respect level rise. It was just a dream coming true. I always wanted to be an Olympian, and I definitely wanted to win an Olympic medal, and now we had one."

The players had a few moments in the locker room, and a few sips of champagne were guzzled, before returning to the field for the medal ceremony. During the interlude, Michelle Akers sipped the bubbly. The team was astonished to see their leader get all rubbery legged and discombobulated.

"Watching Michelle Akers celebrate any time is memorable in itself, and this time was no different," recalls Brandi Chastain. "Mish is one of the most graceful and powerful players in the world, and then she turns into this uncoordinated celebrant. It's like an awkward jump, two feet off the ground, and her arms at different heights."

When the players finally made their way back out to the podium, it didn't seem like anyone had left their seats. "They blasted 'We Are the Champions' so loud it sounded like a rock concert," adds Chastain.

FIFA dispersed medals, the national anthem blared, and the American flag unfurled. "Several players shouted the Anthem badly," recalls Julie Foudy. Then the team posed for pictures and waved to the crowd one last time, before gathering by the tunnel, where they spoke briefly with NBC's Bob Costas for their only live coverage of the day.

"The shame of it was that America wasn't experiencing what the players were," recalls Chastain. "We wanted to share that experience with as many people as we possibly could. But that's something the team only thought about afterward."

Despite a lack of prime time, the Atlanta Olympics for the national team was a phenomenal success. The games were tape-delayed, and the latter rounds were covered extensively by print media around the world. The Olympics showcased a charismatic group of elite female athletes, whose winning style and exuberance were contagious.

For the five Olympic matches, the national team drew over 270,000 fans. They proved they could fill large stadiums, something organizers of the 1999 World Cup took into consideration.

The question now was could the U.S. maintain the momentum to get them through the next championship cycle and to their ultimate goal: establishing a professional league.

Building on the Olympics and promoting themselves as never before became their mantra. Anson Dorrance's salient cry "Sell the Game" echoed wherever they went.

The most significant buildup in their eleven-year history began the moment they received their Olympic gold medals, but the long road to acceptance and respect wouldn't come easy. Challenges to their dominance would spring from places far off the pitch, in the least likely of places, and to their biggest of stars.

23

The Mia Parables

Love the ball. Love the grind.

—MIA HAMM

Chapel Hill, 1993

One-on-one meetings with Anson Dorrance could be intimidating.
For her sophomore goal-setting conference, Mia fortified herself
before entering his office. Wearing her game face, she slid in through
the half-opened door and, before Anson could greet her, took her
seat in front of the desk.

Anson's little office was a shrine of soccer clutter. Stacks of recruit-
ing letters, soccer magazines, newspapers, old mail, and coffee mugs
covered the desk. It took a few minutes of digging to find Mia's file,
but Anson eventually found it. Flipping it open, he reviewed his notes,
and when he'd finished, looked Mia straight in the eyes.

"Mia, we're here to discuss something important. We both know
what you've accomplished here at Carolina the last two years, but we
need to think about what your goals are going forward."

Mia waited. She wasn't sure where Anson was going with this, and
if he had any more to say. Of course, she knew what her goals were,
but it was hard to put it into words.

"What do you want to accomplish here, Mia?" Anson asked. "What
do you really want?"

Mia wasn't sure what to say, so she settled for a safe response.
"To be a good soccer player?"

Anson nodded, smiled, took a sip from his coffee and leaned back in the chair.

"What do you really want?"

Mia shifted her chair. When Anson got like this, he could be very forthright.

"I don't know, more assists, goals," she replied.

Anson shifted forward his chair. It made a sudden creak.

"Mia, what is it that you really, really want?" he repeated softly.

Mia scraped her Adidas against the bottom of the desk and then nervously tugged her hair.

"To be the best," she exclaimed softly, surprising herself with her honesty.

"Do you know what the best is?"

There was another long silence. Then Anson rose from the chair, ambled behind Mia to the light switch, and clicked it off. In a second the light flashed back on, and Anson returned to the desk.

"To be the best is a light switch decision," he said. "That's all it takes. To be the best at something is a choice, a decision. But it takes a 100 percent commitment. And no one can make that choice but you. Not me, your parents, or your teammates. Only you."

Mia considered Anson's careful choice of words. To be the best in soccer had always been her unspoken goal. It's the reason she strived for perfection and why she worked so hard between practices and during the off season. She knew she had it in her to be the best, but she didn't want to disappoint herself or others by failing to maximize her ability. It's what in part drove her. But to see it as Anson saw it, greatness as a concrete choice—not fate, luck, or a wish—was as daunting as it was real.

Surprisingly, Anson didn't engage Mia further. He saw that she got it. He knew Mia subconsciously always knew she wanted to be the best, but for the first time, she had admitted it. Anson acknowledged her, and for Mia, it was empowering.

With nothing more to say, Anson excused her and told her she'd see her at practice.

After Mia left the room, Anson retrieved a pen from the pile and

wrote in her file, "1993—to be the best," and then placed the file back on the pile.

Mia walked out of the building, feeling much stronger and energetic than when she had walked in. She admitted her secrets and aspirations to Anson, and he said they were within her grasp. To hear it from someone so important in her life gave her confidence. As Anson said, being great was her decision, not his or anybody else's. She'd confessed to it, Anson wrote it down, and now she was free to pursue her dreams and goals on her terms.

It's no accident Mia Hamm became one of soccer's all-time greats and Anson Dorrance one of college's most successful coaches. It was also no coincidence that elite players such as Kristine Lilly, Carla Overbeck, Tisha Venturini, April Heinrichs, Cindy Parlow, Emily Pickering, and countless others were drawn to Carolina and came to revere Anson Dorrance and his staff.

During a dicey period in America when young women weren't sure what to do with their competitive desires, and when cultural mores were rapidly shifting, Dorrance picked up on the sea change. He permitted and pushed his players to pursue their goals, on their terms, without fear, guilt, or repercussions. Then with expert coaching and training, he pushed them beyond what they thought they were capable of. He allowed his players to break from society's oppressive sexist yoke and to view the world on their own terms.

Mia took the lessons from her sophomore meeting and ran with them. She fulfilled her goals at Carolina that year, scored dozens of goals, set records, won another championship, and then took the same passion and conviction to the national team and raised the bar.

For Mia, a light went on that spring day in Anson's office, a light that may have dimmed and flickered, but never entirely went out. Then, in early 1997, that light flickered like never before. Garrett, her beloved adopted older brother, had been diagnosed with aplastic anemia, an insidious blood disease. The illness was diagnosed several years earlier but had taken a turn for the worse. To survive, Garrett needed a bone marrow transfer, and he needed it now.

All this was terrible news for the family, most notably Mia. With-

out Garrett it's doubtful she would have become the player and person she became. Growing up, he had been her biggest proponent. To whatever city or town Major Bill Hamm's military career took the family, it was Garrett, the superior athlete, who made sure his kid sister was protected.

He taught Mia to throw a forward pass, hit a baseball, perfect her jump shot, and kick a soccer ball with force. With Garrett, Mia was never a tag-along little sister. He guarded her against bullies and the mean kids who called her a boy because of her short hair. With Garrett, Mia was always on the team, always by his side, always first.

Bone marrow transfers are tricky, and matches can be hard to come by; the fact that Garrett was a Vietnam War baby made it that much harder. Garrett's biological father had been an American soldier when he met his Thai mom, and they were difficult to locate. The Hamms seemingly waited forever to find Garrett's biological dad and eventual match. When they finally found him and the operation took place, a preexisting fungal condition was reignited, and the disease went to Garrett's brain.

Mia was in Georgia, at the Olympics, when all this was going down. Garrett managed to somehow get to Atlanta to see his kid sister win the gold medal. Still, to see her brother deteriorating was terrifying, and to make matters worse, he had a wife and infant son.

Mia suddenly had a lot more to worry about than soccer. By the time the 1997 season began in late February, she was still an emotional wreck. Stretched at both ends, she played four matches and even scored a goal, but her mind was elsewhere.

Mia was with the family when Garrett drew his last breath on April 16. He was in a coma, but she was able to say goodbye. When the national team resumed play on April 24 for their six-city Women's Cup series, Mia was notably absent. She understandably missed the first two matches, but her teammates hadn't forgotten her. They wore black armbands in honor of Garrett, and when Mia saw this on TV, she about lost it. It was then she knew, as much as it hurt, she needed to be back on the pitch with her teammates.

Tony DiCicco remembers: "We were in the tournament and we played a friendly down in Tampa, and our next game was in Milwau-

kee. Mia wasn't there for the Tampa game, but for the next game she said she wanted to come in.

"It was pouring in Milwaukee. There was standing water on the field, and I wasn't sure we would even play, but we got it in, and in the first minute of the game Mia scores. The team celebration after was unforgettable.

"Mia told me she needed to be with her teammates because losing her brother was something she could barely handle. As a young girl, he was the one that brought her along when they would go to the sandlot and play pickup. He would get her on his team and regardless of the sport, whether it was football, soccer, basketball, made sure she played.

"She looked up to him and loved him so much, and then she lost him. She mourned, but after a few days she felt she needed to be with her team. She got support from her family, but now she needed her sisters.

"All I knew was I was nervous and wondering how she would handle this, but she scored a minute into the game and scored again 18 minutes later. Then Shannon MacMillan scored, and Tiffeny Milbrett, and Christine Rampone. It was 4–0 at the half, and we ended up beating South Korea 7–0.

"From here on out, Mia would use Garrett as a source of inspiration. When he had been ill, she started a foundation based on his disease that worked with families who needed organ and bone marrow transplants. Her group is all about helping families deal with it all. She put her pain into helping others so they wouldn't have to experience what she went through."

"There was something unique about Mia, our team, and that particular bunch of girls," says Kristine Lilly. "We were tight and all part of the leadership, in one way or another, and it was partially due from Anson and Tony getting the right captains for us, and the players wanting to fulfill what the captains and staff wanted.

"Mia wasn't a captain. She led by tearing defenses apart and promoting and speaking on behalf of the team. She's a smart and caring person and also super funny, but outsiders never saw that. For

instance, we'd always tease Mia about her haircut. Back in the day it was like a little mullet. She was the first one of us to get a big commercial, and it was for her hair, of all things, Pert Plus.

"She went to shoot the commercial, and they had her shake her hair out like a model. So when she came back, we're all going, 'Hey, Mia, how was your trip?' and then we'd all shake our heads out like she does in the commercial.

"We'd laugh and give each other shit because it kept everyone humble. It's a game of soccer, not rocket science, and if you're gonna give it, you're gonna get it back. It was the same on the field: if you're going to tear someone up, someone's gonna come after you next time.

"I realized, after the fact, Mia felt she missed out. She told us once, 'I missed so many great moments on the bus with you guys because I was doing media.'

"I never really thought of it that way. For us it was always, 'Mia has her interviews; she's talking up the talk and promoting us.' There were times we were waiting on her, but it turns out it was actually hard on her because she missed the laughter on the bus.

"I played behind her mostly, and sometimes I played up front with her, so I'd get a good view. I would have to catch myself sometimes because she'd get the ball twenty yards out, and she'd line up her defender, and I'm thinking, *She's gonna tear it up right now*. I'd spectator a little bit, then I'd snap out of it. She may need me if something goes wrong.

"Mia was a competitor, a perfectionist, and she wanted to be able to help her team, and her way of helping was scoring and assisting. She had an intense game face, a look that said, 'No one's messing with me today.' The media and their cameras were always on her. If the media claimed she was in a slump, and not scoring, her eyes would show that heat.

"Not many people could handle what Mia did and be as successful. I got nothing but respect."

When it comes to those who respect Mia Hamm, include her coach, Anson Dorrance. Mia was a prime example of an elite athlete who overcame the challenges national team players faced with their fit-

ness during long lulls between matches. The lack of yearlong train-
ing facilities forced U.S. players to become self-sufficient. Hamm was
among several at Carolina and on the national team who were self-
motivated, to the point of exhaustion.

Nothing shows that drive to excel more than what Dorrance wit-
nessed on a cold February morning in 1993. For the ten- to fifteen-
minute commute to his office at UNC, Dorrance took the Estes Drive
extension from his home, before making a left on to MLK. Then a
right after the police station onto a couple of side streets before arriv-
ing at his campus office.

When he wasn't rushed, Dorrance might take the longer, scenic
route. Instead of turning onto MLK, he'd veer left at Umstead Dr. and
drive past woodsy, tranquil Umstead Park.

This day, Dorrance chose the scenic route. Driving past the park,
he noticed a figure near the playground doing what appeared to be the
Carolina soccer endurance drill known as cones. Curious, Dorrance
slowed to watch. Realizing it was one of his kids, he turned into the
parking and observed the athlete do a series of five and back cones,
then ten and back, and then twenty and back. That's when it hit him.

Oh my gosh, that's Mia.

"She was out there basically killing herself," recalls Dorrance. "I
mean hot air shooting from her lungs, sweat flying off her brow. I
was just so impressed; I couldn't wait to get to work. I didn't tell Mia
I was there. I zipped into the office, scribbled a note to her, dropped
it in the mail, and forgot about it."

When Dorrance saw one of his players do something extraordi-
nary, he'd often drop them a note. What impressed him most about
Mia that day was she was in the second semester of her senior year,
soccer season was over, yet here she was, running cones like she's
prepping for the World Cup.

Imagine the surprise six years later, when Dorrance received a
copy of Mia's new book, *Go for the Goal*, in the mail. And there on
the bookplate was the note he'd written to her. *The vision of a cham-
pion is someone who is bent over, drenched in sweat, at the point of
exhaustion when no one else is watching.*

That passage has since become the standard for athletes determined to make the needed sacrifices to maintain peak performance.

"For me, the important part of that quote is *when no one else is watching*," says Hamm. "It's easy to be motivated when someone's cheering you on, but do you continue to hold the same standards when no one is watching?

"We knew what the time stamp was on those cones and what the distance was. There were times in the season when the five yards apart were more like six yards, and then toward the end of the season it was more like four. But you knew what was expected of you.

"The day Anson drove by, I could have run eight cones and no one would have known any different. But what the women at Carolina and the national team taught me was, as long as I maintained that high standard, I could grow to the level I felt I could grow.

"To me, that meant so much; I was about to take a step into the unknown. I was graduating from college and leaving a controlled environment that helped me develop. I was about to go into an area where I once again had to go back and to train on my own. I often asked myself, 'Was I ready?'

"That note from Anson told me I was ready."

24

Storm Clouds

My favorite planet is the sun.

—TONY DICICCO

The national team played a full slate in 1997, including a victory tour spanning six months and several major U.S. cities. The goal was to build on their Olympic successes, grow the team brand, and prep for the 1999 World Cup, scheduled for the United States. Once again their rallying cry was, "Sell the Game," as U.S. Soccer made ambitious plans, and the coaching staff made adjustments to keep the winning momentum.

The national team flourished in that season, going 16-2. The list of impressive newcomers included Sara Whalen, Ronnie Fair, Michelle French, and Christine Rampone. Among those who debuted in 1996 were Lorrie Fair, Cindy Parlow, and Danielle Fotopoulos.

Mia Hamm rebounded from her devastating personal loss, leading the team in scoring en route to being voted 'Player of the Year,' while thirty-two-year-old Michelle Akers, her game diminished by injuries and chronic fatigue syndrome, fought hard to make an impact.

By the time 1998 kicked in, DiCicco reestablished himself, and it was due in part from sage advice Hamm gave him. DiCicco came to the realization that to be an effective coach with women, he needed to adapt and rethink some of his principles, attitudes, and strategies. One morning he heard Mia say something on a radio interview that struck a nerve. She was explaining to the commentator how coaching women differed from men, and she used the phrase, "Coach us

like men but treat us like women." When he heard it, DiCicco did a double take. He could have sworn she was talking directly to him.

"It made a lot of sense," recalls DiCicco. "Mia was saying, 'Don't think we women can't do fitness standards that men do. Don't think we can't work as hard, and that a training session should be less intense, or you should demand less of us.'

"She was saying, 'Treat us and coach us like any elite man player, but treat us like a woman,' meaning, 'Don't get in our face, don't belittle us, and don't yell at us.'

"Sometimes, I crossed the line with my passion, but the players knew I cared about them not just as players but as people. Mia's quote is also a great lesson in coaching men. I have four sons, and I learned a lot from coaching women how to coach boys."

DiCicco eventually tweaked his approach, and his players responded in kind. A DiCicco standard became him shouting as he entered the pitch, "I love this job!" His optimism was infectious, and the team became closer.

"I loved helping my players when they had a family issue or something hard for them to resolve," adds DiCicco. "They knew that I was there for them. I think they felt that I was a player's coach, but there were times that I crossed the line.

"We were playing a tournament in Guangzhou in 1998. We ended up winning, but I thought we played awful. When it was over, Carla and Julie came into my office and said, 'Are you going to cut us and bring in some young players?' I said, 'No, there are going to be some young players challenging for spots, but I think we have the nucleus here to win next year.' Julie said, 'Well, if you're not going to cut us, stop yelling at us.'

"I thought about what she said. A few weeks later we had a training camp at the Olympic training center in Chula Vista, and before we opened, I told my staff, 'We're not going to coach in the traditional style this week. If you see a mistake, freeze and tell them, 'Okay, that's good, but I think this is better.' Let's correct it on the spot, bite your lip, and wait until you see it done right. Catch them being good, and then celebrate that.

"We coached that way the entire week, and afterward Carla and Julie came in and said, 'This is awesome, we love this week.'

"So I coined the phrase 'Catch Them Being Good,' and it's been a part of my coaching philosophy ever since. Do I still make a mistake once in a while? Sure. But I try to celebrate the right plays and coach positively what I would perceive as mistakes."

In terms of achievement, by 1998 the national team women were becoming more successful than the U.S. men's team. At the '98 World Cup in France, the men finished thirty-second out of thirty-two teams, but the low finish was made worse by the constant finger-pointing. The U.S. coach was calling out players, and the players were calling out the coach, and both of them were calling out U.S. Soccer. It got to the point the men's side was in jeopardy of losing their sponsors.

Except for Nike, the sponsors were not going to stay on; and going into 1999, it became important the women's side not suffer the same fate as the men and lose sponsors. That meant there was enormous pressure on the team and the staff to keep winning.

Assistant coach Lauren Gregg, who witnessed the politics and felt the pressure firsthand, says DiCicco handled it all as well as anybody could.

"They were questioning Tony's open leadership style," says Gregg. "He masterfully integrated the players' input and still guided the ship, but there was the perception from U.S. Soccer that the players were steering the ship. The truth was they were fighting hard for what they thought they deserved and bringing attention to the basic things we needed as a team to function.

"But U.S. Soccer felt like the players were ungrateful. 'We're giving you residency now, and so you should be happy.' It wasn't that the players weren't unhappy as much as they were trying to fight for a different way for the next generation.

"So, Tony had this huge responsibility. He had to navigate how U.S. Soccer felt about our growth, but also have the players' 100 percent support, and on top of that, we had to sell and win the World Cup.

"The amount of time that we had to relegate to media, school visits, and interviews was way beyond what most people would tolerate,

but we had to juggle the responsibility, and we had to keep winning, sell the game, and fill the stadiums.

"It was clear to us if we didn't win and fill those stadiums, there would be no professional league. A lot was happening fast, and part of it was the growing pains of U.S. Soccer. The national team didn't evolve slowly; it happened in less than a decade. We went from nothing to full-time professional athletes and childcare, so all this was new.

"All we ever fought for was what we needed to be successful. Joy Fawcett needs her children with her versus leaving them home for six months. For her and us to be successful, you do what it takes. If a guy needed that, you do what it takes. That's all they were after."

With the '99 World Cup less than a year away, the last thing DiCicco needed now was more distractions. But nasty headwinds were fast approaching that he had no control over. Headwinds, if not addressed prudently and swiftly, could threaten not only his job but the entire fabric of the national team.

25

The Elephant in the Room

In 1998 Debbie Keller was living the dream. A solid national team forward since 1993, Keller was third on the team in scoring and a strong contender for the 1999 World Cup team. Keller came to the national team via the University of North Carolina, where from 1993 to 1996 she was considered one of the best players in the country. Twice named National Player of the Year, Keller helped lead Carolina to three national titles. Since joining the national team in 1993, she had been a spot starter with over 40 caps and 19 goals.

Then in 1998 it all came crashing down. In May a former Carolina teammate, Melissa Jennings, an out-of-shape, walk-on goalkeeper was cut by Anson Dorrance. A week later Jennings marched into the chancellor's office and accused Dorrance of sexual harassment.

Jennings, who is Mormon, claimed that Dorrance, also a Mormon, told players on her first official visit to the school to go out and get her drunk. Jennings claimed Dorrance violated her religious rights, adding he once borrowed $400 from her to buy the team Gatorade and never paid her back. Far more lethal, Jennings inferred Dorrance had a pattern of inappropriate remarks and behavior with the players, and she demanded he be fired.

Dorrance denied the charges, and the university conducted an internal investigation. They concluded that at the time Dorrance may have "engaged in inappropriate sexual banter but had done so in a jesting or teasing matter."

The board did agree Dorrance violated the universities guide-

lines; the school issued letters of apology, and Dorrance received a reprimand.

Incensed, Melissa's father apparently wanted more, and he demanded Dorrance be immediately fired. When the board refused, Jennings sued the school for $12 million, claiming by discussing sex with members of his team Dorrance denied his daughter the benefits of collegiate athletics, violating Title IX.

The suit also included members of the coaching staff and several UNC officials who Jennings alleged were aware of the events but did nothing to stop them.

Publicly the incident went unnoticed until later that July when Debbie Keller, who was currently on the national team, joined Jennings in the lawsuit. The case sent shockwaves through the soccer world and the national team.

At the time eight former Tar Heels were on the national team roster, and their response to Debbie Keller was harsh. A strongly worded letter defending Dorrance was circulated and signed by the current team and over a hundred of Dorrance's former players.

The letter claimed Keller's accusations were false, biased, and absurd. Signers included Mia Hamm, Carla Overbeck, Tisha Venturini, and Cindy Parlow.

But not everyone sided with the pro-Dorrance contingent. There were detractors whose doubts and opinions were expressed by some and not expressed by others. The Carolina faction robustly opposed Keller's charges, while several non-Carolinians were either pro-Keller or indifferent.

"I don't have a ton of intimate knowledge," recalls Julie Foudy. "I didn't know Debbie that well, but I just remember it being a huge stress for the staff and the group in terms of the staff, but not necessarily for the players. But for the staff, it was something you could tell they weren't discussing, but it was like this tension that lurked."

Fearing irreparable damage that could fragment the national team, Tony DiCicco decided to address the issue head-on. "I had players angry with Debbie and players who were supporting her," says DiCicco. "I had players that hated UNC because they won all the time, and I had Kristine Lilly dating Debbie Keller's brother. The thing was

festering, so I called Colleen Hacker in and said we need to address this, and she agreed."

The national team was at the University of Richmond on September 20 preparing to play Japan in the final match of the USA Cup, when Hacker addressed the group.

"Colleen got one of those big mobile, rectangular, rolling coat hangers you see in hotel rooms where you can hang your coats," says DiCicco. "She put the contraption between herself and the team, and she started talking to them about normal mental skills, and the whole time she's kind of working her way around the hanger. Finally, one of the players says, 'Hey Colleen, do you want me to move that coat rack?'

"Colleen says, 'Well, funny you brought that up because just as the rack is a distraction to you guys, you have a big distraction on the team right now. And the way you handle it is going to determine your success or lack of success.'"

"I see the coat hanger, and I'm thinking, 'What the hell is this?'" recalls Shannon MacMillan. "Then I started to giggle. I was like, 'Uh-huh, I wonder how this is going to go?' But it worked."

"It was a great way of bringing out the elephant in the room," DiCicco adds, "that invisible factor everybody knew about but was not addressing how to handle.

"So, next Colleen draws up three circles. One circle was the legal process, another was the team, and the last one was your personal feelings. We talked about not letting those circles intersect. They can touch, but they can't cross because once they start overlapping, everything is affected.

"It was a moment Colleen and I thought had a big impact on what we were going through. It didn't work for everybody, but each person on the national team now understood their personal feelings and the legal process were separate entities and had to remain separate."

Despite the turmoil, Keller remained productive, finishing the season with 14 goals, numbers usually good enough to be called back into camp, but with the lawsuit pending, nothing was certain.

In January, when DiCicco posted the twenty-six-player Florida residency camp roster, Keller's name was missing. When the *Chi-*

cago Tribune questioned DiCicco about her omission, he claimed it had nothing to do with the lawsuit.

"Debbie Keller is a very talented player, but there are a lot of very talented players who didn't get invited into residency," DiCicco told the *Tribune*. "The reason she wasn't invited doesn't have anything to do with chemistry; it was about where we think she is with her game and where it will be down the road. It's one of those difficult decisions, but she is an outstanding player."

Keller believed the omission was in direct retaliation to the lawsuit and filed for arbitration. The incident, meanwhile, was getting consumed by the media. On February 28 Keller told her side to *Newsweek* magazine. In an article titled "I Belong on That Team," Keller said Dorrance created a hostile environment at UNC. She denied any direct sexual misdoings but claimed he would call her frequently and monitor her activities, and occasionally he would touch her head and stroke her hair.

Keller told the reporter she had received several handwritten notes from Dorrance she believed crossed the line. The *Newsweek* article also included some of the more graphic examples.

The Carolina contingent took exception to the article, insisting Dorrance's coaching style had nothing to do with sexual innuendos and intimidation. "I have personal letters Anson wrote me saying how much he believed in me," says former Carolinian Carla Overbeck. "The reason Anson was such an incredible coach was that he made you believe he genuinely cared about you as a person. He had a way to connect with his players. He and his assistant, Bill Palladino, made you think you were unique and one of the most important players they ever had.

"As a player, you wanted to play hard and win for them. You would do anything for them because of the special bond they cultivated. Anson and Bill started coaching together in 1979, and it was incredible how you felt loved by them. We knew Anson would do anything for us, and in return, we would kill for him."

The very week Keller filed arbitration, U.S. Soccer invited her back to camp, but to many of the players she had become a pariah. At a team meeting, she tried to tell her side, claiming, "I didn't do this to

hurt the team." But by now DiCicco had had enough of Debbie Keller. He cut her the following week on the grounds she was out of playing shape and couldn't help the team.

"Tony had to make sure we didn't divide the team over this," adds Overbeck. "The Carolina people had a different opinion than the non-Carolinians because we were around Anson firsthand and privy to certain information.

"I had an opinion because I was close to the situation, but when it came to cutting her, I was with Tony because I didn't want the incident to break up our team.

"It was hard, but I had to put my emotions aside so they wouldn't negatively affect the team. Even though I felt very profoundly and passionate about something, I had to do what was best for the team, and so I was all in with Tony. It was just something I had to deal with internally.

"Colleen Hacker was very, very important to us during that time," adds Overbeck. "Our team could have divided, and she stepped up brilliantly. She was there for us individually and as a group and did team exercises that helped us deal with what we were going through. She was incredible."

Debbie Keller's arbitration hearing was scheduled in Chicago on May 9. DiCicco was ordered to attend and was noticeably on edge. On May 2 the team was preparing to play Japan on their "Nike Road to Pasadena Tour."

They were in the middle of a scrimmage at Emory University in Atlanta when DiCicco started shouting at Shannon MacMillan. "When are you going to start scoring, Mac?" he screamed. "How do you expect to make the team playing like that? Pick it up!"

Pressure from the Keller incident caught up with DiCicco, and he was venting his frustrations out on Shannon. Somebody had to step in and let him know his tirade was detrimental not only to Shannon but the entire team.

As captain, Carla Overbeck was never one to shy away from confrontation. In this case, Carla was privy to information that Shannon wasn't aware of and that caused DiCicco to blow up.

In front of the entire team, Overbeck stepped in front of DiCicco

and let him know in so many words that he was out of line needed to tone it down. After that, things settled, and the scrimmage continued with no additional flare-ups.

"I knew why Tony screamed at her, and it had to do with his frustrations," recalls Overbeck. "But he took it out on Mac, and that wasn't fair, and it's why I jumped in. Being a captain, I felt I could not let it go on without someone saying something.

"Shannon couldn't fight for herself because she was still on the border of making the team. It wasn't pretty, and it got really emotional, but I know Shannon was happy someone stood up for her and said something to Tony. And I loved Tony. I just felt he wasn't fair to one of my teammates."

MacMillan's recollections are equally poignant.

"I was overly emotional with Tony, and it devastated me," says MacMillan. "I remember the awkward walk to the bus, but Carla had a word with him, and Tony stood up in the bus and apologized.

"Afterwards, I wanted to crawl in a hole, but then Carla came to my room, put her arm around me, and said, 'Shake it off, Mackie. We got your back here. You're fine.'

"I said, 'Thank you for standing up for me.'

"Carla said, 'Of course I'm going to stand up for you. What Tony did wasn't right. I don't care if it's the coach, teammate, or friend, I don't want to see my teammate treated like that.'"

There were never any ill feelings between DiCicco and Overbeck over the incident. Carla understood the pressures he was facing, and she held no grudge.

"I knew Tony was fighting with the federation over something, and he was just frustrated," adds Overbeck. "Airing out players was not Tony's personality. It was ugly for a little bit, but as far as any carryover, there wasn't any. We forgot about it and moved on."

On May 9 DiCicco flew to Chicago for Keller's disposition hearing. The following day the three-lawyer arbitration panel returned with their verdict. They ruled U.S. Soccer had committed no wrongdoing in not selecting Keller to participate in the six-month-long training camp that began in January in preparation for the next month's World Cup.

The case was dismissed. Keller had underestimated the fierce loyalty her fellow Carolinians had for their former coach. The question remains: Was justice served? Was Dorrance guilty, or were the accusations trumped up to coerce Dorrance and the university for financial gains?

The only ones who know for sure what happened are Dorrance and Keller. As far as the players, if somebody knows something, they've kept it to themselves.

"I honestly don't know," says Carla Overbeck. "I wasn't there. Clearly Debbie felt something was valid, or you wouldn't sue somebody. But in regard to Anson and Bill Palladino: I can only speak for myself, but I can only say how special those two men made you feel as a player at North Carolina."

Shannon MacMillan's take reflects what most of the team were thinking at the time of the incident. "There was a lot of whispering going on, but I don't know enough to speak conclusively on that," says MacMillan. "From where I was standing, they handled it properly because it didn't become a massive issue. I think that's a credit to the team. It wasn't 'whose side are you on, and let's see' type thing. My take was that it was handled well, in terms of not splintering or become a massive issue that could derail us."

Debbie Keller's career with the national team came to an abrupt end in 1999. She played international soccer in Europe for a couple of seasons and then retired. Eventually, she returned to Raleigh, got married, and went to work at a beauty salon.

In 2004 she accepted $70,000 from the university. The money barely covered her legal costs and was a pittance to what she could have earned had she remained with the national team and made the World Cup roster.

At the University of North Carolina, any mention or likenesses of Debbie Keller for the most part have disappeared.

Melissa Jennings and her father continued to pursue their lawsuit against Dorrance and the university. In 2008, as a means of resolving the case, Jennings accepted $385,000 from the school and a written letter stating: "Dorrance and the coaching staff never made a pass at her or asked for a sexual relationship, but that Dorrance and the

coaching staff did make multiple overt sexual comments that were uninvited and offensive."

Throughout the ordeal, Dorrance and the university steadfastly denied the charges. As part of the settlement, Dorrance attended sensitivity classes for eight years. As of today, Dorrance is still coaching Carolina and is a revered elder statesman. He is still married to his wife, M'liss, and has five grown children.

PART 3

TO THE CUP

26

Lightning in a Bottle

Los Angeles, 1966

The large legal bundle was imposing, and like a disgruntled lion, Jack Kent Cooke, bundle in tow, stormed the tiny office where attorney Alan Rothenberg was stationed. He didn't mince any words. "There hasn't been a contract written yet that can't be broken," he roared. "You get me out of this!" And with that, Cooke dropped the bundle on young Rothenberg's desk and marched off.

In 1966 no sports impresario loomed any larger in Los Angeles than Jack Kent Cooke. Ever since he tried and failed to get an American League expansion team to play in his native Toronto in 1959, he'd been scooping up sports franchises like they were baseball cards. First he bought 25 percent interest in the Washington Redskins in 1961. Then it was the LA Lakers in 1965, followed by the LA Kings expansion team in 1966. Of course, he needed a place for them to play, so he built the Fabulous Forum in Inglewood to showcase his two teams, though legally they couldn't play there yet.

The problem was when he purchased the Lakers, and then the Kings, Cooke had to prove to the NBA and NHL he had a venue for them to play, so he cut a deal with the LA Coliseum Commission to use the LA Sports Arena. Now, with the Forum completed, he needed to get out of the Sports Arena contract so he could showcase his new teams at the Forum.

No one knows why Cooke chose the seemingly inexperienced Rothenberg to take on the formidable task. He certainly had his pick

of seasoned lawyers from the prestigious firm of O'Melveny & Meyers. Whatever his reasons, Rothenberg was man of the hour, and as he stared at the thick sheaf of legal papers cast before him, he considered his options. He could pass on the case, forsake the imposing Cooke, retreat to his prestigious firm, and insist on litigation more suited to his experience, or he could take on the challenge.

Rothenberg's passion after politics was sports. He'd played several as a kid in Michigan and loved the competitive high and excitement that came with them. He looked at the imposing package on the desk and started skimming pages. While Rothenberg reviewed the material, his old competitive instincts kicked in. They were telling him to take the challenge.

Rothenberg argued that Cooke had made the Sports Arena deal under duress. At the time, the public was excited about the Forum and was looking forward to the new state-of-the-art venue. Bowing to the political and public pressure, the Coliseum Commission backed off, Cooke prevailed, and the Kings and Lakers had its new showpiece.

From there Rothenberg moved quickly up the corporate ladder, litigating monumental deals with Cooke that turned the LA Lakers into a storied franchise, forever changing the professional sports landscape in LA.

Rothenberg also assisted Cooke with the purchase of the LA Wolves, a nascent NASL soccer team that survived until 1968. Rothenberg was Cooke's attorney when the LA Lakers won their first NBA title in 1972, and he helped bring Kareem Abdul-Jabbar over to the team in 1975. Rothenberg eventually quit Cooke and headed a group that bought the LA Aztecs, another NASL team, and then sold them in 1980, before the league's demise.

In 1984 Rothenberg had another breakthrough when LA Olympic organizer Peter Ueberroth made him commissioner of soccer for the games. Surprisingly well attended, the Olympic matches included multiple sellouts at the Rose Bowl. The '84 Olympics proved that soccer in the United States had the potential to draw large crowds and that Rothenberg had the talent to host successful tournaments.

With soccer's success at the '84 Olympics, FIFA awarded the United

States the right to host the 1994 Men's World Cup. The same year Rothenberg was elected president of U.S. Soccer.

Under Rothenberg, the '94 World Cup was a rousing success. By staging matches in large stadiums, the tournament made a $50 million profit, proving soccer fans will come out in droves for the right event. Building on his growing clout, in 1996 Rothenberg established the MLS, the first successful professional men's outdoor soccer league in the United States.

Until then Rothenberg's soccer forays had been on the men's side. With soccer exploding in the country, he felt the time was ripe for U.S. Soccer to step up efforts on the women's side as well. In February 1996 Rothenberg made a bid to FIFA's Sepp Blatter to host the 1999 Women's World Cup in the United States. Blatter approved, and the U.S. joined Australia and Chile as candidates to host the event.

Meanwhile, the 1995 Women's World Cup, in Sweden, wasn't generating cash. FIFA staged the tournament in undersized venues scattered across the country and then failed to promote it. The matches were played before crowds of five thousand or fewer. Ticket sales were minuscule, with only five thousand fans present to witness the climatic USA vs. Norway semifinal. Fearing a similar financial disaster, Chile and Australia backed out of the running for the 1999 World Cup, leaving the United States the sole candidate.

Blatter was relieved the U.S. was still in play, but when Rothenberg hinted at staging the tournament in football venues, Blatter balked. Fearing half-filled stadiums, Blatter insisted on staging the event in smaller stadiums all in the U.S. Northeast to limit travel expenses.

Filling large venues was not doable in FIFA's eyes. Then the Atlanta Olympics came along, and everyone's perceptions changed. Women's soccer in Atlanta was a huge success at the games, proving that under the right conditions, the women could sell out football venues. All this didn't go unnoticed by Rothenberg's ambitious assistant Marla Messing, who was present in Atlanta and saw it all firsthand.

Following the Atlanta games, Rothenberg called Blatter again. This time when he insisted the World Cup take place in larger stadiums, Blatter agreed, but only if U.S. Soccer would foot the bill. FIFA wanted to be off the hook if Rothenberg's lofty ambitions came up short.

By accepting financial responsibility, Rothenberg stepped out on a limb. There were no guarantees he could fill football stadiums. What if the U.S. lost early and didn't make it to the knockout round, much less the final?

With all this on his plate, and U.S. Soccer's reputation on the line, Rothenberg turned to the one person he believed had the grit, talent, and brainpower to make the deal work.

Marla Messing was twenty-seven when she met Alan Rothenberg at their LA law firm Latham & Watkins in 1991. Although she was some twenty years younger, Rothenberg appreciated Messing's ability to close deals. At the time Rothenberg was president of U.S. Soccer and chairman and CEO of the 1994 Men's World Cup organizing committee. When Rothenberg let on he was looking for an administrative assistant, Messing was all ears. Rothenberg brought her in at an entry-level position, but she proved so valuable he named her chief of staff.

"Alan had a sense of my work ethic," recalls Messing. "He gets up at four o'clock in the morning, and when he got to the office, I would already be there. I think that caught him off guard."

Rothenberg eventually made Messing his executive vice president in charge of ticketing, entertainment, and special events. Messing helped sell a record 3.5 million tickets, bringing a record sixty-four thousand fans per game and generating an operating surplus of over $60 million.

The 1994 World Cup proved Messing had the savvy to pull off big-time events. When it came time to draw up a business plan for the 1999 Women's World Cup, Rothenberg made her president and chief executive.

Using the 1996 Olympics as a prototype, Messing pulled together a team of extraordinary women who shared her vision. For the organizing committee chairperson and CEO of the event, Messing picked world champion swimmer Donna de Varona. An advocate of Title IX and cofounder of Billie Jean King's Women's Sports Foundation, de Varona brought to the table formidable organizational skills and a golden Rolodex. De Varona knew everyone from entertainers and media moguls to politicians and national broadcasters. With de Varona,

the 1999 World Cup went from a vision stage to reality stage very quickly.

Using her Madison Avenue connections, de Varona placed national team players into commercials, major network interviews, and celebrity All-Star soccer matches. One such match took place Boston, where Red Sox shortstop Nomar Garciaparra met his future wife, Mia Hamm.

Meanwhile, the national team took to the road for a series of friendlies at the tournament's host cities. Players appeared at clinics and schools, signed autographs, posed for pictures, mingled with the press and fans, and even took ticket orders. They sold the game at the grassroots level, knowing each youngster they met was a prospective new fan.

"People gravitated to this team because they were identifiable," says Tony DiCicco. "They were the girls-next-door type and represented what Americans love in their sports athletes. They were accessible, tough, athletic, and committed, and win or lose, exemplified a respectful attitude."

Success, of course, was reliant on the team winning, and there were no guarantees. China and Germany were worthy adversaries, but if the United States had an advantage, it was their workhorse mentality. The national team thought of themselves as blue-collar with defender Joy Fawcett as their prototype.

"Even though Joy started every game, she came to practice every day as if she was in imminent danger of getting cut," recalls Brandi Chastain. "She kept this attitude every year, and it carried over to the rest of us. Blue-collar became our culture, and it enabled us to keep winning."

No one understood this workhorse mentality better than the captain, Carla Overbeck. She encapsulated the no-nonsense style that America had come to appreciate.

"'Who else in the friggin' world is doing this?' Carla would bark at us during a hard practice," recalls Chastain. "'China's not friggin' doing this, Norway's not friggin' doing this, but we are!!' 'You tell 'em, Carla!' we'd say.

"Not that there wasn't some self-doubt. Foudy would be telling us

out of the right side of her mouth, 'Oh heck, yeah, we got this. We're going to fill all the stadiums, and it's going to be awesome!' "Meanwhile, the left side of her mouth is saying, 'Oh, shit, is this going to happen? I mean, how can we be saying this is going to happen?'

"But deep down, we believed we could pull it off, but a women's World Cup in the United States had never happened, so there was this reservation, could it transpire?"

The buildup and excitement caught on like a wildfire. "We caught lightning in the bottle," recalls DiCicco. "The tournament was in July, and we were in between sports seasons, and not a lot was happening. Baseball was in the dog days of summer, football hadn't started, and the NBA playoffs and the NHL had ended. We were in a good opening for an event, and Americans love an event.

"There were naysayers, of course, who said our stadiums were going to be empty, and it was going to be ridiculous, and our team was aware of this. Not only were they preparing to play, but they also knew they had to help sell this event, and they did."

DiCicco gave the team wide latitude when it came to promoting themselves. He urged players to do as many clinics and interviews as possible, sign as many autographs, and pose for as many pictures as they could.

"Tony pretty much said yes to everything," says Chastain. "He understood we had to sell women's soccer, and if that meant Mia had to do an appearance, or I did something, we'd find a way to get it done."

DiCicco had a lot on his plate. Not only did he have to prepare his players, but he also had to contend with sponsorships. Messing's committee worked with DiCicco and with Nike and the other sponsors, and by working together, the players found time to endorse the team in ways that wouldn't disrupt their training.

The biggest promotional coup of the season came when the team press officer, Aaron Heifetz, booked Brandi Chastain on the *Late Show with David Letterman*, as a last-minute replacement for Mia Hamm. "Brandi's nickname was 'Hollywood,'" says Julie Foudy. "Fittingly, her first words when she entered the green room were, 'Hair! Make-up!'"

Chastain was a relative unknown at the time of her appearance. Her last bit of public acclaim occurred a month earlier when she appeared

on the cover of *Gear*, a men's magazine founded by Bob Guccione Jr., wearing nothing but two strategically placed soccer balls. On *The Late Show*, Chastain was compelling and Letterman was smitten. He proclaimed himself "Mayor of Babe City" and shared his newfound passion for Brandi and the national team with his viewers.

While some found Letterman's comments sexist, Brandi and her teammates had no problem with it. "We felt 'Babe City' was more complimentary than derogatory," says Chastain. "What Dave was saying was an acknowledgment of how awesome this group was. We were a strong, physically fit, confident, and comfortable group of women. Dave allowed us to be seen by an audience that hadn't experienced women's soccer before, and we were grateful for the attention."

According to Julie Foudy, Brandi was perfect for the times. "Brandi had this understanding way about her," says Foudy, "but she also had a grandiose side. She'd like to put her hair down and take her jersey top off at practice, and we'd bust her for it. 'There's Hollywood,' we'd say, and she'd laugh along with us. Brandi was a goofball and fun. She wanted to give so much to the game and still does. Whenever kids were around, we would have to drag her off the practice field because she wouldn't stop signing. We'd be yelling from the bus, 'Hey Brandi! We gotta go!' She was just a bundle of positive, contagious energy."

It turned out that the *Late Show* was just a precursor. Within a month Brandi would return to Letterman, only this time she'd bring the whole team, and everyone would know her.

"I had a conversation with Brandi before the tournament," recalls DiCicco. "I said, 'There's no question in my mind, that if you really commit, you can be one of the best in the world. She committed, and I said this to her later: the '99 World Cup was her event.' We start with the *Late Show*. She went on Letterman, and Letterman loved her, and loved the team, and he became a big proponent of the whole World Cup."

27

Road to Pasadena

There had been a good deal of talk in the press before the World Cup tournament how the U.S. was a team of destiny. In retrospect it might seem that way, but not to Brandi Chastain.

"There was plenty of chatter that the U.S. would win," recalls Chastain. "The World Cup committee set us up on a grand scale in large football stadiums with big audiences. They made it a point to say that women's soccer deserved to be in the limelight, but that didn't mean we felt we're going to win no matter what. Sometimes that gung-ho attitude can make things a little less intense, but everyone felt the intensity all the way through. The only sense of destiny came from being in the moment. We had worked hard, and if we were destined, it was because we were ready and not because of some pre-ordained edict sent down from the soccer gods."

For group play, there were sixteen teams placed into four groups, with the winners and runners-up of each group qualifying for the knockout round. The U.S. was in Group A, which included Nigeria, North Korea, and Denmark.

Game 1, USA vs. Denmark, Giants Stadium, East Rutherford, New Jersey, June 19

"The highway to the Meadowlands was total gridlock," recalls Shannon MacMillan. "Our police escort rode at a literal crawl, and we thought we're going to be late for the game. Then we started seeing people with their faces painted, wearing our jerseys, and hanging out of their cars pointing at us. I think, 'Oh my god, is this really happening?'"

"We were flabbergasted," adds Tiffeny Milbrett. "We asked, 'What are all these cars doing?' Then we hear Aaron Heifetz with the ticket numbers, telling us we're sold out. That's when I started feeling the pressure. Every moment we spent as a team was about propelling our sport to the future, and that's a lot of pressure. The men never have to deal with that kind of pressure. They may feel pressure to perform, but they never have to worry about propelling their sport into the future. 'Well, if you don't do this, the league's going to fail, or if you don't win, the next generation of players won't get paid.' You're telling us if we don't do such and such for you, we're not worth the investment of continuing our careers and the league. We always had that kind of pressure, and it was particularly evident for this World Cup."

Michelle Akers was feeling a different kind of pressure. Her chronic fatigue syndrome had worsened since the Olympics, and she adapted to a strict training regime that affected her sleeping and diet. "Coming into residency the team saw Michelle's energy level was off," recalls Carla Overbeck. "She wouldn't come to some of our team dinners, and when we invited her to things outside of training, she was always like, 'Oh, I can't.'

"We thought she was being antisocial or didn't want to hang out with us. Then one day she broke down. 'It's not like I don't want to be there with you guys,' she said. 'It's because I can't. If I come to dinner, it will put my recovery back, and I won't be able to train tomorrow.'

"We didn't grasp how severe it was until then. I remember thinking, 'Holy shit, she's been trying to be this absolute warrior for us, and now she can't do it anymore.'

"We all agreed to rally around her, and let her know whenever she can, we want her here. If that means she doesn't do team activities, then she doesn't do them because she can't, and that's okay."

For Lauren Gregg, her realization that the crowds of people on the freeway were there for the team was an epiphany. "Looking through the bus window was gratifying but emotional," recalls Gregg. "I thought about the countless battles and moments where nobody cared. When we did it because we loved it, and we cared about the boys and girls that came behind us, and what we did actually meant something, It was important to see all the boys in face paint as it was the girls

because it was boys respecting girls as athletes, and as people. It was just electrifying, gratifying, and humbling."

When they arrived at the stadium parking lot, the scene was reminiscent of a football tailgate party. People dressed in USA attire, families and barbecues, kids playing pickup soccer between the cars. For Brandi Chastain, it brought back childhood memories of watching George Best and the San Jose Earthquakes. "Those young people came to the game with the same hopes, dreams, and excitement I once had," says Brandi. "It was a nostalgic, inspiring, and great way to start the tournament."

To one fifteen-year-old girl in the crowd the whole thing was magical. She had driven to the game with her parents from Delran, New Jersey, with hopes of seeing her heroes up close and snagging some autographs on her national team poster. She played club and high school soccer, and she wore number ten because her hero was Michelle Akers.

While the Jersey girl waited for the gates to open, the team bus parked, and the players headed inside. They were assigned the New York Jets locker room, and when Kristine Lilly, whose family had Jets season tickets, learned where they were, she about went into shock.

"Lil was literally crying," recalls Brandi Chastain. "She was in her stall, screaming, 'Oh my god! I'm in Wayne Chrebet's locker. He's my favorite player!' Watching Lil's meltdown was pretty cool."

From the locker room, the team entered the field and into the brilliant light of day. The grass was emerald green, and the stadium looked humongous. Overwhelmed by the immensity and noise, players got emotional, and some even drew some tears.

Their pregame jitters continued into the match, and both teams started slowly. Then in the 17th minute, Chastain played a long ball to Mia Hamm on the far side. Mia fired a left-footed rocket, near post into the upper ninety for the game's first score. As Hamm charged downfield with gleeful ebullience, the seventy-eight thousand looking on celebrated with her. Hamm assisted Julie Foudy with a goal in the 72nd minute, and Kristine Lilly added one 17 minutes later for the crucial 3–0 first-round win.

The girl from Delran also had a good day. When she returned

home, she unfurled her poster, replete with several national team signatures, and taped it to her bedroom wall. She tried sleeping that night, but her young mind was overflowing with visions of the game and of life's endless possibilities. Eventually she drifted off to sleep. She awoke early the following morning, and after grabbing some cereal, retrieved her soccer ball, went outside, and kicked it against the curb for two hours. More than ever now, fifteen-year-old Carli Lloyd was ready to pursue her dreams. She'd push herself to the limit if she had to, do whatever it took, to take her place alongside those immortals on her poster.

Game 2, USA vs. Nigeria, Soldier Field, Chicago, June 24

Nigeria was a talented, but undisciplined team, and when the heavily favored Americans allowed a goal in the 19th minute, it was the equivalent of getting sucker punched. Enraged, the U.S. mounted an offensive onslaught, a torrent of goals by a who's who of future Hall of Famers: Michelle Akers, Mia Hamm, Tiffeny Milbrett (2) Kristine Lilly, Joy Fawcett, and Cindy Parlow all score. By the time the bloodletting stopped, the U.S. was ahead 7–1. Nigeria attacked Mia Hamm unmercifully all game, resulting in two yellow cards. Following one exchange Hamm got in one Nigerian's face, reminding her if she continued to dish it out, she should prepare for a smackdown of her own.

For one fourteen-year-old girl in the stands who drove up with her club team from St. Louis, the offensive mauling was secondary to the U.S. defense. Being a sweeper, the youngster fixated on the backline where center-back Carla Overbeck put on a clinic. She homed in on Overbeck, eager to adopt her skills into her own game. Even at her tender age, Becky Sauerbrunn was already drawn to the subtleties of the game.

Following the match a crowd formed by the team bus, hoping to catch a glimpse of the players. As the bus pulled away, several fans gave chase, including a woman who ran alongside the vehicle for a quarter mile. "I don't know who finally decided to have the bus stop," recalls Brandi Chastain, "but I grabbed my boots and signed them and passed them out the window to our tenacious fan. Like our team, she wouldn't give up, and I felt she deserved them."

Game 3, USA vs. North Korea, Foxboro Stadium, June 27

The final group match took place three days later in Foxboro, Massachusetts. Michelle Akers took the day off to recharge and watched from the bench as her teammates soundly defeated North Korea, 3–0. A brace by Tisha Venturini, a solo goal by Shannon MacMillan, and it was onto the knockout round. After her second goal, Venturini surprised her teammates with a perfectly executed back flip. The stunt sprung from a pact a few players made with the purpose of outdoing each other in goal celebrations. MacMillan, who assisted Venturini on both her goals, was duly impressed. "On her first goal, I'm trying to celebrate with Tish, but she's pushing me off her," recalls MacMillan. "I didn't realize she was preparing to pull out this massive back flip. After the second goal, she waves us off again, and I'm like, 'Wait, what?' Then she busts out the flip, and we were like, 'Where did that come from?' We were floored. We had no idea she even had that in her."

First up in the knockout round was Germany. Heading into the tournament the U.S. knew the Germans would be a formidable opponent, and DiCicco had his concerns. "We had traveled from New York to Chicago to Boston and now to Washington DC," recalls DiCicco. "Germany had a lot of travel too, but they played their third group game in Washington DC, and now they're playing us, so they were more rested. We know we had our work cut out."

Game 4, USA vs. Germany, Jack Kent
Cooke Stadium, Landover, July 1

With 54,642 fans on hand, including President and Hillary Clinton, the national team was in for fight of their lives, and the pressure to keep winning was palpable. The question was, would the national team's preparation and training be enough to defeat Germany, who at the time was arguably the best team on the European continent? Winners of six consecutive European championships, Germany would go on to win the following two World Cups. With the likes of Betinna Wiegmann, Birgit Prinz, and Silke Rottenberg in goal, soccer fans and the president couldn't have asked for a better matchup.

In the locker room before the game, DiCicco reminded his players that the two cardinal sins of soccer are allowing goals at the beginning of a match and during the last five minutes of a period. DiCicco's words were prophetic. Five minutes in, Brandi Chastain cleared a ball toward goalie Briana Scurry, thinking she would easily collect the ball and kick it downfield.

"Normally it was a play that should have been forgettable," recalls Chastain, "a casual flip, a person zigging, the other person zagging, but when the ball skirted past Bri and into the net for an own goal, we just looked at each other, like, what the hell?"

A lack of communication was probably the biggest culprit. The grandstands at Giants Stadium rose straight up, and the sound didn't dissipate. It was loud on the field, and players were having trouble hearing. Add in the emotions and jitters that accompany a match of this magnitude, and it's a formula for disaster.

"To Carla's credit, she didn't fly off the handle," says Chastain. "She clapped her hands in that familiar clap specific to Carla and said, 'Brandi, don't worry about it. It's okay, we're going to move forward, and you're going to help us win this game.'

"For the rest of the match, I never thought about that play. Carla had cleared me of the burden. I trusted and believed her. It's what our team culture was all about. I use lessons I learned from Carla all the time. What are you going to do in a moment where you can't change it? You let it go.'"

"It was tense, loud, and you couldn't hear anything," adds Overbeck. "The defender's job is connecting with the goalkeeper, but Brandi had no way of hearing Bri. There was a miscommunication. I knew she was beating herself up, and so I wanted to be the first one to get to her and let her know everything is okay. I said, 'We need you to be the player you can be, so forget about it 'cause we're going to score another goal and win this freaking game, and you're going to be a part of it!'"

Down 1–0, the U.S. needed a quick pick-me-up to perk their spirits and stem the German tide. At the 16-minute mark, Tiffeny Milbrett answered the call with a clutch goal, and suddenly the game is even again.

The two teams were coasting into the two final minutes of the half

when out of nowhere, Germany's Bettina Vigman launched an outrageous left-footed, curling ball into the side netting. The U.S. lurched into halftime, down 2–1.

DiCicco was livid, and his remarks at the intermission were brief. "If you want your dream to end, continue playing the way you're playing," he told the team. "If you don't want your dream to end, then let's zero in on the way we know we can play, in the second half."

Although it wasn't stated, DiCicco directed much of his wrath at Chastain. Sensing impending disaster, Overbeck promptly confronted her coach. "Tony was thinking about subbing Brandi out because she wasn't playing well, but I said, 'No. No. No, Tony, we need Brandi. If she's not doing well in the second half, you can make that judgment then.'"

DiCicco stormed out to the field, and no one heard from him again until seconds before the second half started when he started yelling out, "One hundred," to Kristine Lilly from the sidelines. "One hundred was a type of defense we played," recalls DiCicco. "It meant we are 100 percent committed over 100 percent of the field and designed to put the opponent under maximum pressure. I told Kristine because she was closest, and the look on her face . . . was like 'yes!' It got the team together, and we came out stronger the second half."

Overbeck's wise call to keep Chastain in the game may have saved the day. In the 49th minute, Brandi picked up a loose ball near the German goal and, using an off-balance side-volley, knocked the ball past the goalie. After running a few steps downfield, Chastain flopped over on her back and stared into the sky with the look of gratitude and relief.

"I don't think she scores that goal except for that support from Carla, and that's great leadership," says DiCicco. "Carla was pissed as hell that Brandi passed it into our goal, but she also knew if we were going to beat the Germans we needed all eleven players engaged. Carla reeled Brandi back in, she scores the tying goal, and that's the punch line."

"I was proud of the way Brandi rebounded," adds Overbeck. "If I were in that situation, I would be swearing and hating myself. I

just wanted to make sure I got to her first and let her know that we needed her."

The match remained deadlocked, 2–2, until the 65th minute when a shot by Hamm was deflected out of bounds, resulting in a corner kick for the U.S. DiCicco's assistant, Jay Hoffman, suggested Shannon MacMillan go in for the corner kick, DiCicco concurred, and Shannon was quickly subbed in for Julie Foudy.

For MacMillan the match had been an emotional roller coaster. DiCicco had been screaming at her all game to get ready, but she never got the call. According to Mac the dialogue by DiCicco was, in retrospect, farcical.

"Mac, warm up!

"Okay, sit down.

"Mac, warm up!

"Now get in!

"No, no, not yet!"

MacMillan said could have sat on the bench had she chose, tuned out and feeling sorry for herself, but she had bought into the team and was committed to do whatever she could to motivate her teammates, while keeping a sharp eye on the action.

"I kept noticing Joy (Fawcett) was open on the near post on corner kicks. I'm trying to get that point across at halftime, but it was crazy loud in the locker room and impossible to get a word in.

"The second half I'm watching from the sidelines, and the next thing I know Mia takes a shot that gets deflected out of bounds, and I'm getting subbed in the game. While I'm running out, I notice Tiff Milbrett heading over to take the corner kick. I'm going to let her take it, but then we made eye contact, and she's like, 'No, it's yours.'

"What makes the play memorable is Joy and I are best friends. She usually played behind me when I was at forward, so we always had a connection. I readied myself for the corner kick, she was at near post, and we both knew where the ball was going. At the last second, I reminded myself, don't get too excited—just hit the ball square.

"The second the ball left my foot, I see Joy flying through the air. She gets her head on it, and the ball goes in, and next thing I know I'm racing toward her to celebrate. At the same time Brandi's com-

ing over to hug me, and I kind of juke her to get to Joy. She's my best friend, and we just scored a massive goal together, and I want to celebrate with her."

DiCicco says several dynamics were at play. "The first was Mac and Joy are like sisters. They'd do anything for each other," says DiCicco. "Joy was Mac's sounding board. Whenever she went through the mill with me, she'd run her angst by Joy, whom she lived with during residency. Joy's kids loved Shannon; they called her 'Mackie.' She'd babysit them and was like a surrogate mom.

"The second dynamic was Joy Fawcett's duo capabilities. Joy was revered and looked on by the team as the steady hand, the one they'd turn to for advice and wisdom. She was also the best defender the USA ever had. The other two in that category are Christie Rampone and Becky Saurbrunn, but I'd put Joy first because not only was she a great defender—she also scored goals. I used to say, 'Joy picks the opposition's pocket because she never had collisions and hard tackles. She just steals the ball.'

"When you think of great defenders, and you add in the ability to attack, I had two players in Brandi and Joy that we've never seen again on the national team. We've never seen attacking players that can defend and attack in those qualities, and of the two, Joy was the best.

"Joy was also a leader. She was like Kristine Lilly because she didn't say much. But at practice, we'd sometimes do a 4v4 tournament. I'd take the four goalkeepers or four forwards and say, 'Okay, you guys are captains, and we're going to have a draft.' They'd flip a coin to see who picks first, and every time the first pick was either Kristine Lilly or Joy Fawcett. The players understood if you had Joy or Kristine on your team, you'd have the winning team.

"If they needed to score goals, they'd score; if they needed to defend, they'd defend; and if they needed to be feeders, they'd feed. They played at a consistently high level, and that was Joy Fawcett. She was a leader, role model, and the first soccer mom. She didn't say a lot, but when there were issues with the team, the players went to Joy, and she would give them her perspective, and it was usually the one that the team followed."

The U.S. went ahead, 3–2, but everyone knew, with 22 minutes remaining, Germany would be clamoring for the equalizer. The U.S. had to stay focused, and that meant replacing tired legs with fresh ones.

In the 72nd minute, speedster Lorrie Fair subbed out Chastain, who'd tweaked an ankle and wasn't 100 percent. In the 84th minute, DiCicco subbed Tiffany Roberts for Cindy Parlow, and for the next 9 minutes, Germany did everything they could to crack the U.S. defense, but when the final whistle sounded, it was still 3–2 U.S.

The national team had dodged a bullet and headed to the semis. "After that game, I knew we were going to win," recalls Kristine Lilly. "It was just too crazy; it was like we were destined."

With the win over Germany, the national team advanced and moved west to Palo Alto's Stanford Stadium to face Brazil in the semifinal. Palo Alto is next to Brandi Chastain's home in San Jose, and close to the Doubletree Hotel, where Brandi's mother, Lark, played host to the group and helped ease the World Cup tension.

Lark had a long history of cheerleading. When Brandi was young, Lark would stand on the sidelines of Brandi's youth league games with a big yellow megaphone and let Brandi know she was there for her. Now she was cheerleader for the entire national team. Players and families spent a full day relaxing by the pool before the match, and Lark brought food and made everyone feel at home.

"She set up a full day in San Jose," recalls Brandi. "It was a weird thing for me, but it felt like a group vacation, people being around the pool with their families. It was the eye of the storm, but relative calm for what had just happened and what was about to happen."

After the drama and craziness of the quarterfinal, there was naturally a letdown heading into the semi, but the U.S. couldn't let up. Led by world-class forwards Formigi and Sissi, Brazil were formidable, but in comparison to Germany, Brazil seemed anticlimactic to the players. Tiffney Milbrett says the match had a completely different feel to it, and players weren't as nervous.

"We always assumed it was going to be Brazil in the quarters and Germany in the semis," says Milbrett. "The toughest game was Germany, and we got through them, so here's Brazil who was more a for-

mality. We didn't know a lot about them so we were wary about what they could bring to the table."

"Brazil was excellent, their forwards, quick and crafty," adds Carla Overbeck. "They were in our way to get to the final, so we had to take them seriously."

One player taking nothing for granted was goalkeeper Briana Scurry. Since named the team's starter in 1994, she had been nothing short of spectacular. Almost half of her caps had been shutouts, and in 1999 she was probably the best goalie in the world.

Scurry was also a reminder that the national team did not limit themselves to white players, but the question remains, why so few African Americans? In Scurry's five years on the national team, she had been one of only a handful. Why the discrepancies?

Exposure and finances were obvious reasons. African American youth with an interest in soccer would need to come up with club and travel expenses and fees for equipment and uniforms. For many minority families, this luxury was unaffordable, but without a club team, minority kids couldn't receive the necessary exposure and training to learn the nuances of the game.

Another factor was perception. In the mid-1990s, soccer in America was primarily white middle-class suburban, and national team sponsors pushed for that sensibility. Youngsters in the African American community hadn't been exposed to soccer. Compared to the marquee sports, baseball, football and basketball, soccer wasn't an attractive option.

It's no coincidence the first African American to suit up for the national team, Kim Crabbe (in 1986) has become one of soccer's most prominent proponents for underprivileged kids. Crabbe has dedicated her life to bringing low-income kids to her soccer camp in Wilmington, North Carolina, and exposing them to the beautiful game.

Scurry credits Crabbe for setting the stage. She says part of the problem was African American prospects were accessed differently than whites and generally were given a shorter leash when it came to proving themselves on the pitch.

"People will say, 'Well, that's how it is with the national team,'" Scurry told *The Undefeated*. "It seems to me African-American play-

ers weren't afforded the longest learning curve, compared to other players that I felt got more of an opportunity to be seen than maybe they should have got."

A case in point was Crabbe, who after a cursory look at a national team training camp in 1986, never got called up again. The first African American to cap was Sandi Gordon in 1986. She remained with the team two years and was the longest-tenured African American player until Scurry's unprecedented twelve-year run.

By all accounts, Scurry was beloved by her teammates, and her work ethic and humor were what they responded to most. Shannon MacMillan recalls a fateful day at practice in 1999 when Julie Foudy mistakenly challenged Scurry on her work ethic.

"Goalkeepers had their running regime," recalls MacMillan, "and so one day, Foudy starts whining how on days when goalkeepers ran fitness with us they'd be allowed easier runs and extra rest. Foudy keeps popping off, and so Bri invites her over to do some goalkeeper fitness. She puts Julie through the whole routine, the jumps, the spins, the leaps, and by the time they'd finished, Jules had a new respect for goalkeepers. 'You can do the diving and jumping and rolling and stuff,' Foudy told Bri. 'We'll stay over here and run.'"

As far as racism, MacMillan says there was none she was aware of. "There wasn't anything from the team" claims MacMillan. "But I have to imagine Bri experienced some racism. I don't recall any specifically, but being in goal, you get a group of fans behind you, and Bri being closest to those seats can hear them much more than we could."

Scurry apparently had a wicked sense of humor. Before the Atlanta Olympics, she had boasted if the U.S. won gold, she would streak through the streets of Athens wearing only her medal.

"That was a bet Bri lost," says MacMillan. "Following our gold medal game she agreed to do it but wasn't saying where or when."

That night, following the victory party, Scurry and a friend borrowed her parents' rental car and searched out a quiet residential street. At the suitable time and place, Scurry removed the towel she'd wrapped around her and draped her gold medal around her neck. While the friend videotaped her, Bri sprinted naked, down the darkened street.

"I ran about 20–30 feet," Scurry later said. "It was a little nerve-racking, but I did it."

When someone on the team asked Bri what she would have done if the police spotted her, Scurry remarked, "I'd just show them my medal."

USA vs. Brazil, Stanford Stadium, July 4

The World Cup was now the hottest ticket in the nation. On Independence Day, seventy-three thousand fans showed up at Stanford to see if the national team could defeat Brazil and continue their record-breaking run.

Fans at Stanford were enthusiastic and dressed for the occasion. Among those in attendance was a thirteen-year-old soccer fanatic from Redding, California, who made the two-hundred-mile jaunt to Palo Alto with her parents, twin sister, and a friend. The young club player wore a smattering of red, white, and blue face paint and stars. Tattooed on her left arm and shoulder were the names Akers, Lilly, Foudy, and Hamm. Even as a young girl, Megan Rapinoe showed the style and panache that twenty years later would propel her to stardom at the 2019 World Cup in Paris.

Stanford Stadium was the polar opposite of the more vertical-styled Giants Stadium. Stanford is bowl-like, with one end partially open, which helps dissipate the crowd noise. Regardless of shape, Stanford Stadium was as boisterous as the Fourth of July. The U.S. came in with the same starting lineup, but unlike in the semifinal, this match they came out firing.

At the 7-minute mark, Julie Foudy fired a nifty cross that slipped through the hands of goalie Maravilha and into the firing range of 5'10" Cindy Parlow. The tall center-forward deftly headed the ball into the back of the net for the first goal of the game. Parlow, who would later become the first woman president of U.S. Soccer, with her size supplied the U.S. with a physical presence. Her contributions culminated with her inclusion into the National Soccer Hall of Fame in 2018.

Both clubs played a fundamentally strong first half, but after intermission the U.S. came back noticeably flat. There was hesitancy, most

notably by Mia Hamm, who couldn't penetrate the stubborn Brazilian defense. With the U.S. offense stymied, Brazil roared back, and it was Scurry who received the brunt of the attack. For the tournament, the goalie hadn't been thoroughly tested until now. Brazil was tenacious, sending shot after shot on goal at Scurry, who maintained a brilliant defense.

"It was the best game I've ever seen an American goalkeeper play in a big game," recalls Tony DiCicco. "Brazil was coming at us, and they got in several times but couldn't get by Bri. She made a half dozen saves that are phenomenal in any game, but to do it in the semifinals of the World Cup when your team is only up 1–0 is incredibly special. Michelle Akers clinched it for us with a clutch penalty kick in the 80th minute, but it was Bri who saved us that day."

Had Scurry had been any less adept it would have been sayonara, USA. Carla Overbeck says Scurry's intensity was particularly noticeable. "Bri was constantly barking at us defenders," recalls Overbeck. "At one point she even told Foudy to 'get the cobwebs out,' and so now we're fighting. I'm thinking, *Oh my gosh*. I say, 'C'mon, Bri you can't be saying that,' but she just gave me that glare of hers. We loved each other, but we put each other in their place when someone said something that wasn't helpful. But Bri was tough and athletic as hell. We knew if they got past our last line of defense, she had our back. She gave us confidence and was just amazing that semifinal."

Lauren Gregg says Scurry's performance at Stanford was the pivotal moment in the tournament. "Winning a World Cup isn't always about playing your best soccer," Gregg maintains. "It's more about winning the game that day and doing whatever you need to do to be successful."

"We were under so much pressure for these matches, and granted we didn't always play our best soccer, but we were still doing what we needed to do which was selling the game, selling out the stadiums, and winning. For the coaching staff, our job was maintaining the confidence of the group. Our message to them was, 'We can't be unsettled, and we know how to win. Confidence was vital in that tournament, so the staff kept reminding them who they are, and where they've come from and how hard they worked. That we didn't

need to do anything different than be the best version of ourselves, so let's focus on that."

From SFO, it's a short flight to LAX, and from there an hour bus ride to the Pasadena Hilton, the national team's home for the next six days. The team filled the week with public practices, Colleen Hacker's motivational games and exercises, and crowded press conferences.

Tiffeny Milbrett says the days leading up to the final were absolute mayhem. The national team was the hottest story in the nation, and more and more people were coming around to catch a glimpse of them.

"Thousands of people wanted to come to our training," recalls Milbrett. "I have no idea if it was controlled or not, but it was the first time we had experienced that kind of situation. At practice, Michelle Akers and I would joke we were the animals at the zoo. People were like, 'Oh my god, look, they moved,' and we'd go, 'What animal are you right now, Michelle?' She would be like, 'I'm an elephant,' and they're going, 'The elephant, oh, look, it just moved.' Everybody was going nuts trying to get their eyes on us. It was absolutely crazy, leading up to the final."

28

Game Day

Tony DiCicco and Lauren Gregg were inseparable. Both coaches loved the game and its players, and their attention to detail was a shared passion. During the World Cup buildup, they had discussed, practiced, and covered every aspect of the game, and they studied any possible scenario, including penalty kicks (PKs). Gregg had scores of notebooks filled with observations on each player's PK approach, their mindset and success ratio, where each kick landed, and what foot they used. By the time the final rolled around, she felt they were ready.

"We did PKs over and over until they became rote," recalls Gregg. All our players could kick the ball between the posts, but even the greatest in the world sometimes miss. We tried to take the mystery out and make them routine."

Team practices had been intense up till now, but by the time they got to Pasadena, the staff had eased up and stopped tinkering. They decided any last-minute changes would do more harm than good. For their final meeting, rather than turning it into a strategy session, the staff told the team as a group what made them unique.

"We were passionate about using video as a teaching and motivational tool," recalls Gregg. "We had some equipment which we had fought to get, and a little a room at the Hilton where I could set up the equipment and edit. I didn't sleep the night before the final, because I had put together a special compilation video showing moments where the team shined and excelled."

After breakfast players and staff met in the meeting room, and Gregg turned off the lights. "The coaches didn't need to say much,"

says Gregg. "The tape reinforced who the players were. The message was: 'If we do what we do best, we're going to win.' When it ended, Tony gave a small speech, reminding them just to go out and just be themselves. 'You earned this,' he told them. 'You've done everything we needed to do, so go out and enjoy yourselves today. Be prepared to fight and battle, but at this point, we don't need to change anything.'"

In addition to the group tape, Gregg and Colleen Hacker had put together individual videos highlighting their best moments. On game day Carla Overbeck had a ritual where she gathered some of the veterans together to view their videos as a means of motivating themselves.

"I'd get Foudy, Mia, and Lil, and we'd watch each other's videos," recalls Overbeck. "Seeing us all perform at the highest level fired me up. The last thing I always saw before boarding the bus was my teammates and me doing well. It was inspiring and made me want to compete."

Boarding the bus, Overbeck was pumped. She was born in Pasadena, and now she was back where it all started, playing the most important game of her life. "I'm thinking, I don't want to lose this game, but I also knew it would be a dog fight. China's possession style is incredible, and as a defender having to play against Sun Wen, one of the best attackers in the world, I knew I'd have my hands full."

As the bus approached the Rose Bowl, Overbeck, whose husband Greg was an avid golfer, was surprised to see thousands of cars parked on the golf course adjacent to the stadium. "I couldn't believe it," recalls Overbeck. "I think Greg would die if he saw all these cars parked on this lovely golf course, but mostly I'm feeling the electricity and excitement.

"Aaron Heifetz would get on the bus going to training and say, 'Yeah, it's a sellout, eighty-eight thousand.' And then we'd get back on the bus from training, and he's like, 'They just opened up another thousand seats, and now they're gone.' Today, as we got closer to the Rose Bowl, he said they weren't opening up any more seats, and the game was going to be the most-attended women's sporting event ever. That's when it hit me. I'm thinking, we have worked so hard, and we've done everything we can do, the clinics, the press conferences, visiting schools, and this thing has just snowballed into what

it was. I kind of took a breath, looked out the bus window, and said to myself, 'Now we're gonna win this freaking thing.'"

For Brandi Chastain, the ride to the game was a time for reflection. "I was in the forward part of the bus," recalls Chastain. "We're all kind of in our zone, some of us talking, others listening to music. I'm thinking about all the time we spent together for this tournament. We're on the road, in hotels, hopping from room to room, and talking to different people. You've got a meeting with Tony or Colleen, or you're watching highlights or somebody else's highlights, having a meal, things are continually happening.

"Driving over, I could feel the energy. We're excited. We had our red, white, and blue fingernails done; players have spray color in their hair. Now we're on the bus to the final, pressed up to the windows taking it all in. When the bus pulls in, there is this sea of cars, and I'm thinking, this is amazing, it's finally happening."

For Lauren Gregg, the ride over was a time to reflect and focus. "You can't help but see the street lined with all these people cheering and supporting us," recalls Gregg. "It was a special moment because we're a family, and we've been fighting all these battles together, and no one knows all we've been through but us. But that doesn't matter; our goal has been this moment, and now here we are.

"I remember looking behind me and seeing players together with the people they'd always sit with, talking and doing their thing. But as we neared the stadium, everything stood still. Suddenly we see faces painted, and posters being held to the windows, and people jumping and screaming. As we entered the grounds, all this outside energy is building momentum, but it doesn't climax, it's just building, and building, and building. I remember having this great sense of joy, pride, and happiness."

The Tunnel

Built in the early 1920s, the Rose Bowl was modeled after the Yale Bowl in New Haven, Connecticut. Originally horseshoe-shaped, it has since been expanded into a bowl, and for decades it has hosted a slew of classic events including the annual Rose Bowl game, Olympic soccer, rock concerts, and international track and field. Jackie Robin-

son played here as a running back with UCLA, and the national team played there as recently March on their "Road to Pasadena Tour."

The third-place playoff between Brazil and Norway was in progress when the national team arrived, so the players had plenty of time to drop off their gear and check out their surroundings. "We were already dressed so we all put our stuff down in the locker room and walked to the edge of the tunnel," recalls Gregg. "It was a special time for players and coaches to absorb the environment and reflect on where we've been and what we wanted to accomplish."

With the field occupied, the national team attempted their warm-up in the tunnel. Gregg was reminded of a trip to Canada years earlier, when their plane was delayed. By the time they arrived at the field, it was dark.

"It was a fitness day, so we put on the minivan headlights, and the players ran sprints to the glow of the car headlights in the parking lot," says Gregg. "I compared that moment to now, the group just went with it. They didn't get thwarted by things like warming up in tunnels or parking lots because it wasn't in their nature to. There was no whining or complaining. They just adjusted and moved on."

Gregg was mostly correct in her "no complaining" synopsis, but this was the World Cup final, and some of the veterans took exception to warming up on concrete.

"At first, I'm like, oh my god, what's going on here," recalls Carla Overbeck. "But then I see China doing the same thing we were, and it was no big deal. I reminded myself I'm playing with the best players in the world, China's a great team, and there's no time to complain."

For Brandi Chastain, the tunnel was a mystical place steeped in history, albeit not that much for women. "The Rose Bowl is teeming with historical moments, but few if any in women's sports, and for a sports junkie like me, there's excitement about that," says Chastain. "We get to the locker room only to learn we get an extended stay downstairs, and so there's a buzz as everybody gets ready for the game. Foudy is in our faces singing in her Ethel Merman voice, Bri's on the floor stretching with her headphones on, Joy is in the corner reading a book, and Mia's off somewhere probably throwing up.

"Meanwhile, I'm doing circles in the middle of the locker room

when word comes that it's time to take the field. As I'm leaving, I glance over at Tony's charts. For penalty kicks, he's listed in red letters, Akers-Chastain-Lily-Overbeck. Underneath, in black letters: 'Everyone is prepared to take and make a penalty kick.'

"We get to the tunnel, but the other game is still in progress, so we wait some more. To blow off steam we start running up and down the tunnel, and kick balls against the walls. It's dark, dank, moldy, and, just like our team, totally authentic.

"I feel we won the match in the tunnel. You have to be tough because things don't always go as planned. People have a list of things they have to do, but they don't always fall into place. Our team is agile, flexible; our philosophy is, 'Oh well, that didn't happen; we go on to the next plan and see what the next option is.' Options one and two might be shut down, so we need to know what option three and potentially four are. We don't get to the field at the prescribed time, but so what, we make the best of it."

Not everyone was as zen about the tunnel as Chastain. To Michelle Akers and Tiffeny Milbrett, the concrete warm-up was unprofessional.

"The third-place game was tied after regulation, so they went straight to penalty kicks," says Milbrett. "If I were them, I would have been angry because no one wants to go straight to PKs. It was one of those backward things the federation always did to us that would never happen in the men's game. They forced us to have our warm-up underneath in running shoes with hardly any touches on the ball. We could see China warming up next to us, and I'm thinking, *That's a real professional way to prepare.*"

Akers was angry but dealt with it by incessantly kicking a ball against the tunnel's concrete wall. Meanwhile, nonstarters were forced to watch. They would have to do their warm-up outside. The tunnel was too small to equip all the players.

"When we emerged from the tunnel there was this explosion of fan noise, and it sucked the air out of me," recalls Shannon MacMillan. "I was like, 'Oh my god.' I'd never seen so many people."

Shannon joined Joy Fawcett on the field. As was custom, they started listening for the booming baritone of Joy Fawcettt's dad. "Every pre-game we'd listen for '*Go B*' (B for Biefeld, her maiden name). It was

so loud we could always hear it. Our last warm-up we'd jog across the field and get into our zone. We were doing our running when I finally heard her dad shout, 'Go Mackie!' I waved and then found where my brother was sitting. We always knew where the family section was by the roar of Joy's dad."

When Brandi Chastain emerged from the tunnel, the first thing she did was check the weather. "Whenever I come out to a field for the first time, I check the direction of the wind, and where's the sun, and is there an advantage or disadvantage somewhere and how can you exploit it? It was hot, but we had trained in Orlando—not the coldest place on Earth—so we were ready. The weather was definitely to our advantage."

Luxury Boxes and Grandstand

From their perch high above the field, Alan Rothenberg and Marla Messing could finally relax a little. Their World Cup gamble exceeded all expectations. The national team had become the hottest sports story of the summer. They had filled the Rose Bowl, and the president and First Lady were on their way. Bill Clinton was in town to mend some trade differences with the Chinese. He arrived late to the game, but their party all made it to the Rose Bowl press box, reinforcing the fact that female athletes do indeed matter.

The media critics in the press box, who had convinced themselves women's soccer had no place on sports' brightest stage, were forced to admit they'd misread the tea leaves. They underestimated the enthusiasm for women's athletics and the millions of youngsters who looked to the national team as role models. America was discovering the national team was every bit as committed to their sport as their male counterparts and, when it came to competitive zeal and winning, surpassed them.

For Anthony DiCicco, looking on from his seat in the tenth row, behind the U.S. bench, the final was the crescendo of a half year's work. For six months, from Orlando to California, the coach's son had been present as an intern. For his trouble, he received a coveted seat in the family section alongside his mom, Diane, his siblings, and Brandi Chastain's older brother Chad.

What stood out most to Anthony, besides the hundred-degree heat, was the "Ponytail Posse," the thousands of youngsters in face paint and Mia Hamm jerseys roaming the stadium. Their consistent high-pitched hum stood above the general crowd noise, a youthful reminder that the post–Title IX revolution was in full swing.

"The difference with the World Cup final to the other matches was there were more corporate types and FIFA VIPs," recalls Anthony. "But it didn't matter. Just being in the stadium was a blessing. Every seat was a valuable seat, and we were just fine. There were moments when it was electric, certainly when the players came out on the field, but there was also an element of the heat. The players played through it, but I remember thinking this is going to be an exhausting afternoon."

As the pop group The Hansons harmonized the national anthem, four F-15 fighter jets screamed overhead, startling the Chinese team. One plane went into a stall before thundering straight up into the atmosphere, leaving the Chinese players even more rattled. The show of force, a reminder of brazen U.S. power, was palpable, particularly to the China contingent, who needed to shut out the noise if they were to have any chance of winning.

"What we see truly transcends sports," ABC's Robin Roberts told the forty million viewers looking on. "This is a moment in American culture not just for women's sports, embracing women athletes in this magnitude, and the athletes themselves realize they are a part of something special."

The Backline

At high noon referee Nicole Peitigna from Switzerland blows her whistle, and it's "Game On." The opening minutes are flat, and hesitancy is evident on both sides. The slight discrepancy between winning and losing Dr. Colleen Hacker preaches about will never be more evident than today. Both teams played four matches in eleven days, and now it's 102 and even hotter on the pitch. Players are physically and emotionally drained. The contest will be a siege, not a lightning strike.

"In big games like this, players are more intent on not making a mistake the opposition can take advantage of," says Brandi Chastain. "China and the U.S. are good at scoring goals. We have great attack-

ing players. We're also good at defending attacking situations. As a defender, I never want to make a crucial mistake that allows an opponent to score on me.

"The dialogue on the field is positive and proactive," adds Chastain. "The staff has prepared us. We concentrate on being in the moment, taking in only what we need. We know to focus on 90 minutes is impossible. Colleen says people can focus on one thing for about 45 seconds tops, so we are continuously battling that focus-refocus moment. Colleen has given us tips to stay focused. Mine is to tighten my ponytail. Julie's is to snap a rubber band. Mia's is to pull up her socks. You can see all that on display during the game."

The first half is defense, defense, defense, and Carla Overbeck is earning her keep. Before the game some on DiCicco's staff questioned if she should even be starting. The argument was she'd slowed some over the years, and younger, faster legs were needed to stop Sun Wen and the Chinese onslaught. But DiCicco nixed the idea. It's the intangibles he's focused on, and Overbeck is the one player the others always turn to in crunch time.

Overbeck knows the heat can make for sloppy play and misjudgments. Carla's task, besides keying on Sun Wen, is to motivate players and help guide the ship.

Julie Foudy is loud, Michelle Akers commanding, Mia Hamm explosive, and Fawcett and Lilly steady, but on a day like this, with everything on the line, it will be Overbeck overseeing the defense that will be most critical.

"Carla's role was keeping us going in a game where the margin between teams is almost imperceptible," says Lauren Gregg. "What Carla's showed us that day was strong leadership. She tied into every player: she was the one sitting on their shoulder, whispering in their ear, 'Let's go, you can do it.' Carla was like having a twelfth member of the team for every player. Nobody is playing alone because Carla is on that field. She is a pivotal factor in keeping us in the game.

"She came out intense and strong in her tackles, but she also brought something extra. It was nothing flashy, and nobody's going to remember her performance, but you ask every player if they didn't feel like Carla Overbeck had their back on July 10. They'll say, 'Definitely.'

Her leadership was visceral. I could feel, see, and hear it through my body. It was like, 'Hey guys, let's go!' but she said it with her whole body, and with a full breath of air, and in the tone only Carla has. She is unyielding in her demand for you to be your best, and behind you at the same time. That's what made Carla so good and kept us in the game."

Shannon MacMillan concurs. "Carla joked she wasn't the fastest, but she was one of our smartest players and hard to beat on defense. She was our voice on the field, and it was that distinct voice. 'C'mon Mackie,' she'd say, and whenever I heard that voice, I'd be so inspired that I'd want to run through a brick wall for her."

Midfield

It's midway through the first half, and there is still no score. So far Michelle Akers has withstood the punishment. She's quarterbacking, distributing balls, changing the point, stifling Sun Wen, more or less keeping the U.S. in the game.

The sidelines are stocked with a cadre of helpers, ready to assist Akers in any way possible. There is equipment man Denis Kalinas, an Akers supporter on and off the pitch. It was Kalinas whom Akers rushed to and kissed on the forehead following her clutch penalty kick against Korea. The two regularly practice PKs, Kalinas being the goalie, of course. Today his job is to furnish Akers with fluids, moral support, and a steady stream of health bars.

For Akers, this isn't a game of soccer. It's a war of attrition. Her body, riddled with bumps, bruises, broken eye sockets, and chronic fatigue, is in constant danger of breaking down. The question is, can she sustain herself, stay away from any game-ending injury, and not let chronic fatigue defeat her?

When the half ends, the match is scoreless, and Akers heads for the coolness of the locker room. Inside, she collapses on the floor. Kalinas places cold towels over her neck and shoulders, and Doc Adams examines her shoulder, face, and knees and feeds her enough black coffee to get her blood pressure up.

Akers is oblivious to whatever halftime speech DiCicco is telling the team, but it doesn't matter what he says. Mustafa has her own

game plan, and it's strictly survival. Can she muster the strength, stamina, courage, and faith to finish strong and help get her team to the victory podium?

A prayer and an arm up from Doc Adams, and Akers is back on her feet. "You're gonna be all right, Mish," Adams tells her. "We need you out there. You can do it."

Doc escorts her back to the pitch. When play resumes, Akers is recharged, determined to win every ball and control the flow. Her aim to be so disruptive the Chinese will avoid her, hopefully easing the physical onslaught on her body, but the opposite occurs.

China comes out the second half with renewed vengeance. They punish Akers and Hamm, throwing them to the turf with vicious body blows and tackles. Akers retaliates. She challenges goalie Gau Hong on a corner kick. Akers backs into her bodily to distract her, but her efforts backfire. Hong knees Akers in the back of the thigh, giving her a charley horse. For her efforts, the ref flips Akers a yellow card.

The Second Half

To Anthony DiCicco, the slow pace is not surprising. "It is hot as hell, brutally hot, and a hard-fought game, given the conditions," recalls Anthony. "Neither team has had incredible looks, but it's a cagey game. That's what finals tend to be. No team wants to make the crucial mistake that costs them the championship.

"China is playing with tremendous confidence, and they've got one of the best players in the world in Sun Wen. So there's lots of respect for the Chinese. The margins we knew were going to be razor-thin, but for me, I had no fear of anything other than victory."

The second-half minutes tick by, and there's still no score. Mia Hamm, stymied by the Chinese defenders, is frustrated, and Akers, like a solar eclipse, drifts in and out of darkness. She hits the wall twice but somehow makes it through the first 90 minutes.

In the first minute of extra time, her luck runs out. On a China corner kick, goalie Briana Scurry and Akers go up head to head to meet the ball. Both players are airborne when Scurry unintentionally strikes Akers in the back of her skull with her forehead. Mustafa goes down in a clump. A shockwave of angst filters through the Rose Bowl.

The Sidelines

"Michelle is a mess," recalls Carla Overbeck. "She's mumbling, 'I can play, I can play,' but her eyes are glazed, and she can't even stand. She keeps telling us she's okay to play, but we're like, 'Mish, you can't even walk. What you're saying is not making sense.'

"I'm thinking, 'Holy shit, what are we going to do without her?'"

While doctors and trainers attended to Akers, DiCicco and his staff parley in the technical zone. It will be Doc Adams who decides if Akers plays or doesn't. It's out of DiCicco's hands.

"We had prepared the team for something like this," says Lauren Gregg. "What if we don't have Michelle? What if we don't have Carla? What if we don't have Bri or Mia? We had enough confidence in the group we could adjust."

During the meeting, DiCicco recommends Sara Whalen, the fastest back on the team, to replace Akers, but Gregg insists Whalen is too young and inexperienced, and veteran Tiffany Roberts is far better suited to handle the pressure.

Akers is on the sidelines now. She is incoherent and on the verge of passing out. DiCicco looks at Adams for a sign. After asking her a few questions, Adams looks forlornly at DiCicco and shakes his head. Kalinas and Adams lift the fallen warrior and slowly make their way to the medical room.

"You're in, Sara," DiCicco shouts, and the World Cup continues.

Extra Time

As the captain, Carla Overbeck has two major concerns: first and foremost, she needs to make sure the team doesn't crumble over losing Akers. The other is Sara Whalen: does the twenty-three-year-old have what it takes to fill the gaping hole left by the veteran?

"You wonder if Sara is up for the task," says Overbeck. "You try to convince yourself she'll be comfortable and confident enough to do the job. You're saying everything will be fine, but at the same time, you're thinking, 'Are we going to be fine?' We just lost one of the most critical pieces to our team. Can we do this?"

"To be honest, I wasn't sure, but I couldn't allow the team to see

doubt creep into me. I have to pretend to be strong and demand more of myself and them.

"I said, 'We can do this.' Then I tried to instill confidence in my teammates and convince myself them that we can do this without Michelle. We can't make up her presence on the field. So I tell them, 'We all have to play better.'

"As far as Sara, I try to put myself in her position. She's intimidated, afraid, scared, and coming into the biggest game she'll ever play in her life. She's been sitting on the bench for 90-plus minutes, and now she has to come into this match and perform like she's a starter.

"I want her to know she's replaced Michelle because she can do it. I say to her, 'Sara, you can do this. We believe in you.' But I'm not sure she even heard me."

When play resumes, the Chinese naturally go right at Sara Whalen. For the first time in the match, the U.S. buckles and China begins to penetrate.

Whalen is all nerves and knocks her first touch out of bounds. The U.S. backline doubles down and prepares for war. It's now or never. Somehow, they need to hold off the Chinese onslaught, finish regulation, and get the game to golden goal. If Brandi Chastain is worried, she doesn't show it.

Chastain says: "Our best player is out of the game, but unlike when we lost Michelle in the '95 World Cup, we remain calm and don't panic. China throws everything at Sara Whalen, and there is a common concern from the stands, if the team and Sara can withstand the pressure. But we're fine. We know Sara is a tremendous player with great skill and determination. Technically she is comfortable on the ball. We have prepared for this moment, and Sara and the rest of us stand firm. We are more hardened and more experienced than we were in '95.

"But in the remaining moments of regulation, the heat is starting to play a factor. The last five minutes we're just trying to survive the game with no defensive errors, and somehow, we get through it.

"Now we're on the sidelines, getting water and applying cold towels to our heads. We're stretching, resting, preparing for the next set of overtime minutes. It's hot. There are depleted bodies; legs are cramped.

But we're aware, and that awareness becomes heightened because it's golden goal. If either team scores, the match is over.

"Overtime begins. Both teams are focused, and goal-scoring chances are nil. We need to be keen on defense, and we are, but so is China.

"Then what happens next is a microcosm of our team. For months, Tony, Lauren, and Colleen have drilled into us that you have your job to do, and everybody relies on each other, and you're expected to do your part. Anson calls it 'your sphere of excellence, or area of domination.' Anson loved to try to dominate the opponent, and Tony doesn't approach it quite the same way, but the philosophy stuck, so we're used to playing under this kind of emotional awareness."

Golden Goal

For 100 grueling minutes the match has remained scoreless, and for the first few minutes of golden goal it remains that way. Then 10 minutes into the period, China sets up a corner kick. Temperatures are soaring, players are physically spent. As the U.S. defense sets up, DiCicco glances at Kristine Lilly standing near post, readying herself for the incoming corner kick.

At 5'4" Lilly is one of the smallest players on the pitch but a giant among her peers. There's a brief lull as the teams make last-second adjustments. The pause allows Lilly to regroup and DiCicco to do a final survey. Set pieces are dangerous, especially in golden goal when players are tired, but how they are defended can be the difference between winning and losing a World Cup.

Before the match, DiCicco posted two handwritten poster-sized sheets by the locker room door. Written on razor-thin paper, and in an era before PowerPoint, the sheets provide all the game information needed, with no glitz or glamour beyond the reassuring flow of DiCicco's distinctive handwriting. Every line or cross-out on the sheets is easily identifiable to his players and staff, well thought out and written with confidence. The letters KL (Kristine Lilly) written beside the near post for corner kicks represent what DiCicco is currently seeing live, as he considers the field. He's pleased to see Lil at her assigned position. The corner kick will be coming in from goalkeeper Briana Scurry's left side, and Lilly is where she needs to be.

As DiCicco looks on, Scurry rests her hands on her knees and barks instructions. Lilly takes advantage of the lull, and as the Chinese position for the set piece, Lil splashes water from Scurry's bottle onto her face and leans against the post to rest her feet. Temperatures on the field are rising, and like everyone else, Lilly is dead tired. She uses the recovery time to refocus, while DiCicco uses it to reflect. "Has the team learned the lessons from previous mistakes on corner kicks? Will they remember the importance of set pieces and the need for everyone to know their responsibility and execute?"

All DiCicco can do is watch, and for someone who covets control, it is sheer torture. He can try projecting his voice—but not over a crowd this immense and loud. For the moment, like everyone else, he's relegated to the role of spectator. It's not that he's not trying to insert himself into the outcome or regain a smidgeon of control in a moment when the game teeters on a knife's edge. He simply can't. It's in the players' hands now.

The referee's whistle sounds. China's number 10, Liu Ailing, lines up in front of the advertising boards in the far left corner. She's preparing to take a right-footed, in-swinging ball. Lilly wipes her face and puts a hand over her heart, while Scurry contends with the midday sun from the direction of the oncoming corner kick.

Ailing's kick explodes as if it's attached to a rope. She couldn't have delivered a better ball. It arrives fifteen yards in front of the goal, near the back post, in the vicinity of Chinese center-back Fan Yunjie, and defenders Shannon MacMillan and Carla Overbeck.

Yunjie outjumps MacMillan and heads the ball perfectly toward the goal. It has all the energy of a championship-winning ball. A hush rolls over the Rose Bowl, and ninety thousand hold their collective breath. A Chinese goal is inevitable. Then the unfathomable happens.

Briana Scurry: "The ball is flying through the air, and I'm diving to try to save it, but I'm nowhere near it. I'm thinking, 'Oh, shit.' And then the ball comes back out again, and I'm thinking, 'Oh . . . shit.'"

No sooner has the ball slipped past Scurry when out of nowhere it whistles past her ear in the opposite direction. She didn't realize the correctly positioned Kristine Lilly, using all of her 5'4" frame, has jumped and miraculously struck the ball off her forehead. The ball

lands precariously in front of Scurry, where Brandi Chastain's alertness and clinically executed side volley clears it away just as China's Sun Wen and Zhang Ouying, hunting the rebound, converge on the spot where the ball is about to land—an instant too late.

Chastain sees it all unfold in front of her like a one-act play.

"Leading up to this game, in 175 caps, I have never seen Lil have to make a play in that position," Chastain recalls. "For a lot of players, being in a place where you've never had to make a play becomes redundant. They're thinking, ahh, maybe I shouldn't be here. Perhaps I'll go somewhere else. Perhaps I see something in the middle of the box, and I'll go there instead and leave the position I'm supposed to be in, because, I mean, c'mon, I'm not going to have to make a play.

"But Lil doesn't leave her spot. As the ball comes across the goal, I see Bri shuffle into her next ready position. Then I see a Chinese player outjump one of our players, and she heads the ball back across the goal. Bri is a remarkable goalkeeper. The most spectacular part about her is her ability to leap. She has long arms and fingers. All of a sudden she springs to the ball, her arm is extended, but the ball is going past her. I see her eyes tracking the ball, and it's going past her hand. Then I see Lil on the post. She heads the ball out, and it lands right to me. I do a side volley to clear it out of the penalty area.

"Talk about being prepared, talk about clutch. It's golden goal at the freaking World Cup final, and Lil's exactly where she's supposed to be. It's the turning point of the match. If the ball goes in, the game is over. The idea of doing your job, no matter how mundane, or how infrequent it is, worked in this case. Colleen was right. Details matter, and the details mattered at this moment on the grandest scale. Lil did what she's put there to do, and we play on. For me, and everyone else, it's the most impressive moment of the whole tournament."

As one of the two U.S. defenders who went up with Yunlie, Carla Overbeck has a unique perspective.

"I was at the back of our defensive line and close to the net, and the ball went over my head," recalls Overbeck. "I jumped, and it went over my head, and I crashed into one of the Chinese players, and so I was on the ground and didn't see the play.

"Apparently they won the ball, but Kristine, like always, is 100 per-

cent reliable, and she's on the post and heads the ball off. Someone in the press asked me after the game, 'What happens if Lil doesn't head that ball off the line?'

"I'm thinking to myself, 'I don't remember that.'

"When we got back to the hotel we're watching the film. I see it for the first time, and I'm thinking, 'Holy crap, I had no idea that happened.' I'm like, no wonder why people were asking me about that play, but I didn't see it because I was on the ground."

On the sidelines, DiCicco and Lauren Gregg can finally relax. "I remember taking this big breath," Lauren says, "and Tony and I turning to each other. We just looked at each other, like, 'You know, we survived that and are still in it,' and then we went back to the game."

DiCicco's sentiments echo Gregg's: "One time in a hundred that Lil had to be there, and she was."

From his view from the stands, Anthony DiCicco immediately recognizes the significance of the moment. "Lilly's header went down in a millisecond, but as the team came to realize, a millisecond is all that is sometimes needed to change the course of history," recalls Anthony. "But there was more to it than a game-saving header. My dad and his assistants Lauren Gregg, Jay Hoffman, and Colleen Hacker and the team had been meticulously cultivating layers of leadership between 1995 and 1999, and it is now paying dividends. The layers had merged, and now it was Lilly's turn to lead in the way she was most comfortable leading, by example. As Bri said later, "It's Kristine . . . doing what she does, doing her job."

Lilly later recalled the aftermath. "After I headed the ball off the line, I hear Julie [Foudy] coming out of our goal, and we just looked at each other like, 'What the heck.' Julie is laughing and says, 'Let's get the hell out of here.' I remember not laughing but thinking, 'Holy shit! Did that really happen?'"

The margins of the moment were razor-thin. But in the aftermath of Lilly's save, Briana Scurry's doubts were gone. "We've got this. We've got this game. If that wasn't gonna kill it, ain't nothing gonna kill it."

29

The PK Thing

China and the U.S. have played 120 minutes in the broiling sun, but few if any fans have left the building. For people worldwide, riveted to their TV sets, watching women's soccer for the first time, and previously unaware of the players' skill, grace, and tenacity, the match has been an eye-opener. For each Kristine Lilly header, Carla Overbeck tackle, or Tiffeny Milbrett juke, the cynics, and disbelievers, are converted into true believers, and new fans. Cultural barriers get crushed, and with each passing minute, millions of people are falling in love with the national team. But there is more at play than just the game. There's a rising occurring, an awakening. Kristine Lilly says it best: "This is more than about the game, and it's about female athletes. It's about sports. It's about everything."

Beyond the pitch, up in the Rose Bowl grandstands, the change is palpable. Throughout the concourses, thousands of young people, mostly girls, but boys too, swagger about confidently in their USA face paint and Mia Hamm jerseys as if they own the place, and in a sense they do. The national team is their team, not their parents' or grandparents'. The national team represents their dreams and aspirations, and they claim ownership.

The players said all along that their sacrifice is for the next generation. If it sounds Pollyannaish and trite, so what. To the young people watching, the call is as real to them as a Michelle Akers body slam against the boards or a Joy Fawcett full-on sprint down the sideline.

What Anson Dorrance envisioned on Carolina's Fetzer Field in

1976 is blossoming full bloom twenty-three years later at the place coincidently called the Rose Bowl.

For the players, pressure to win is as evident as the heat. Colleen Hacker repeatedly tells the players, "Pressure is Privilege," and the pressure is mounting. For participants and fans, penalty kicks are the epiphany of pressure, the cruelest finale to a sporting contest ever conceived.

Ironically, PKs were made to protect participants, not torment them. How soccer's version of Chinese water torture came to light is a captivating tale.

In 1890 linen manufacturer, goalkeeper, and influential member of the Irish Football Association William McCrum came up with an intriguing solution to stop blatant fouls. As a player, McCrum witnessed opposing attacks that maimed and killed players. When he submitted a proposal to curtail the violence to the Irish Football Association, it included a new term, "penalty kick." The initiative was promptly approved by the board, which incorporated it into the laws of the game.

The penalty kick shootout was created in 1970 and is the stepchild of McCrum's invention. Around since the 1950s, PKs were formalized in 1970, when the secretary of the Israel Football Association (FA), Yosef Dagan, proposed it to FIFA after seeing his national team crash out of the 1968 Olympic quarterfinals due to drawing lots out of a Mexican sombrero. The Israeli FA led the move for its approval to FIFA, which accepted the initiative on June 27, 1970.

McCrum had no idea what he had unleashed. He died in 1932, never knowing the impact his initiative had on soccer nor the psychological well-being of its players and fans.

Penalty kicks are inherently unfair, conclusive, and inconclusive. They seem easy to do. Just stand twelve feet from the goal with only the keeper as a deterrent, and kick the ball in. But for many participants, emotions, mind games, and doubts get in the way, making the most gifted shooters panic or crumble.

For Mia Hamm, the game's greatest scorer, PKs are the equivalent of Kryptonite to Superman or sunlight to Dracula. She rarely takes them. Unfortunately for her today, with the world championship on

the line, Mia has no say in the matter. On this day, her stature is her worst enemy. Tony DiCicco insists Hamm take one.

Once overtime is over, players converge on the sidelines to rest, regroup, and rehydrate. Some talk, others collapse on the grass; legs get massaged, muscles iced, and cold towels are placed on throbbing heads.

Among those lying on the grass is Brandi Chastain, the same Brandi who almost coughed up the quarterfinal with an own goal and then minutes later helped win it with a real one. Extremes and drama are the norm for Brandi, and why she is known as "Hollywood" to her teammates.

As Chastain winds down, Lauren Gregg surveys the scene from the technical area. She's holding a makeshift list, an index card containing several names. The original PK plan is in her game notebook but was inadvertently left in the locker room during halftime, hence the index card.

The names on the list represent the best penalty kickers available to the U.S. team. Gregg's job: present the list to the players and then look for signs of trepidation. If she detects reservations or doubts, she'll deal with it. DiCicco trusts Gregg unequivocally, and the list is something Gregg takes very seriously.

Gregg doesn't rush the process. Players need to decompress, rehydrate, and relax on the cool grass, so Gregg gives them space. An ex-player, she knows the last thing they need right now is for an assistant coach to get in their face and start yelling out names.

"It was time to unwind," says Gregg. "They just played this intense game, it's hot, Michelle is out, and Kristine just saved the game with a freaking header. They know it's penalty kicks. If they need to talk to one of the coaches, they can, but it's best for them to take time to process the moment."

Gregg confers with DiCicco on any last-minute changes. "With Michelle out, I had Brandi and Foudy as our best options," recalls Gregg. "Tony and I had a dialogue the previous night, and we figured the next logical player to replace Michelle would be Brandi or Julie. Tony goes with Brandi, but he wants her to take her PK with her left foot."

Chastain is traditionally one of the team's key penalty takers, but she's had a rough year. Going with her opposite foot seems risky, but DiCicco has his reasons.

"We played China in the final of the Algarve Cup in March," recalls DiCicco. "Brandi took a PK, and Gao Hong was all over it, and we lost. Afterward, I said to Brandi, 'You're hitting all your PKs right-footed, and to the goalkeeper's right. You've got to hit some to the goalkeeper's left.'

"She tried it but wasn't comfortable. Brandi was very good with both feet, so I said, 'Can you take them lefty too?' She said, 'Yes.' I said, 'Practice them right and practice them lefty because you have to show the goalkeeper a different look.'

"The night before the final we had a coaches meeting. I told Lauren that Brandi should take a penalty. Her nickname was 'Hollywood,' and she probably practiced scoring a penalty in the final of the World Cup a thousand times in her mind.

"Lauren didn't think Brandi should kick one because she had a bad year, but I wasn't sure. When she brought me the list during the break, she had Foudy five and Brandi six. I said, 'I'm good with the list, but flip-flop Foudy and Brandi, and put Brandi five.'

"Lauren says, 'Are you sure?'

"I said, 'Tell you what, go up to her and ask her if she wants to take a penalty, and then ask if she'll take it with her left foot.'

"Lauren asked, Brandi says 'yes and yes,' and the rest is history."

While DiCicco and Gregg concur, the rest of the group is getting anxious, but before Lauren can announce the order, she needs to check with Brandi if she's good using her opposite foot.

"We're back on the sidelines, taking in liquids," recalls Chastain. "There is little talk. We're going into penalty kicks, and we all know what that means.

"There was a potential list posted in the locker room for penalty kicks and free kicks. They include Akers, me, Lilly, and Overbeck. Unfortunately, Michelle isn't in the game anymore, but we're still comfortable. We survived golden goal, and now we're doing the PK thing.

"I'm lying on the grass trying to cool down, and Lauren comes up and says, 'Hey, Brandi, do you want to take a penalty kick?'

"I think what an odd question. I'm already one of the penalty kickers. Michelle is out, so I automatically would be one of the players kicking.

"'Yeah, of course,' I tell her, and Lauren says okay and walks away. I'm left thinking, well, that's kind of strange, but whatever, and I just let it go.

"I'm trying not to overthink anything. I'm just resting on the grass, trying to be peaceful, and then Tony comes up and says, 'So, you're gonna take a penalty kick?'

"I'm like, 'Yeah. I already spoke to Lauren about it. No problem.'

"Tony reminded me of the Roadrunner cartoon character, because at this moment, that's the image I have of him. If you put his face on the Roadrunner, and he says, 'Okay, you're going to take a penalty kick, and you're going to take it left-footed'; then he sprints away and leaves a dust cloud behind him. That's Tony, and that's all he told me. Tony didn't want a conversation. He just wanted to say to me that I'm kicking left-footed and then get out of there as fast as possible.

"So I'm like, okay, I guess I'm going to take it left-footed. I didn't spend any time thinking about it, but, looking back, it was an empowering moment. Here we are in the final of the World Cup, and I'm going to take a penalty kick with the foot I don't usually use. I use my left foot in games because I play on the left side, but I don't take penalty kicks with my left. But Tony believed that I could. Like Carla did in the semifinal, there was a ridiculous amount of trust at that moment. I'm not going, 'Oh my gosh! Where am I going to put the ball?' I say okay and watch Tony sprint off like the Roadrunner."

Once Gregg finishes with Brandi, she's free to give the PK order to the rest of the team.

"The only one I went up to before I read the order was Brandi," says Gregg. But now the whole group needs to know. I finally announce the names, Carla, Kristine, Joy, Mia, Brandi, and they start to get excited. The pressure's off, and people start pumping each other up and get ready for the shootout."

Gregg is about to turn away when a familiar voice stops her. It's Mia Hamm, and she's not smiling. "I'm not sure I should take a kick," she says.

Gregg is concerned but doesn't show it. She's watched Mia grow from a teen to a young woman, and she knew when something wasn't right. The last thing Gregg needs to do now is panic. She has to remain calm, convey confidence, and state clearly what's at stake, and not introduce a discussion.

"Mia, you're one of the best forwards in the world. We need you," Gregg tells her.

Mia says, "Okay."

The team huddle before penalty kicks is a flurry of colorful Foudy-isms. "No one in the world works bleeping harder than us, no one bleeping deserves it more than us, let's go bleeping, bleeping, bleeping, and bleeping."

"Carla and Jules would split the leadership duties," recalls Shannon MacMillan. "Foudy did the main stuff; Carla would have her moments in the huddle too, but with her, it was a little pat on the back that said we got this, or that look she gave and everyone respects."

30

"Fake It Till You Make It"

China wins the toss and will kick first. Their lineup is experienced, formidable, and lethal. They recently beat the U.S. on penalty kicks at the Algarve Cup and are confident. Xie Huilin starts things for China with a booming kick past Scurry to give China the 1–0 lead.

First up for Team USA: Carla Overbeck. "Let the captain show us the way" is Lauren Gregg's thinking. "You want the player who wants the ball going first. It had to be enormous pressure to go first, but Carla was unflappable, which is why I put her there."

"When they called the order, my first thought was, 'Let's get this shit done,'" recalls Overbeck. "I'm glad they put me first. I want the responsibility and opportunity to put my team in a position to win. We would always say, 'Fake it till you make it.' I want to put my team ahead, and then that gave me the confidence to be confident with them.

"When I got out to the PK area, they rolled the ball out, and I flicked it up with my right foot and caught it in my hands. I was trying to block out all the noise, make it as routine as possible, and put my team at ease. If I make it, we're tied, 1–1, and that puts us in a great spot, and the other guys won't have as much pressure."

From his view, Anthony DiCicco is impressed. "Most players would pick the ball up and place it on the kicking spot," recalls AD. "But Carla nonchalantly flicks the ball up to herself with her foot. I remember it as not unusual but extremely confident, typical of the swagger of our team."

Everyone on the team notices Overbeck's approach, including Brandi Chastain.

"The moment that sets the tone for the shootout is when Carla comes down to the penalty area for the first kick," says Chastain. "Her 'bring it on' attitude gave us confidence. She makes her kick, and now we're feeling good."

In the second round, China's Qiu Haiyan makes her kick. She will be followed on the American side by Joy Fawcett, whom Gregg puts second for a reason.

"Joy is undeterred, focused, expressionless," says Gregg. "She always gets the job done, and it's why we place so much confidence in her. Neither Joy nor Carla is considered an attacking player, but players we can rely on."

If Gregg knew Fawcett's knees were shaking, she might have had second thoughts. Joy figured she was going third, not second. Regardless of the order, Fawcett soldiers on. As she preps her kick, she doesn't look up. Gao Hong will stare her down if she does. The Chinese goalie is guessing left, but Fawcett strikes the ball hard and to the right, and Hong barely moves. Fawcett does her job. It's 2–2 now, and the pressure swings back to Scurry.

Both Scurry and Hong are world-class, but the former has the advantage today. Tony DiCicco is also the team's goalkeeper coach and has shown Bri tricks of the trade. "Bri wasn't great on penalty kicks, and I had to work with her," says DiCicco. "One thing I always said is when you have a hunch, a deep feeling where a player's going to shoot a penalty, then go with that hunch. It's the biggest advantage the goalie has."

Scurry had been creeping up off her line to cut into the angle and make the goal smaller. It's an old goalie trick DiCicco showed her. Men goalies do it all the time to throw off the kicker, and so far this ref has let it go. Bri will continue to test the ref's boundaries.

Save Scurry

The third Chinese kicker, Liu Ying, is scared, and Scurry knows it. Her body language is off. Liu is unsure, she's a kicker without a plan, and like a shark smelling blood, Scurry homes in on her.

"I saw her shoulders and head down, and I knew this was it," recalls Scurry. "I knew wherever she was kicking I was going to save it."

As Liu sets up, Scurry creeps off her line and leans left. Liu's strike is in the same direction. Scurry is parallel to the grass, her arms, fingers stretched to the max. She's leapt with so much force that she strains a muscle. She feels her gloves on the ball, and the crowd's roar confirms what she already knows.

"Save Scurry!" JP Dellacamera cries into the ABC mic.

Scurry is beside herself, pumping her arms, marching up the field screaming. "I just gave you guys the ultimate gift. Now go make your kicks, go make your kicks!"

"To make a save in PKs is unheard of, and a wave of relief swept over me," recalls Chastain. "I'm 100 percent convinced we would win now. I don't know if Bri will make another save or if we'll score another goal. I'm just confident we'll win.

"Bri was all over it," adds Chastain. "She knew where that player was going to go, she left her line too early, and maybe the ref should have called it back and make her rekick, but she didn't. Bri made a great save, and that was the difference."

The U.S. bench is going crazy. "Tony and I hugged each other, and I'm jumping higher than I've ever jumped in my life," recalls Gregg. "My arms are flapping in the air, and we're just going crazy with excitement."

There's also some concern from the bench that the referee would foul Scurry for shaving the line, but play continues. The line infraction later gets a lot of press, but Anthony DiCicco, who's heard it all, says the criticism has been overdone.

"I didn't feel at the time or now that it was particularly controversial, but it's taken on a life of its own, and I'm not sure why," says Anthony. "Certainly, it is within the letter of the law that you have to stay on the line until the ball is struck, but the truth is, Dad coached Bri to get off her line. He coached all of his goalkeepers to do so because it's one thing for the referee to make that call, but it's another not to give your team the best opportunity to make the save. In Bri's case, it wasn't that she just got off her line on that shot. She was off her line on all five shots. What made that one the difference is the

way Bri has described it since. The body language she read in Ling. She knew going into the kick that this was the one."

The Heartbeat

The last time the crowd noticed Kristine Lilly she was making a game-saving header off the near post. Now she's attempting to follow up on Scurry's save and put the U.S. ahead, 3–2. Why Lilly at number three? Gregg had several options going into penalties, including Julie Foudy, Shannon MacMillan, and Tisha Venturini.

"I had confidence in all these players for different reasons," says Gregg. But when you're talking dependability, Lil is the heartbeat of our team. She plays every minute of every game, and as a coach, you want to keep building on the momentum she brings. Our philosophy is we're always the aggressor, and Lil was the right person to be at that point."

As a lefty, Lilly's natural inclination is to the left side, and Hong had been leaning that way. Lilly is also savvy enough to know switching feet now could create indecision. She will go with her strength and challenge Hong on her left.

From his seat, Anthony DiCicco reads it all the way.

"Lil aimed to the bottom left corner, and it ended up scoring in the top left corner," recalls Anthony. "Dad always said if you're going to miss, aim low so that you have that advantage. Lil played within the margins that day, but as the most consistent, reliable stalwart for the team, it made perfect sense for her to be out there."

When she'd finished her kick, Lilly nonchalantly jogged back to her teammates at midfield, like she was playing a pickup game. Humble, professional, no-frills Lil makes it 3–2, U.S., and if their remaining two kicks are successful, they'll win the World Cup. But in PKS, nothing is guaranteed, and no one knows that better than Mia Hamm.

As her teammates joyfully cluster around Lilly, Hamm isn't smiling. She's prepping in her mind her upcoming kick. But first she will watch China's Zhang Ouying, the fourth Chinese shooter. Ouying is outwardly calm, calculating, and clinical. She kicks left, Scurry guesses right, it's tied again, and Mia is next.

Reluctant Hero

It's been several minutes since Hamm told Gregg she was having doubts about her PK and was told she would kick one. Undeterred, Hamm approached Shannon MacMillan and tries her.

"When Lauren announced the lineup for PKs, there was a moment of bum-ness when my name wasn't called because we've been training, and I was down with them," says MacMillan. "But after Lauren gave the order, Mia comes up to me and says, 'Mac, are you taking one? What number are you?'

"I pointed up to the crowd. 'I'm after that guy up there in the white shirt,' I told her. 'I'm number 22.' It was some smart-ass comment, and Mia's like, 'You're not taking one?'

"'No.'

"She goes, 'Will you take mine?'

"I say, 'All right.'

"Then Lauren comes up and says, 'Mia, I already submitted your name, and you have to take it.'

"And there was this look on Mia's face, like, 'Ohhh shit.'

"Mia did not like taking penalties, where someone like me would be dying to kick one, but this wasn't about her. She was thinking about us, and who was best qualified to take one.

"To Mia's credit, she was able to say, 'I don't think I'm the best option for the team.' It wasn't about her, as much as 'I want to put the team in the best opportunity to succeed.'"

For Tony DiCicco, having Hamm do a penalty kick was a no brainer.

"As a coach, I'm not going to leave the most prolific goal scorer in the history of the game on the bench in a penalty kick shootout," says DiCicco. "Mia just thought there were better penalty kickers on the team. We had Michelle Akers, and when she was around she was the best. Brandi Chastain was darned good, and so was Carla Overbeck. Mia thought that Shannon should be taking the penalty, but once we told her that she needed to take one, she was fine."

Anthony DiCicco believes his dad's decision to stick with Mia was rooted in faith.

"Leading up to the final Mia was really struggling with her pen-

alties in training, but when the big moment came, he had faith she would execute when she had too. It was his unwillingness not to put his best goal scorer at the spot because PKs are not technical. Every player who plays at just about every level can score a penalty kick. It's really about the mental strength that's required and the mental battle with the goalkeeper.

"Mia's a warrior, and she always has been. She has that special quality, that X factor, that the greatest who ever played the game must possess, and at that moment, with the World Cup on the line, that's what she tapped into."

When it comes time, Hamm doesn't give Gau Hong the chance to spook her by looking up. She scouted the goalie, and in all the previous U.S. attempts, Hong went right. Hamm wipes a lock of hair from her face, approaches the ball, and as Hong shifts right, Hamm strikes a low line drive to the empty net on the left. Mia stepped up, and it's 4–3, U.S., and China's in a heap of trouble.

On her triumphant return to the pack at midfield, Hamm is animated but unsmiling.

"She just kind of screamed and pulled one of her fists back to her," recalls Lauren Gregg. "It was the release of this obvious tension. She tried to shut everything out, but the pressure can well up inside and that moment was a moment of release for her . . . thank god."

"Where Am I in the Order?"

Brandi Chastain has been anxious, but her angst is mostly logistical. For the duration of the penalty kicks, she's been oblivious to the order. By the time Sun Wen makes her way for the fifth Chinese attempt, she finally figures she must be going fifth.

"I must not have been paying attention, because I have no idea where I am in the kicking order," recalls Chastain. "Maybe I didn't hear it or just put it out of my head, but I feel a bit embarrassed. I don't ask anybody. I don't say, 'Hey, girls, can you tell me what number I am?' Because they would be like, 'Jeez, are you kidding, Brandi? Come on!' Besides, I don't want to get in their way. They're doing their own thing to get ready and have enough stuff to worry about.

"We have Mia Hamm, the highest goal scorer in the history of

women's soccer, and she doesn't want to take a penalty. But Tony tells her, 'Whoa, Mia, you don't have a choice. You're going to take a penalty. You're Mia Hamm! You're the all-time goal scorer!'

"So I don't want to get in the way of whatever Mia needs to do at that moment by asking, 'Hey, Mia, do you know what the order is? Where am I in the order?'

"So I sit back and wait for them to go, and when it's obvious I'm not first, second, third, or fourth, I figure I must be the last."

Chastain isn't the only one dazed and confused. There is uncertainty by the U.S. bench players over the score, and so it's left to Aaron Heifetz, who's been charting goals, to update the bench. After Hamm scores, he informs everyone Sun Wen is the fifth Chinese shooter, and if she misses, the U.S. will win.

DiCicco told Scurry earlier Sun Wen had the propensity of shooting right, but Scurry forgoes the advice. "We knew where Sun Wen was going. Unfortunately, Bri went the other way," recalls DiCicco. Sun Wen went right to an open net, and Bri basically stood still."

Scurry later told the press she'd injured herself stretching for the ball against Ling and couldn't move, but all that is of little concern now. If Brandi's successful on her PK, the U.S. will win the World Cup.

Up in the tenth row, Anthony DiCicco is gauging Brandi's body language, while the person next to him has his head buried in his hands.

"I was next to Brandi's older brother, Chad," recalls Anthony. "As she was about to kick Chad says, 'I'm not sure I can watch her do this.'

"I go, 'HUH? Chad, your sister's about to score the winning penalty kick in the World Cup. You have to watch!'"

Meanwhile, Brandi is on the penalty stripe doing her best to shut out the noise. It's a real Hollywood moment.

"As I approached the referee to get the ball it was incredibly quiet," recalls Chastain. "The distance to the goal seems a lot farther than fifteen yards. I don't lift my head to look at the Chinese goalkeeper. I'm not going to give her another chance to do what she did to me in Portugal when I smashed my penalty kick into the crossbar, and we lost 2–1.

"'Just don't look at the goalkeeper,' I tell myself. My head and eyes are down, but I see the goalie's feet in my peripheral vision. I step

back from the ball, tap my toe on the ground, and feel the edges of my shoe around my foot. Then I settle my plant foot and wait for the whistle, and when it blows, I approach the ball like I've done in practice a million times. My shoelaces are up for maximum power, and I strike it hard toward the middle of the net.

"It feels like it takes a long time to get there, and I may have made it a little too close because the ball hits the side netting. As the ball hit the side net, the whole world fast-forwards. Everything is exponentially brighter, louder, faster, and then the celebration, also in warp speed.

"From the ball hitting the net to when I ripped off my jersey and fell on my knees—it all happened in an eye-blink. I turn around, and all my teammates are there. It's a spectacular feeling."

Shannon MacMillan has a photo in her hallway of the penalty kickers at midfield precisely the moment Chastain scores.

"We're all midstride," says MacMillan. "Lil's in the air, Carla's got her fist up, and we're about to go run to Brandi. It's my all-time favorite picture because of the emotion."

Seconds after the photo is snapped, the kickers are in a full sprint heading toward Chastain. The two fastest, MacMillan and Sara Whalen, are the first to arrive.

"I saw the shirt coming off, but it was just a blur, and so we didn't even think about it," says MacMillan. "We were just trying to get to Brandi and celebrate. I see she's whipping the shirt above her head, and all of a sudden Sara and I are on top of her. Then the rest of the team is there, and it's like, oh my gosh, it's all done, we did it."

Down on the bench, Gregg and DiCicco see Chastain's right arm reach over and grab the left side of her jersey. "I could see her six-pack abs," recalls Gregg. "I saw her drop to her knees and see her shirt waving around and around in her right arm and a horde of players running out toward her."

Up in the stands, Anthony and Chad Chastain are ecstatic. "We went crazy," recalls Anthony. "It was a moment of a lifetime, and one of pure unadulterated joy, the kind you want to mainline over and over. Of course, the shirt is what everyone remembers, me too, but there are other things.

"In my mind's eye, I see the other Americans sprinting to Brandi from midfield, and Aaron Heifetz standing out amidst the growing pile because he's wearing a gold vest, and it made me laugh. I found out later some people at U.S. Soccer thought Aaron's participation in the pile-on somehow detracted from the visual on TV, but Dad and Brandi defended him. They knew that in those once-in-a-lifetime moments, people act on pure emotion."

Chastain is in complete ecstasy as players gather on her. She's clad in her black sports bra and shorts, but JP Dellacamera and Wendy Gebauer, the two ABC announcers, make no mention of it.

Carla Overbeck says she was not surprised by Brandi's spontaneous reaction and was in no way put off. "We would beg Tony to let us do our fitness in our sports bras," says Overbeck, "so it was no big deal. It was just a celebration and raw emotion and excitement. After a while, we're like, 'Okay, put your shirt back on, B.'

"People are saying she planned it and we're like, 'No she didn't.' It was just pure elation. Guys do it all the time, so we didn't know what the big deal was."

Chastain herself has stated it was a moment of madness and nothing more.

"So much has been made about whether I had planned to tear off my jersey. I can tell you it was 100 percent spontaneous. I mention this because if I had designed it, a lot of things would have had to go right.

"First off, the match is going to have to end in a tie. The team is going to have to go through overtime, and Tony is going to have to make a list that puts me at the end as the final penalty kicker. We're also going to need China to miss or for Bri to make a save. Then, if all that happens, I get to score the winning PK and do a celebration with my shirt off.

"Anybody with any common sense will see that planning for all that is virtually impossible. I'm a gambler, but I'd gamble more on a lottery ticket than having all those dominos fall into line.

"I like to explain it as 'a great moment of insanity' where every emotion was available and on display, and I just had just to let them all out. The moment was pure satisfaction, joy, confidence, gratitude, and happiness, and more . . . it was just an explosion of insanity."

31

AAAKERS

Michelle Akers never saw the majority of the penalty kicks. She was flat on her back on the trainer's table in the medical triage room, packed in ice, with two IVs in her arms. That's not to say she didn't hear their reaction. The medical staff had a little TV in the room that Doc Adams and the others had clustered around. When Akers listened to the screams after Scurry blocked China's third kick, the excitement got her curious. With Doc Adam's assistance, she hoisted herself to a prone position so she could watch Brandi's attempt. After she scored, there was chaos. Doc Adam's got inches from Michelle's face and started screaming, "We won! We won!"

The realization she was a World Cup champion again perked Michelle's spirits, tears poured down her bruised eye sockets, and she had a sudden urge to be back on the field. She told Doc Adams to remove the IVs from her arms, and with Adams along for support, she began the slow march through the locker room to the field, where the medal ceremony was about to begin. Once in the tunnel, they ran into problems. The president and his party were due to arrive shortly, and the secret service blocked the entryways to and from the field. Agents had strict orders not to let anybody through. Since Akers was no longer wearing her jersey, they refused to let her pass. Doc Adams insisted she be allowed through, and finally they relented but for whatever reason kept Adams back.

Groggy and in pain, Akers stumbled on alone. When she got to the end of the tunnel, she was met by a burly cop with orders not to let anyone through. Akers was in dire shape with a concussion and

chronic fatigue. Her team just won the World Cup, and now she had to contend with a bull-headed security cop who wouldn't know a soccer player from a mop. Exasperated, the barefooted Akers physically tried to bulldoze her way past the cop. But her energy was fleeting, and the futility of the effort was taking a toll.

She was literally at the end of her rope when a FIFA official who recognized her happened upon the scene. The cop stood down, and Akers was back in action. By this time Doc Adams rejoined her, and together they continued their mad odyssey back to the field.

A carpet of confetti awaited her on the pitch, but by the time she arrived at the podium the medal ceremony was winding down. With Doc Adams guiding her, Akers made it to the platform, where FIFA's Sepp Blatter saw her and, after an emotional hug, hung the first-place medal around her neck.

When her teammates saw her, there were heartfelt hugs and tears, but Akers was starting to feel the strain. Doc Adams sat her down on the corner of the podium, and while the team did a victory lap, Mustafa rested. She was content to sit and watch as her teammates charged madly around the field with American flags, and though she couldn't partake, it was gratifying to see everyone so happy.

Then, like an apparition, from the victory haze emerged her best friend, Amanda Cromwell. Somehow she had snuck down from the stands and came to her aid. There were more hugs and tears before Cromwell detected a strange cheer emanating from the stands. They were chanting something, but Akers in her diminished state couldn't make it out.

"You hear that, Mish?" Cromwell asked.

"What? Hear what?"

"They're calling your name."

Thousands of fans, many who hadn't been born when Akers suited up for her first Mundalito Cup in 1985, were cheering, "AAAKERS, AAAKERS, AAAKERS."

The salute brought chills. Akers insisted they both go to midfield and acknowledge the crowd. As her teammates looked on, Akers moved to the middle of the Rose Bowl floor and waved—a fitting trib-

ute to one of the world's most courageous athletes, man or woman, who ever set foot on a field, pitch, or sporting arena.

Finally, Doc Adams insisted it was time to go, and Akers slowly made her way back, but before reaching the tunnel, they were met by Tony DiCicco, holding the World Cup trophy. The two champions embraced, and with Tony at her side, Michelle raised the cup, to the crowd's rousing approval.

"As we walked off the field, I sensed we were both leaving the team, even though neither one of us wanted to," recalls DiCicco. "I had a sense we would never be at that level ever again, and as it turns out, that was sadly the case."

32

Presidential Approval

Before President Clinton visited the winning locker room, he ventured to the losing side and congratulated the Chinese team on a gutsy performance. It was a savvy move by Clinton, considering the recent political trade squabble with Beijing.

Moments later the president, Hilary, and Chelsea Clinton and the governor of California, Grey Davis, together with Arsenio Hall and a phalanx of secret service agents, burst into the victorious national team locker room and were met with a chorus of cheers.

Clinton told the team how proud the nation was of them and the impact they made on the world. Players snapped photos, shook hands, and chatted, but when Clinton spotted Akers all alone by her locker, he excused himself.

"For someone who knows how to take a hit, you played a heckuva game," the president told her.

"It was a big deal the president would be on hand to celebrate," recalls Anthony DiCicco, who was present. "As the leader of the free world, he understood the foreign relations impact and the significance of the Women's World Cup and the rising popularity of the national team."

Anthony found it somewhat unusual that Arsenio Hall, who had not been particularly relevant, was allowed to crash the team party with the president.

"I don't know how well the president knew him past the famous saxophone episode," says Anthony, "but sure enough he was flanking the president as they came down to the locker room."

It seems that Arsenio Hall wasn't the only comedian in the room. The team general manager, Brian Fleming, had made a deal with the players that they could shave his head if they won. In front of the president, the First Lady, and the weary secret service, Fleming had his head shaved. Of course, Julie Foudy was there to supply some comic relief. Imagine the look of the secret service as Foudy stood with a pair of clippers in her hand going, "Can I offer you a trim, Mr. President?"

ABC named Carla Overbeck player of the game. Sun Wen won the Golden Ball as the tournament's best player and shared the Golden Shoe with Sissi of Brazil, as top scorer with seven goals and three assists apiece. Michelle Akers won the Bronze Ball for the third-best player in the tournament.

Regarding her being named MVP, Overbeck remains humble. "To be honest, if somebody would have scored, they would have been MVP, or how about Kristine Lilly hitting that ball off the line. If that doesn't happen we lose."

In a classy move, Mia Hamm visited the China locker room, where she met with a despondent Sun Wen, and in a show of mutual respect, they traded jerseys. The superstars represented their countries well. Unfortunately, only one could raise the cup that day. Depleted, Mia later passed out and needed an IV to replenish herself. A small price to pay for World Cup glory.

The national team partied into the wee hours of the morning and then rested an hour before starting on a whirlwind week that whisked them to the East Coast for a flurry of "A-list" events.

"It was time just to exhale and say now we can just enjoy it," says Shannon MacMillan. "The next morning we were on the Disney Main Street parade, and then we flew to the White House, and the next thing we were in New York at a Bruce Springsteen concert."

During the White House visit, Hillary Clinton informed the team that she along with some U.S. senators were flying to Cape Canaveral in Air Force One to watch the space shuttle launch. Since the mission would include female astronauts, it was only natural the national team come along.

"We asked Mrs. Clinton, 'How do we get down there?' and she says, 'Come with me,'" recalls MacMillan. "So we sat in the last few rows of

the plane and looted anything that wasn't screwed down—embossed napkins, cups, M&M boxes with the presidential seal—everything and anything was fair game. Unfortunately, the launch didn't happen due to technical issues, but it was one of those moments where you're like, 'Wow, how did that happen?'"

33

Women Power

Brandi Chastain's game-winning penalty kick and subsequent celebration has become memorialized in magazines, videos, books, and even in the Rose Bowl statuary garden beside Jackie Robinson. The moment has become etched in lore, considered a revolutionary moment for women.

For Chastain personally, her Rose Bowl moment has been life-altering. Instead of running from all the fanfare, she's embraced the event and turned it into a powerful teaching device she shares with her fans.

"There are people I've never met who relive the jersey celebration moment when they spot me in airports, grocery stores, and all sorts of random places," says Chastain. "When we talk, I learn what the moment meant to them and get to see it from a different perspective. It has evolved, but in essence, it was a grand celebration of a beautiful moment—a moment where many people get to experience it but in a different way than I did—and you can't script that.

"I tell young girls celebration is vital for women in the workplace as well as sports. Whether they are managers, owners, corporate presidents, or college students, women usually don't give themselves enough credit. We downplay the fact that we do great things because socially and culturally, it's ingrained in us to take the high road.

"When someone compliments us, we deflect it, and say, 'Oh no, no, no,' and we remain very humble. But the World Cup celebration image to me is all about empowerment. So I try to use it as a way for young girls to see that it is essential that we accept the compliment,

learn to expect our greatness, and pump ourselves up when we do something right.

"It doesn't have to be winning the World Cup. It can be a job well done daily, but if we don't own those golden moments, and we don't feel right about the good things we do, nobody else can. I like people celebrating a good thing done because it's infectious. When the national team was on the field, and things weren't going great for me, I would stand or pass the ball with the person who looked like they were in the zone and having their best day because I knew their positive vibe would wear off on me.

"My teammates were good at helping each other. My celebration moment speaks to a willingness to be confident and celebrate the good things that we do and share them. It's like a little pebble when you drop it in a still pond, and the ripples go out and get bigger and bigger. That's how I see my celebration moment at the Rose Bowl. It's still impacting young girls who weren't even alive when that kick took place."

For Tony DiCicco, Brandi's "moment of insanity," with the exception of winning the World Cup, was no big deal. If the weather was hot, his players often worked out in sports bras. So to him, when Brandi ripped off her shirt after her winning PK, it was par for the course. It was Brandi being Brandi; it's just more people witnessed it.

"Brandi had seen men do it all the time," says DiCicco. "In her exhilaration, she pulled off her shirt, but I don't think it took away from anything. She made the cover of every major newspaper and magazine in the country. It was just showing women power. Some cynical people said she was doing it for Nike to make a big contract. Still, for anybody who knew the game of soccer, they understood ripping off your shirt is done, but not often because you get penalized. But back then it was how soccer players celebrated, certainly on the men's side.

"So nobody on the team ever questioned it. We laughed about it. Julie Foudy told me, 'If I went fifth, I could have taken off my shirt,' and Julie was very capable of taking it.

"But Brandi had already made that kick in a full stadium a thousand times, and nine hundred and ninety-nine were in her mind. In basketball, as a kid, you'd take the shot, five, four, three, two, and

one, and hit the basket, and it's game over. Brandi had done that. She dreamed of big moments that the eleven-year-old dreams, and now when she's taking that kick, her body knows just what it needs to do, and she put it in the corner because she's done it a thousand times already. And that's why I had her take it."

Anthony DiCicco realized the moment Brandi waved her shirt it would be big, although he didn't think people would still be talking about the event some twenty years after the fact, and in his opinion, mostly for all the wrong reasons.

"The moment was a perfect encapsulation of the energy that had swept across the country," Anthony opines. "Still, it was a massive distraction from the much more important message of the power just unleashed by the mass attention on women's soccer. It's an iconic image, for sure, but the hypersexualizing of female athletes and the role their bodies play in somehow validating their success seems wrong to me. Brandi and the others were elite athletes who were comfortable in their skins. They wouldn't have accomplished what they did had they been anything less.

"Some funny and bizarre stories had circulated, like when Brandi was doing a photo shoot a few weeks before the World Cup. She was all oiled up and slipped out of her shirt, but it all undermines the more important message: that these women were incredibly powerful athletes who came together and formed a sisterhood that achieved its peak at the World Cup."

Lauren Gregg believes Brandi's moment of insanity helped pave the way for female acceptance and legitimacy, opened doors to a new league, and left a powerful legacy.

"We showed how both boys and girls celebrated women's sport, and these players could now make a living on it. On top of that, we were on every magazine cover under the sun and all the late-night shows. All of that was just icing on the cake and made it so much more fun than just a private journey."

Gregg agrees that the commercialization of the event bordered on sexualizing and was probably overblown.

"There were questions, and there still are today," says Gregg. "Are

we selling our players as athletes, or are we selling them as beautiful women?

"Instead of celebrating it was more, 'Wow, look at this ripped, healthy athlete,' and even today there is the question, do we only promote the prettier players, and why are women's sports celebrated through certain players and not other players?

"Unfortunately, that criticism embodied the moment for some people. But for those of us who knew Brandi, it was just sheer joy and nothing else. She wasn't trying to grab attention or show herself without a shirt on. It was just the moment."

Regarding hypersexualizing, Tiffeny Milbrett says Brandi's shirtless moment—or the reaction to it—was disheartening to her in some degree.

"I could not believe how sexualized the moment became, and that was disappointing," says Milbrett. "I mean, have men never seen women's stomachs before? What Brandi did is something you see in men's soccer all the time.

"When it happened, I was like, 'Oh yeah, that's normal.' I admit I haven't seen too many women do what she did, but we're never really in those powerful moments of victory like the World Cup to be able to do something like that.

"But there was more to it than Brandi just taking off her shirt. In the public's eye, we became celebrities. It catapulted the sport and our profession into the stratosphere. It gave us credibility to push for causes we always strived for and showed our strengths in ways never seen before, and I'm proud to be a part of that."

As good as it was for the national team in the summer of '99, to some invested observers, most notably U.S. Soccer, the World Cup success was something they couldn't quite get their arms around. Alan Rothenberg and company did a fine job constructing the event, but they hadn't prepared to take advantage of the lucrative windfall.

As it was, it took the players, most notably Julie Foudy, Mia Hamm, and Carla Overbeck, to lead the victory charge and fill the void where their federation fell short.

34

Antagonists

The spectacular finale to the 1999 World Cup should have been a wake-up call for U.S. Soccer to seize the moment, proclaim a victory tour, and help grow the game. Unfortunately, they dropped the proverbial soccer ball on all accounts. Their original concept of a victory tour was travel to Africa and play in a series of matches to sparse crowds unfamiliar with the national team. The players themselves were baffled. What benefit to them was an African tour when interest and the opportunity to grow the game was here in the United States?

The calamity doesn't start and end there. Since the national team began in 1985, U.S. Soccer had treated the women players unequally compared to the men's team. Whether they were aware of the shoddy treatment, only U.S. Soccer can say, but they seemingly did everything in their power to undermine the team or, at the very least, hold them back. The national team's initiative and desire to win and grow the game speaks to the character of the players and coaches and their wiliness to persevere.

Julie Foudy and the senior leadership tried for years to improve team conditions and fight for equal pay. Alan Rothenberg, Hank Steinbrecher, and company may have been visionaries when it came to planning events like the Olympics and World Cup, but they were negligent when it came to offering equality and respect for members of the national team.

Julie Foudy, who led the efforts to force U.S. Soccer to see the error of their ways, describes the events before and after the '99 World Cup that eventually helped set precedents for future national teams.

"One problem U.S. Soccer faced was they were quite familiar with men's soccer, but all of a sudden they've got these once feisty naive female teenagers, who'd come on board in the early 1990s, who were now twenty-something-year-olds. We were coming of age, and we were becoming more sophisticated in how we fought our federation.

"What set our team culture apart was we were very good at saying what is it we want for our group, the sport, what matters to us most, and how we are going to get there. At some point, we needed to say to our federation, 'Stop what you're doing because by oppressing us you're getting in the way and not helping.' Their job is to build the game, but they hindered our growth in some way.

"So we always took it as our responsibility to answer to this bigger calling of exposing more girls, and more boys, to see girls playing soccer. We felt it was equally important, and it shouldn't just be girls watching girls playing. It should be girls and boys watching girls play.

"We were very specific in terms of voicing our displeasure with contracts and conditions. We were unified and conscious in understanding what exactly we were fighting for, and we had public sentiment on our side when it came to that.

"In regard to the '99 World Cup, well before the event, we had called U.S. Soccer and asked them, 'What are you doing about marketing us?' And they'd say, 'What do you mean?'

"We told them, 'We would go into a city on the Road to Pasadena Tour, and there is nothing posted about the game, and no one knows anything. Then you come up to us and say, "No one wants to watch you play, so why are you asking for money?"'

"We'd tell them, 'But wait, how are people supposed to come to see us play if they never know that we're playing. You have to invest in some marketing.'

"But they don't market us, and we get frustrated about it, and little things become big things, and it continually starts to grate on you.

"For example, we board a plane, and none of us has seats preassigned because the travel agent doesn't have the time or doesn't care enough to give us seats. We could be traveling overseas, so I literally would take photos of us sitting, and there would be scattered red USA jerseys going up the entire middle of the plane. I'd send the pic-

tures to U.S. Soccer or Al Rothenberg, who was the president, and say, 'These are the little things I'm talking about, right, that matter!'

"We're traveling ten hours stuck in the middle or back of the plane. They would have smoking sections, and we're the last section right before smoking, so we're a soccer team representing the United States, sitting among smokers for ten hours.

"Finally, it got to a point, after the '99 World Cup, where we had some leverage. Leading into the tournament, we asked U.S. Soccer: What are you planning in terms of a post–World Cup celebration? This is going be big, right? Shouldn't we be capitalizing on that?

"And they're like, 'We don't have any plans.'

"We say, 'What do you mean you don't have any plans?'

"It was like they didn't care. It wasn't on the radar, or it wasn't important. So we formed our own marketing group, and we started marketing and got separate sponsors. Now it turns out we can't do an outdoor victory tour, because our influence didn't cover fields and outdoor stadiums, but we can do an indoor victory tour. So we seek U.S. Soccer's approval, but because they are not paying attention, they somehow block our tour, because they never responded.

"So we keep on without them. The World Cup rolls up, we win, and by now we got Toys 'R' Us, Bath & Body Works, and Indoor Jeweler as sponsors. But now U.S. Soccer finally decides it wants to do the victory tour. They come in late, and now they say, 'How dare you do this?'

"We're in New York after the World Cup. Mia, Carla, and I are all trying to get down to Washington DC on a train, but Carla got off at Baltimore Union Station instead of Washington DC's Union Station, and she missed the meeting.

"John Rangel, our lawyer, was there, and the three of us are sitting there with Alan Rothenberg, president of U.S. Soccer, and their legal counsel. They say, 'How dare you do this tour?'

"We say, 'How dare you not even plan a tour? How can you criticize us for going out and continuing to spread the game for all these young girls who have been watching us play all over the country, and now you try to stop us from going to the ten sold-out cities we plan

on going to? We had the foresight to say, "If you're not doing it, we're going to do something."'

"So U.S. Soccer tried to make us feel guilty. They said, 'We'll do the tour with our sponsors, and we'll pay you the same money you were going to make.'

"We started laughing. We said, 'Are you crazy? Do you think we would just take the money and go with you? Our sponsors believed in us before anyone knew the World Cup was going to be a success. They went out and sold it, so we're going to stay loyal to those sponsors and these people, and screw you! We have the right to do it!'

"So they said, 'Okay. We're not going to take you to the 2000 Olympics if you don't side with us.'

"By then, we were getting smart. Billie Jean King told us, 'You need to get all the younger kids on board so they understand what you're doing. Let them know this is ultimately for them, and so when U.S. Soccer tries to lock you out, they can't call in the eighteen-, twenty-, and the twenty-five-year-olds.'

"So we called the younger kids on the U-19 and U-21 team. We had a conference call with them and their parents and told them what we were doing.

"We said we hadn't asked you to stay out of it, because we can't, but please don't go as scrubs for the 2000 Olympics. We want U.S. Soccer to realize the force we are coming with, and if you go in, we can't get this done. As a national team, we are unified, but we need you to stay off the Olympic roster.

"They all agreed, and when U.S. Soccer threatened us again about getting the U-20s to replace us for the Olympics, we already had the kids in our pocket.

"This was all happening after we won the World Cup. We're this huge story, and there's a lot of momentum around us. But now they're trying to tell us, 'We're not going to take you to the 2000 Olympics.'

"I said to them, 'Ah, that's interesting. I bet Nike's gonna love that, Mia.'

"And Mia turns to me and says, 'Well, I think we had a pretty good run, Julie. I'm pretty good with not going to the Olympics. What about you?'

"I say, 'I'm pretty good too, and I bet our entire team is pretty good as well.'

"U.S. Soccer says, 'Well fine. We'll take a U-23 team.'

"And we said, 'Ahh, nope, we've already talked with them, and they're with us.'

"So then they say, 'Well, we'll take a U-19 team to the Olympics if that's what it takes.'

"'No, we've already talked to them. But we haven't spoken to the 15s and 16s. You can talk with them if you want.'

"They are dying now. Mia and I sat back there and smiled. For the first time, we had the leverage to dictate terms. We walked out of that meeting laughing. We're like, 'Who's driving the bus? We're driving the bus, baby! We're driving the bus!'"

35

Goodbye to a Friend

Anson Dorrance was at his soccer camp in Chapel Hill in June 2017 when he received an urgent call. It was Anthony DiCicco with gut-wrenching news about his dad. He told Anson that Tony was too sick to speak, and if he had any last words for his dad, now was the time.

The heartbreaking call was not entirely surprising. Dorrance had been receiving updates on Tony's dire condition, via a group text headed by Mia Hamm.

Still, nothing prepared him for this. Dorrance planned to compose a "goodbye letter" to Tony over the weekend, but with today's shocker, he'd have to improvise.

"My camp was just finishing up," recalls Dorrance. "It was Saturday, the camp ended noon on Sunday, and I planned to go to work on Monday, clear my desk, and write the most heartfelt note to Tony. I was going to edit it about seventeen or twenty times and make sure it was absolutely perfect. Then Anthony's call came.

"'No, Anson,' he told me. 'Text him something right now.'"

The memorial service, "A Celebration of Life," was held July 21 at Central Connecticut University. Guests included luminaries from the soccer world and players from the national team.

The ceremony was heartfelt and authentic. Friends and associates came up to the podium one by one to reminiscence and talk about Tony's life. Julie Foudy moderated.

When it came Dorrance's time to speak, he told the audience how

their trials and tribulations mirrored the rise of the national team, and despite the odds, they endured to carve out a lasting prototype.

"Thank you, boys, for letting me say goodbye," Dorrance told the DiCicco brothers. He then began reciting from the letter he'd texted to Tony just before he died.

"Dearest Tony, in 1986, you, Lauren, and I were asked to take over the U.S. Women's National Team. At the time, the United States had never won a game in international competition. Five years later, we were the first women's world champions. Five years after that, you reshaped our team, and it became the women's first Olympic gold medalist. Three years later, after polishing the team a bit more, in front of ninety thousand people in the Rose Bowl, you lead our country to our second world championship.

"You also raised the bar, not just for women's soccer on the planet, but for women's athletics. I bring all this up, just to confirm your place in the firmament of great people who have changed the world for the better. But those achievements were not why I love you; they're not why your players love you, and your resume is certainly not why your wonderful wife and extraordinary children love you, Tony.

"You are one of the kindest, most loyal, most principled centered men I have ever known. I can't believe the luck that brought us together. Bob Gansler, my national team coaching mentor, said, 'You were the missing staff member for me.' I trusted Bob completely, and he was right.

"The fun we had together for eight years, taking our team, shaping our team, traveling all over the world, teaming up against our managers during extended stops and crushing them in any 2v2 sports competition we could design. And every day, my respect and trust and love for you grew.

"You were great where I was horrible. Your attention to detail was extraordinary—your willingness to watch tape until your eyes were bloodshot verged on masochism. There was nothing you would not do for me or our cause. And more importantly, I knew as I left, not only was the coaching box for our women's national team checked. But the care for their personal humanity was protected as well.

"Please allow me to say thank you, Tony, for the Mt. Rushmore

achievements and service for our game and our country, but more importantly, deep appreciation from me for going all-in when no one cared about our game. When you step back, there's going to be a terrifying silence in our country's leadership voice. And an empty hole in the middle of my heart. You are easily one of the finest men I know."

When Mia Hamm's turn at the podium came, her discourse was equally heartfelt. She spoke eloquently of how DiCicco changed team culture by creating a positive and challenging atmosphere. She boasted on his strengths, and how through kindness, humor, and empathy, Tony allowed her to confront her weakness and the bonds of perfection she had created for herself.

"In some cases, you pretend those weaknesses don't exist," Hamm explained. "But not with Tony as your coach. He taught me that there could be strength in vulnerability. To completely grow up as a player and as a person, you have to be willing to put yourself out there, warts and all. He didn't want you to worry about failure, but growth.

"I didn't have to be perfect for Tony. He was assembling a team that loved each other, who covered for each other, and who picked each other up. He basically created an environment where we could be us. And where our personalities could be expressed, and individuality celebrated."

Hamm concluded by extolling people to aspire to DiCicco's best attributes.

"As you wake up tomorrow and every tomorrow after that, I ask you to approach your day as Tony reminded us to approach each game: to play hard, to go after it, to take risks, take pride in what you do, to play fair, to live your life with humility, and compassion, to have fun, to express joy, to dance badly, but most importantly, to love."

Since their inaugural trip to Italy in 1985, the national team has faced trials, tribulations, and hardships most professional teams would never dream of facing. They traveled in cargo planes, belching coal trains, ate dog and ox, and used old issues of *Reader's Digest* for shin guards. They played and practiced on anything and everything—from gravel pitches to parking lots, to sparse crowds for little money. They were slandered for being women, disrespected and subjected to abuses

from their federations, and forced to look on while their male counterparts received higher pay for lower performance.

Still, they endured. Despite the battles and the oppressors, the national team played on and over time became celebrated as heroes, role models, and icons.

But their success didn't just happen. It took visionaries like Dorrance, DiCicco, Dr. Colleen Hacker, and Lauren Gregg to set the bedrock for the budding team to flourish.

But at the end of the day, the coaches and staff were merely the facilitators. It was the players' job to turn their coaches' ideas into winning action.

The national team endures in part because these Dorrance/DiCicco-era teams refused to accept anything but excellence. Rather than be bullied by an oppressive federation and sexism, they bulldozed ahead, and followed their hearts, to create something meaningful, beautiful, and lasting out of nothing.

The national team showed by surrounding themselves with the best coaches and staff, and then by training and playing with purpose, unity, and vigor, that anything is possible.

Today's national team, along with and millions of people young and old, male and female, stand firmly on their strong shoulders.

Epilogue

It's been over twenty years since the national team electrified the nation at the 1999 World Cup. Women's soccer has come a long way since then. It's well into the mainstream now, and women finally have a professional league that can sustain itself. But more importantly, they've laid a foundation for women to play a sport they love, and for kids to grow up emulating female role models for the first time.

U.S. Soccer and the current national team have revised several policies such as charter flights and better-quality hotels, but they are still battling each other over equal pay and conditions. But for warhorses like Carla Overbeck, time has softened the edges. She's no longer the hardened fighter she once was. Carla currently coaches women's soccer at Duke University, mentoring the next generation.

Perhaps most surprising, the former captain no longer lays all the blame on U.S. Soccer for their divisive past. Perspectives change over time, and Overbeck's adversarial disposition toward the federation has given way to a grudging respect.

"I know we gave the federation a hard time, and there were some tense moments," says Overbeck," but there is no way we would have been as successful without them. My immature fighting self back then led to an 'I don't like you' mentality. It was always us against them, but I look back at it now, and I can see part of the problem was the federation just didn't know how to handle us. They'd never worked with women and girls before, and they had nothing to compare us with. Everything was new, the whole childcare thing with Joy and

me. It took work to get what we needed, but we always felt like the federation would come around.

"It wasn't like we got everything we wanted. We made compromises, but we weren't idiots, and neither were they. We fought for what we wanted, and they fought for what they wanted, and we came to a middle ground. Was it always the best result? No, and we both had to make compromises, so no hard feelings, sort of.

"My older and more mature self realizes we were naive, and where money is involved, things change. But the bottom line, we wouldn't be where we are today without U.S. Soccer and their support. I admit I didn't like them back then, and we had to fight them for lots of things, but a lot of it was just the unknown."

For Overbeck, what stands out most aren't the bitter battles, or the team's great victories and bitter defeats, but the enduring friendships.

"The character my teammates possessed and still do is incredible," says Overbeck. "I can't imagine another team coming along like ours. Seeing the other countries and the struggles they were going through, and how they evolved, I think they benefited from watching us.

"What we went through with the federation made us stronger, tougher, and more united as a group. We bonded and tried to be fair with each other and made sure that we all played on an equal footing. Mia could have demanded she get paid the most, but as a group we decided our own pay scale, and it was fair to everyone. I congratulate Mia for being Mia. She could have put herself above the team, but she didn't.

"What we did from 1985 to 1999 had never happened before; there was no precedent. There will never be another team like ours. Other national teams will win and get along, but our team was special."

U.S. Soccer didn't bring Tony DiCicco back as coach in 2000, and April Heinrichs took over as head coach. Under April's watch, the national team made it to the 2000 Sydney games but finished second to Norway. At the 2004 Olympics in Greece, Heinrichs and the national team redeemed themselves nicely, winning gold.

The Athens games would be the swan song for many national team veterans. Heinrichs stepped down as head coach in 2005. She returned

to the USSF in 2011 as their youth technical director, a position she held until 2018. A true pioneer of the women's game, in 1998 Heinrichs became the first female elected to the National Soccer Hall of Fame.

In 2001 Tony DiCicco became commissioner of the Women's United Soccer Association (WUSA), the first women's professional league. Unfortunately the league disbanded three years later. DiCicco tried returning to U.S. Soccer, but the federation wanted new blood. When he finally got his chance in 2008, he coached the U-20 women's team to the World Cup in Chile, for their division. Notable players include Alyssa Naeher, Kelley O'Hara, Sydney Leroux, Meghan Klingenberg, and Alex Morgan. Following the tournament, DiCicco urged national team coach Pia Sundage to bring Morgan up to the senior team.

"I told Pia, 'There are two players you need to bring in, Keelin Winters and Alex Morgan.' Pia brought neither one in. She brought some other players in, and then one day we had a conversation.

"Pia asked, 'I need forwards, who I should bring in?'

"I told her, 'Alex Morgan,' but she never brought her in.

"Two months later, Pia asks again, 'Who should I bring in?'

"I said, 'Alex Morgan.'

"Pia said, 'You always say, Alex Morgan.'

"I said, 'You need to bring her in.'

"The reason Alex finally got in was not because of me. I got a call from Florida State coach Mark Kerkorian, who was about to play Cal in the NCAA tournament. He had seen Alex play, and he said, 'Tell me everything you know about Alex Morgan. She looked fantastic.'

"I said, 'I'll tell you everything I know about Alex, but you'll have to tell Pia that she needs to be brought in.' And that's how Alex got into the national team program.

"Alex is a remarkable scorer. My only concern is she gets injured, which may limit her career. But when she's healthy, and confident, she's a phenomenal goal scorer."

April Heinrichs became U.S. Soccer technical director in 2011. DiCicco tried several times to get back with U.S. Soccer, but he was stymied. There was bad blood between Heinrichs and DiCicco for a while, but Tony finally buried the hatchet.

"April Heinrichs is a difficult one for me as I don't have a lot of real

positive things to say," says DiCicco. "However, I have moved on. I have forgiven her for the times she has hurt me, and I hope she has forgiven me for the times I have hurt her. Either way, I have forgiven myself. I chose peace rather than conflict."

Michelle Akers retired from the game in 2000, chronic fatigue syndrome being her undoing. In 2002 she was named FIFA Female Player of the Century, an award she shared with China's Sun Wen. In 2004 she was inducted into the National Soccer Hall of Fame. Today Akers works with abused and neglected horses on her farm near Atlanta.

After winning gold in the 2004 Athens Olympics, Mia Hamm, Brandi Chastain, Julie Foudy, and Joy Fawcett all bowed out together following a ten-game farewell tour. Foudy and Hamm went into the Hall of Fame together in 2007. Fawcett was inducted in 2009 and later went on to coach the women's program at UCLA. Mia heads the Mia Hamm Foundation, a nonprofit dedicated to raising funds and awareness for families in need of a marrow or cord blood transplant and to the development of more opportunities for young women in sports. Julie Foudy works as a soccer commentator for ESPN and runs a soccer camp for mixed ability students. Her Sports Leadership Academy is aimed at exposing student athletes to the ranks of life leadership.

Brandi Chastain, inducted into the Hall of Fame in 2016, remains the consummate soccer junkie, coaching youth teams and assisting women's soccer at Santa Clara University.

Shannon MacMillan and Tiffeny Milbrett retired in 2006 and became club and youth coaches. Both players were elected to the Soccer Hall of Fame, Shannon in 2016, and Tiffeny in 2018.

Briana Scurry remained with the national team until 2008. During the 2007 World Cup semifinal against Brazil, Scurry was involved in a terrible coaching decision involving her coach, Greg Ryan, and fellow goalie Hope Solo. The incident ultimately cost Ryan his job and proved the unity of the sisterhood has strong bonds.

Scurry had not played in a lot of games in 2007, and by then Hope Solo was the starter. Before the semifinal, Solo had started in every World Cup match, but Ryan, believing Scurry's record against Brazil warranted the start, pulled Solo in favor of the veteran.

Tony DiCicco, who was present at the game as a TV analyst, recounts the incident.

"Bri had a good record against Brazil, but you had a goalkeeper in Hope Solo who was playing every game and doing pretty well, and now you're going to make the substitution?

"It didn't make a lot of sense at first, but I heard later Hope was breaking team rules and missing team meals, and she wasn't staying at the hotel but was with her boyfriend. I don't know if these rumors are true or not, but it's what I heard from players on the team.

"If Greg Ryan would have come out and said, 'Hope Solo is benched for this game for breaking team rules, he might still be coaching. But he came out and said, 'I'm going to change the goalkeeper because I have this hunch.'

"It proved to be a terrible mistake.

"Hope Solo's response after the game was also terrible. She wanted to throw her coach under the bus, and I don't blame her for that. But she threw Brianna Scurry under the bus by indicating that she would have made the saves, and the coach made the wrong move.

"She was putting Scurry down, and that's what the players and coaching staff were having trouble with. The team leadership under Kristine Lilly had a meeting with Hope Solo in a hotel room where they read her the riot act. Hope left the room in tears. The leadership later made Hope apologize to Scurry and the rest of the team.

"Now, is this something that takes place in all sports? I don't know. But you have to understand this is a game of sisters. This is a team that sticks together and protects and supports each other, and in their eyes, Hope Solo crossed the line. I don't even think she was on the bench in the third-place game that they won with Briana Scurry in goal."

Elected to the Soccer Hall of Fame in 2017, Scurry is currently an assistant coach with the NWSL Washington Spirit.

Tony DiCicco was elected to the Soccer Hall of Fame in 2012. In 2017 he posthumously was awarded the Werner Fricker Builder Award. His son Anthony remains a highly respected spokesman on all things soccer. He has carried on his dad's legacy, by using his experience, integrity, and knowledge to grow the game at every opportunity.

Dr. Colleen Hacker is currently a professor and an assistant dean at Pacific Lutheran University. She remains an internationally recognized authority on the psychology of peak performance. In 2018 she served as mental skills coach for the U.S. Women's Olympic Hockey team that won the gold in South Korea.

Kristine Lilly retired from the national team in 2010. She played an unprecedented twenty-three years and remains the most capped player, man or woman, in soccer history, with 354. Her 130 goals place her third all-time behind Mia Hamm's 158 and Abby Wambach's 184.

Carla Overbeck is an assistant women's soccer coach at Duke University, a position she has held since 1992. In late 1999 she was diagnosed with Graves' disease, but she refused to let it deter her from competing. She continued playing for the national team until 2000 and for the WUSA from 2001 to 2002. Elected to the National Soccer Hall of Fame in 2006, Overbeck is considered one of the greatest team leaders in the history of U.S. sports.

Carin Jennings-Gabarra retired following the 1996 Olympics. She currently coaches women's soccer at the United States Naval Academy in Annapolis, Maryland. Elected to the Soccer Hall of Fame in 2000, Jennings-Gabarra says the player who most resembles her on the current national team is Tobin Heath.

Lauren Gregg retired from her coaching duties on the national team in 2000. The pioneering assistant and college coach for the University of Virginia is also a physician, author, and member of Virginia-DC Hall of Fame.

Stacey Enos lives in North Carolina and currently works as a real estate broker.

Linda Gancitano teaches middle school in Hollywood, Florida. In 2015 she was honored at the White House for her work in climate education and literacy.

Emily Pickering Harner, who once idolized female roller derby players because there were no professional women's sports, resides in Virginia, where she is her daughter's soccer coach. Emily was elected to the Long Island Soccer Hall of Fame in 2015.

Anson Dorrance is still head coach at the University of North Car-

olina. He's considered the father of women's soccer and one of the greatest college coaches of all time. His record twenty-two NCAA championships in all likelihood will never be matched. He continues to be a lifelong mentor and role model to student athletes and his former players.

Acknowledgments

Thanks to the following players and coaches for their time, insights, and perspectives: Michelle Akers, April Heinrichs, Brandi Chastain, Carla Overbeck, Julie Foudy, Kristine Lilly, Shannon MacMillan, Emily Pickering Harner, Linda Gancitano, Stacey Enos, Kim Crabbe, Carin Jennings-Gabarra, Tiffeny Milbrett, Lauren Gregg, Dr. Colleen Hacker, Anthony DiCicco, Andrew DiCicco, Tony DiCicco.

Thanks to Robert Wilson (agent), Robert Taylor, Courtney Ochsner, Jane Curran (editor), Sara Springsteen, Tish Fobben, Rosemary Sekora, Aaron Heifetz, Kevin Baxter, Tony Quinn, Michelle Kimzey, Rick Goldman, Rick Clemens, Jesse Hoffs, Randy Pennington, Ray Lang, James Doss, Bob Case, Joe Hutchins, Bill Gifford, Marshall Terrill, the Wallens, the Ryans, the Kendalls. Special thanks to Kenneth Pope for staying in the game ninety minutes, beginning to end.

Notes on Sources

1. The Mavericks

Interviews: Emily Pickering, Linda Gancitano, Michelle Akers, Stacey Enos.

2. OOSSAAA, OOSSAAA, AH

Interviews: Emily Pickering, Linda Gancitano, Michelle Akers, Stacey Enos. *Gazzetta Della*—Italian sports paper, August 1985. Roger Rogers game notes.

3. Fury and Finesse

Tim Crothers, *The Man Watching*.

4. The Perfect Intersection

Interviews: April Heinrichs, Lauren Gregg, Emily Pickering. Tim Crothers, *The Man Watching*.

5. The Babies

Interviews: Kristine Lilly, April Heinrichs, Michelle Akers, Julie Foudy, Carin Jennings-Gabarra. Jere Longman, *The Girls of Summer*. Tim Crothers, *The Man Watching*.

6. Green and Growing

Interviews: Michelle Akers, April Heinrichs. Tim Crothers, *The Man Watching*. Michelle Akers with Gregg Lewis, *The Game and the Glory*.

7. The Breadcrumb Generation—Haiti

Interviews: Carin Jennings-Gabarra, Michelle Akers, April Heinrichs. Tim Crothers, *The Man Watching*. Michelle Akers with Gregg Lewis, *The Game and the Glory*. Society of Women's Soccer website.

8. The Queen of Women's Soccer

Planet Fútbol with Grant Wahl podcast, June 17, 2019. Remzecala website, May 10, 2016.

9. Crazy Legs Carin

Interviews: Carin Jennings-Gabarra, April Heinrichs, Michelle Akers, Carla Overbeck. *Vision of a Champion Podcast with Anson Dorrance*, episode 1, "Mia Hamm," Tar Heel Sports Properties and Creative Allies, September 23, 2020.

10. M&M's Cup

Interviews: Carin Jennings-Gabarra, Michelle Akers, April Heinrichs, Lauren Gregg, Carla Overbeck, Tony DiCicco. Tim Crothers, *The Man Watching*. *Planet Fútbol with Grant Wahl* podcast, May 9, 2019. Society of Women's Soccer website.

11. Bookends

Interviews: April Heinrichs, Lauren Gregg. Tim Crothers, *The Man Watching*.

12. A Captain's Tale

Interviews: Carla Overbeck, April Heinrichs, Lauren Gregg. *Dallas Morning News*, July 3, 2015.

13. Improbable Improbabilities

Interviews: Lauren Gregg, Anthony DiCicco, Tony DiCicco.

14. The Only

Interviews: Lauren Gregg, Shannon MacMillan, Tony DiCicco. *The Undefeated*, February 2, 2018. Jere Longman, *The Girls of Summer*.

15. Le Passion Play

Interviews: Carla Overbeck, Tony DiCicco.

16. "Michelle, Get Up"

Interviews: Tiffeny Milbrett, Tony DiCicco, April Heinrichs, Carla Overbeck. Michelle Akers with Gregg Lewis, *The Game and the Glory* (journal entry, ch. 14). Society of Women's Soccer website.

17. Perseverance

Interviews: Brandi Chastain, Tony DiCicco.

18. Mac Attack

Interviews: Shannon MacMillan, Tony DiCicco. *The Oregon Encyclopedia* (Clive Charles).

19. Power to Be Bold

Interviews: Dr. Colleen Hacker, Julie Foudy, Lauren Gregg, Tony DiCicco, Brandi Chastain.

20. The Advocate

Interviews: Julie Foudy, Kristine Lilly, Lauren Gregg, Dr. Colleen Hacker. *Los Angeles Times*, December 7, 1995.

21. The Outlier

Interviews: Tiffeny Milbrett, Dr. Colleen Hacker.

22. The Atlanta Olympics

Interviews: Tony DiCicco, Anthony DiCicco, Dr. Colleen Hacker, Brandi Chastain, Shannon MacMillan, Tiffeny Milbrett, Julie Foudy, Carla Overbeck. Michelle Akers with Gregg Lewis, *The Game and the Glory*. Society of Women's Soccer website. *Sports Illustrated*, January 8, 1996.

23. The Mia Parables

Interviews: Tony DiCicco, Kristine Lilly. Tim Crothers, *The Man Watching*. Jere Longman, *The Girls of Summer*. *Vision of a Champion Podcast with Anson Dorrance*, episode 1, "Mia Hamm," Tar Heel Sports Properties and Creative Allies, September 23, 2020.

24. Storm Clouds

Interviews: Tony DiCicco, Lauren Gregg. Society of Women's Soccer website.

25. The Elephant in the Room

Interviews: Tony DiCicco, Carla Overbeck, Julie Foudy, Shannon MacMillan. Find Law website. *Los Angeles Times*, March 1, 1999. "I Belong on That Team," *Newsweek*, February 28, 1999.

26. Lightning in a Bottle

Interviews: Tony DiCicco, Brandi Chastain, Carla Overbeck, Julie Foudy. *Sports Business Journal*, April 4, 2011, and February 3, 2020 (Marla Messing). Jere Longman, *The Girls of Summer*.

27. Road to Pasadena

Interviews: Tony DiCicco, Brandi Chastain, Tiffeny Milbrett, Shannon MacMillan, Lauren Gregg, Carla Overbeck, Kim Crabbe. *The Undefeated*, February 2, 2018 (Briana Scurry). Society of Women's Soccer website. *ESPN Magazine*, June 18, 2019 (Becky Sauerbrunn).

28. Game Day

Interviews: Tony Di Cicco, Anthony Di Cicco, Lauren Gregg, Brandi Chastain, Shannon MacMillan, Kristine Lilly, Carla Overbeck, Tiffeny Milbrett. Jere Longman, *The Girls of Summer*.

29. The PK Thing

Interviews: Brandi Chastain, Lauren Gregg, Kristine Lilly, Shannon MacMillan, Dr. Colleen Hacker. Wikipedia (William McCrum). *Haaretz*, November 22, 2017 (Yosef Dagan).

30. "Fake It Till You Make It"

Interviews: Brandi Chastain, Lauren Gregg, Carla Overbeck, Anthony DiCicco, Tony DiCicco, Kristine Lilly. Fox Sports—ABC USWNT—China YouTube, *LA Daily News*, June 25, 2015 (Briana Scurry).

31. AAAKERS

Interviews: Tony DiCicco. Michelle Akers with Gregg Lewis, *The Game and the Glory*.

32. Presidential Approval

Interviews: Anthony DiCicco, Carla Overbeck, Shannon MacMillan.

33. Women Power

Interviews: Brandi Chastain, Anthony DiCicco, Tony DiCicco, Lauren Gregg.

34. Antagonists

Interviews: Julie Foudy.

35. Goodbye to a Friend

Interviews: Anthony DiCicco. Video tape—Tony DiCicco Memorial Service, July 21, 2017, courtesy Anthony DiCicco.

Epilogue

Interviews: Tony DiCicco, Carla Overbeck.

Selected Bibliography

Akers, Michelle, with Gregg Lewis. *The Game and the Glory*. Grand Rapids MI: Zondervan Press, 2000.

Crothers, Tim. *The Man Watching: Anson Dorrance and the University of North Carolina Women's Soccer Dynasty*. Ann Arbor MI: Sports Media Group, 2006.

DiCicco, Tony, and Dr. Colleen Hacker. *Catch Them Being Good: Everything You Need to Know to Successfully Coach Girls*. New York: Penguin Books, 2002.

Hamm, Mia, with Aaron Heifetz. *Go for the Goal*. New York: HarperCollins, 1999.

Lisi, Clemente A. *The U.S. Women's Soccer Team: An American Success Story*. 2nd ed. Lanham MD: Taylor Trade, 2013.

Longman, Jere. *The Girls of Summer: The U.S. Women's Soccer Team and How It Changed the World*. New York: Perennial/HarperCollins, 2001.

Murray, Caitlin. *The National Team: The Inside Story of the Women Who Changed Soccer*. New York: Abrams Press, 2019.

Nash, Tim. *It's Not the Glory: The Remarkable First Thirty Years of US Women's Soccer*. [Morrisville NC]: Lulu Publishing Services, 2016.

OTHER WORKS BY ROB GOLDMAN

Once They Were Angels: A History of the Team
Always an Angel: Playing the Game with Fire and Faith (with Tim Salmon)
Nolan Ryan: The Making of a Pitcher
Hauling Time: A Novel